Drawing a Fun Cartoon Character

W9-DGU-748

Cartoon characters, like their human counterparts, consist of various components. Knowing how to draw different parts of your characters helps you put them all together more confidently. Chapters 6 through 9 give the specifics on how to draw basic characters, but these steps describe the different elements common to most human cartoon characters. (If they're from Mars, these steps may not apply!) Try your hand here at creating a mad scientist! The following steps and figures walk you through this process.

1. **Start with the head.**

 Draw a medium-sized oval shape with small ears on each side. Lightly sketch a horizontal line across the middle of the head area. Lightly draw a vertical line down the middle of the head. These two lines intersect at the middle and form a centerline guide for placing the facial features.

2. **Draw the face.**

 In the middle of the head, lightly sketch out the nose and place a small round circle on each side of the nose for the glasses. Under the nose draw a smile and curve it upward on both ends. From each side of the nose draw a vertical line going down on each side of the mouth. Draw a small line below the mouth for the chin.

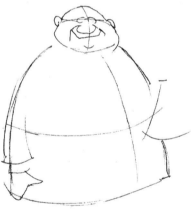

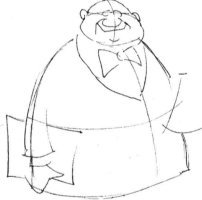

3. **Sketch the body.**

 From each side of the bottom of the head, draw two vertical lines going down, curving slightly outward so that the lines are wider apart at the bottom than at the top to form a bell shape. Draw a horizontal line across from the bottom of the left vertical line to the right vertical line. Doing so forms a complete bell shape. Draw a horizontal line across the middle of the torso and a vertical line down the middle. These two lines intersect at the middle and form a guide for placing clothing and creating a center for the character. Under the head draw a V-shape for the jacket lapels. Draw a bow tie directly under the chin.

4. **Add the arms.**

 On the character's right side, draw vertical lines going down the side of the torso for the arm. At the end of the arm, draw in the hand and draw a large square shape under the arm for the paperwork the character is holding.

continued

For Dummies: Bestselling Book Series for Beginners

Drawing Cartoons & Comics For Dummies®

Cheat Sheet

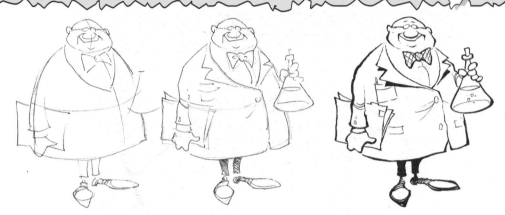

5. Place the legs.

Under the torso area, draw four vertical lines going down about ¼ the length of the torso. Each set of lines forms one of the legs.

6. Add shoes.

At the bottom of each leg draw the shoes. For the character's right shoe, draw a diamond shape that points downward. For the left shoe draw a small, elongated oval shape that points outward to your right.

7. Add some accessories.

On the torso, fill in the area for the outer lapels. Draw a vertical line from the bottom of the lapels to form the middle of the lab coat. Sketch in the glass beaker in the character's left hand. Add the small buttons and pockets.

8. When you're finished, ink your character for his final, complete look.

Shopping for Tools and Supplies

The following is a list of basic cartooning tools and supplies you can add to your workspace:

- ❏ Paper for doodling and sketching:
 - ❏ Scratch paper
 - ❏ Typing paper
 - ❏ Note paper
- ❏ Paper for drawing finished art:
 - ❏ Vellum paper
 - ❏ Watercolor paper
 - ❏ Bristol drawing paper

- ❏ Tools to prep with:
 - ❏ Ruler
 - ❏ Eraser
 - ❏ White correction fluid
- ❏ Tools to sketch with:
 - ❏ Non-photo blue pencils
 - ❏ Charcoal pencils
 - ❏ Drawing pencils
 - ❏ Technical drafting pencils

- ❏ Tools to use for final art:
 - ❏ Pigma Micron pens
 - ❏ Winsor & Newton #2 brushes
 - ❏ Waterproof black India ink
 - ❏ Adobe Photoshop

For Dummies: Bestselling Book Series for Beginners

by Brian Fairrington

WILEY

Wiley Publishing, Inc.

Drawing Cartoons & Comics For Dummies®

Published by
Wiley Publishing, Inc.
111 River St.
Hoboken, NJ 07030-5774

www.wiley.com

For general information on our other products and services, please contact our Customer Care Department within the U.S. at 877-762-2974, outside the U.S. at 317-572-3993, or fax 317-572-4002.

For technical support, please visit www.wiley.com/techsupport.

Wiley also publishes its books in a variety of electronic formats. Some content that appears in print may not be available in electronic books.

Library of Congress Control Number: 2009928742

ISBN: 978-0-470-42683-8

Manufactured in the United States of America

10 9 8 7 6 5 4 3 2 1

WILEY

About the Author

Brian Fairrington is a nationally syndicated, award-winning editorial cartoonist and illustrator and one of the few U.S. cartoonists whose political leanings are conservative. Brian began his career in the mid-1990s while he was a student at Arizona State University, where he began drawing cartoons for the student newspaper, the *State Press.*

Arizona State University is home to the Walter Cronkite School of Journalism, one of the more prestigious journalism programs in the country. The newspaper is part of that program but is independently operated by the students. During his undergraduate years at the *State Press,* Brian won every major national award, making him one of the most decorated cartoonists to come out of college. His honors include the John Locher Memorial Award, given by the Association of American Editorial Cartoonists, and the Charles Schulz Award, given by the Scripps Howard Foundation. Brian is also the two-time winner of the Society of Professional Journalists Mark of Excellence Award, as well as a ten-time winner of the Gold Circle Award, presented by Columbia University's Journalism School.

While still in college, Brian's cartoons were nationally syndicated by the Scripps Howard News Service. After graduating, he became a cartoonist for the *Arizona Republic* and the *East Valley Tribune,* both in the Phoenix area. He then moved from Scripps Howard to become nationally syndicated by Cagle Cartoons, and his work is currently distributed to more than 800 newspapers, magazines, and Web sites. His cartoons have appeared in *The New York Times* and *USA Today* as well as on CNN, MSNBC, and Fox News. Additionally, his cartoons regularly appear on MSNBC's Cagle Cartoon Index, the most popular cartoon Web site on the Internet.

The in-your-face approach and conservative flavor of Brian's editorial cartoons have brought him notice from fans and critics alike. His work has been the subject of editorials in the *Wall Street Journal* and numerous other publications. He was featured on MSNBC's *Imus in the Morning* show and was most recently profiled on CBS *News Sunday Morning.* Brian is a regular guest on the Phoenix-based TV show *Horizon,* where one of his appearances garnered an Emmy Award for news programming.

Along with Daryl Cagle, Brian is the author and editor of *The Best Political Cartoons of the Year* series of books by Que Publishing. To date, Brian has published seven annual "best of" cartoon books featuring the best cartoons from all the top editorial cartoonists in the country.

Brian has done numerous illustrations and full-color artwork for such magazines as *The New Republic* and *Time,* among others. A collection of Brian's original cartoons is on display at the Ostrovsky Fine Art Gallery in Scottsdale, Arizona. An Arizona native, Brian resides there with his wife Stacey and their four children. He can be reached at bfair97@aol.com.

Dedication

This book is dedicated to all those individuals who love to draw and have grown up (and are still growing up) with a passion for drawing cartoons. Thank you to all the cartoonists who inspired me as a kid with all the wonderful and fantastic art that made me want to follow in their footsteps.

A special dedication goes out to all the cartoon fans who, though they may not be able to draw a straight line themselves, still appreciate the funny, strange, wacky, and sometimes serious world of cartooning. Cave drawings were the first cartoons, and it's safe to say in the end that someone will probably draw a cartoon on the outside of the big bomb that blows up the world. Until that day, this book is dedicated to everyone who reads it. As we say in the cartoon world, "Kaboom!"

Acknowledgments

I have to thank Mike Lewis, the acquisitions editor for this book; Chad Sievers, my project editor; and the entire Wiley team for their assistance and patience. I want to thank my literary agent Barb Doyen for all her wonderful motherly advice. A huge thanks to Sharon Perkins for all the tremendous help she provided me on this project. I'd love to work with her again in the future.

I have to thank my wife Stacey, who has put up with all the late nights needed to draw the art and write this book on time (okay . . . never on time). Thanks also go out to my wonderful children: Chase, Hayden, Blake, and Lauren, and the 435,567 times they asked me, "What are you drawing?" Thanks to all my friends and extended family who haven't seen me over the last six months and are probably wondering what happened to me.

Lastly, I want to thank anyone who has ever run for political office or who is thinking about running for office. As long as you feed your egos and relentless thirst for power by entering the crazy world of politics, I will always have material.

Publisher's Acknowledgments

We're proud of this book; please send us your comments through our Dummies online registration form located at http://dummies.custhelp.com. For other comments, please contact our Customer Care Department within the U.S. at 877-762-2974, outside the U.S. at 317-572-3993, or fax 317-572-4002.

Some of the people who helped bring this book to market include the following:

Acquisitions, Editorial, and Media Development

Project Editor: Chad R. Sievers

Acquisitions Editor: Mike Lewis

Copy Editor: Todd Lothery

Assistant Editor: Erin Calligan Mooney

Editorial Program Coordinator: Joe Niesen

Technical Editor: David Allan Duncan

Editorial Manager: Michelle Hacker

Editorial Assistant: Jennette ElNaggar

Art Coordinator: Alicia B. South

Cover Artwork: Brian Fairrington

Parts Cartoons: Rich Tennant
(www.the5thwave.com)

Composition Services

Project Coordinator: Lynsey Stanford

Layout and Graphics: Samantha K. Allen, Reuben W. Davis, Christine Williams

Special Art: Brian Fairrington

Proofreaders: Laura Albert, Betty Kish

Indexer: Claudia Bourbeau

Publishing and Editorial for Consumer Dummies

Diane Graves Steele, Vice President and Publisher, Consumer Dummies

Kristin Ferguson-Wagstaffe, Product Development Director, Consumer Dummies

Ensley Eikenburg, Associate Publisher, Travel

Kelly Regan, Editorial Director, Travel

Publishing for Technology Dummies

Andy Cummings, Vice President and Publisher, Dummies Technology/General User

Composition Services

Debbie Stailey, Director of Composition Services

Contents at a Glance

Table of Contents

Part II: Creating Cartoon Characters 81

Chapter 6: Starting from the Top 83

Chapter 7: From the Neck Down 107

Introduction

You may think cartooning is just for kids, but that's far from the truth! Cartooning is a highly lucrative enterprise. Cartoons influence the way people look at political and world events, they make people think, and they help people laugh at themselves. Cartooning is more than just funny characters telling jokes — it's a snapshot of real-life situations where you, the cartoonist, can share your opinion about life and its endless interesting situations. Being able to draw is only one facet of being a good cartoonist. Being able to get across a compelling point with just a few pen strokes and to add the details that make your cartoons stand out from the pack is equally important. This book shows you how.

About This Book

This book is for people interested in drawing cartoons, whether they're novices unsure where to start or pros who want to improve their art or find better ways to market themselves. Every top-selling cartoonist in the world started out as a beginner. It takes time, practice, and some talent to become a successful cartoonist, but it also takes determination and the desire to stick to it until you become good at it.

More important, this book can show you how to create your very own cartoon characters in a fun environment. I give you step-by-step instructions on how to create not just human cartoon characters, but others like cars, animals, and other creatures. You may even decide to make an unusual inanimate object your main character! And because cartooning is more than just drawing, I also give step-by-step instructions on how to come up with ideas and color your cartoons.

Conventions Used in This Book

Every *For Dummies* book has certain conventions to make it easier for you to get the information you need. Here are some of the conventions I use in this book:

- Whenever I introduce a new technical term, I *italicize* it and then define it.
- I use **bold text** to highlight keywords or the main parts of bulleted and numbered lists.
- The Internet is a wealth of information on everything from the history of cartooning to great sites to buy expensive supplies for less. Web sites appear in monofont to help them stand out.

What You're Not to Read

In today's busy world you may be juggling a full-time job, your better half, kids and pets, friends and family, and a wide assortment of other responsibilities. You don't have much free time. In aspiring to improve your cartooning abilities, you simply want the essential info to help you. If that's the case, feel free to skip the sidebars — those boxes shaded in light gray. Sidebars present interesting (I hope!) supplemental info that helps you gain a better appreciation of the topic, but the info isn't essential to understand the topic, so you won't miss anything if you skip them.

Foolish Assumptions

In writing this book, I make a few assumptions about you:

- You want to know more about cartooning in general.
- You want to know how to draw some common cartoon characters and make them interesting.
- You want to know how to liven up your cartoon backgrounds and settings.
- You may be interested in a career as a cartoonist.

Note: If you're looking for a complete art course, this book isn't for you. Although I give specific, step-by-step examples of how to draw basic characters and backgrounds, I assume you already know how to pick up a pencil and draw basic shapes. You also won't find a complete art history here, although I do give quite a bit of cartoon history throughout the book.

How This Book Is Organized

For Dummies books are written in a modular fashion. This format gives you the option of reading the book from beginning to end, or alternatively, selecting certain parts or chapters that are relevant to your interests or experience. I organize this book to start with the basics and build up to the more advanced concepts. The following describe each part in more detail.

Part I: Drawing Inspiration: Getting Started with Cartoons and Comics

Part I is all about getting familiar with the nuts and bolts of cartooning. What art supplies do you need to get started? How can you set up a workspace

that's efficient without breaking the bank? Can you draw cartoons at the kitchen table with nothing more than a number 2 pencil? What's the first thing you do when you sit in front of a blank piece of paper?

This part answers those questions and then leads you into the harder questions: What types of cartoons are you interested in drawing? How do you develop your characters? And the oft-asked and hard-to-answer question: Where do you get your ideas?

Part II: Creating Cartoon Characters

Part II is all about drawing and developing characters. The chapters in this part teach you to draw your characters starting from their heads right down to their toes, whether your characters are people, animals, or inanimate objects. I also look at the fine art of satirizing the political landscape with editorial cartoons.

Part III: Cartoon Designs 101: Assembling the Parts

Cartooning is much more than talking heads and word balloons. Creating a background perspective that adds detail and interest, deciding how to letter your cartoons, and setting a scene that enhances your cartoons without interfering with your main point are all part of what I cover in this part.

Part IV: Cartooning 2.0: Taking Your Cartoons to the Next Level

Part IV goes deeper into the cartooning world. I look at the impact computers have had on the cartooning world, and I describe tools and toys available today to help you fine-tune your work, like Photoshop. If you want to make this your life's work, this part gives you the tools you need to evaluate your work and find out if you have what it takes to make it in the big time.

Part V: The Part of Tens

All *For Dummies* books contain the Part of Tens section, which gives you fun, helpful information in easily digestible chunks. In this part I review ten steps to creating a finished cartoon, from first pencil stroke to final product. I also help you launch your new career with ten steps to breaking into the cartooning world.

Icons Used in This Book

Throughout the book, I use icons in the margins to highlight valuable information and advice. Here's what each one means:

This icon points out something that's important to remember, whether you're a novice cartoonist or a more experienced one.

This icon indicates helpful hints, shortcuts, or ways to improve your cartooning.

I use this icon to alert you to information that can keep you from making big mistakes!

The text associated with this icon goes into technical details that aren't necessary to your understanding of the topic but that may appeal to those who want more in-depth information.

The info that this icon highlights isn't essential, but I hope these anecdotes about the world of cartooning help you appreciate just how rich that world is.

Where to Go from Here

If you want to know every single thing about cartooning, start at the beginning of the book and read straight through. However, you don't need to read the book in sequence. You may be looking for specific info on certain aspects of cartooning, in which case you can refer to the table of contents or the index to find the subject you want. Each chapter is meant to stand alone, and the info each contains isn't dependent on your reading previous chapters to understand it.

If you're brand new to cartooning and aren't sure where to start, Chapter 2 helps you understand the different cartoon genres and choose the genre that best suits your interests. If you're a beginning cartoonist and need some drawing pointers, jump into Chapter 4 and start with the drawing basics. If you're already drawing but want to improve your characters, check out Chapters 6 and 7.

Part I
Drawing Inspiration: Getting Started with Cartoons and Comics

The 5th Wave By Rich Tennant

In this part . . .

Are you a budding cartoonist, or would you like to be a professional cartoonist someday? The world of cartooning is more diverse and interesting than you may realize. In this part, I explore the world of cartooning, including the different types of cartoons and the tools you need to draw them. I also give you tips on how cartoonists come up with their ideas, and I help you find humor in everyday life. After you know where to look, you'll have more ideas than you'll ever be able to use.

Chapter 1

The Skinny on Cartoons and Comics

So you want to be a cartoonist? Or maybe you already consider yourself a cartoonist — and a darn good one — but you don't have the slightest idea how to market your work. Or perhaps you just enjoy drawing and you'd like to become better at it.

If you want to draw cartoons, you're not alone. Right about now, thousands of budding cartoonists are doodling on any scrap of paper they can find, dreaming of breaking into the cartooning business someday. And who's to say you won't be the next Charles Schulz or create the next Garfield? One thing's for certain: If you're a cartoonist with something to say and you get your point across well, you can — thanks to the Internet — be published anytime and anywhere, even if it's just on your own Web site or blog.

Many people draw well, but they aren't sure how to adapt their drawings for the cartoon or comics market. Others have new ideas, but they draw somewhat crudely and need help pulling a cartoon together. Whether you're brand new to cartooning and want to experiment with different characters and settings to create your first strip, or you've been drawing for quite a while and want some helpful advice to improve your characters, you're probably looking for someone to give you a few pointers. You've come to the right place.

This chapter serves as your jumping-off point into the world of cartooning. Here I give you an overview of cartooning and the different cartooning genres that I cover in this book, I show you how to master the drawing basics, and I discuss how cartoons are marketed and how those markets are evolving. If you've always wanted to be a cartoonist, this chapter gives you the skinny.

Understanding the Different Genres

To be a cartoonist, you need a firm grasp of the different types of cartoons and comics in today's market. I discuss several in this book. Some categories that were once popular now face challenges with the ever-changing market, especially traditional comic strips and editorial cartoons that are married to newsprint.

However, other forms of cartooning that were once off the beaten track have exploded in popularity; they include webcomics, editorial cartoons on the Internet, graphic novels, and comic books. The traditional markets are changing, and the new markets provide an exciting opportunity for cartoonists to get in on the ground floor of cartooning's future.

If you love to draw cartoons and are thinking about trying to become a professional cartoonist, study the categories in the sections that follow and the details about each. Do you have to stick to just one genre? No, but many cartoonists do, which helps their work become identifiable. Check out Chapter 2 for more on different genres and how to work within them. No matter what type of cartooning you may be interested in, it all begins with the basics of drawing and character development. Great ideas and great character development are what make animation in all its forms continue to be popular (refer to Chapter 4 for drawing basics).

Following familiar characters: Comic strips

When you think of cartooning, *comic strips* may be the first thing that pops into your mind. Comic strips are basically a satirical look into the lives of the characters that inhabit them. Comic strips often reflect the subtle truths about our own lives in their observations and insights into the world around us. Comic strips have the longest continuing run of popularity among cartooning genres, largely because people like to follow their favorite characters. This genre historically has been a staple and popular feature in newspapers. As newspapers face market challenges and try to adapt and evolve, popular Web-based comic strips have popped up all over the Internet.

Modern comic strips were first created at the turn of the 20th century as a way to attract readers to newspapers. Comic strips appeared on the scene long before other forms of entertainment media — like radio, movies, and TV — became popular.

Expressing a viewpoint: Editorial cartoons

Editorial cartoons are a popular and sometimes very controversial form of cartooning. *Editorial cartoons* are simply cartoons written to express a political or social viewpoint. They also first appeared on the scene about the same time as the modern newspaper gained widespread popularity.

Early newspaper publishers used editorial cartoons the same way they used comic strips — to attract readers. Editorial cartoonists in the early part of the 20th century were the media celebrities of their day. Their cartoons preceded TV by several decades and were a source of information and entertainment for readers. Editorial cartoons of that era were very influential, even influencing political elections and reforms. From Thomas Nast and his exposure of corruption in the underbelly world of New York politics to the Washington Post's Herbert Block (better known as Herblock) landing on Nixon's enemies' list during the Watergate scandal — and up to the scathing criticisms of the war in Iraq — editorial cartoons have played and continue to play an important role in the annals of political discourse.

Editorial cartoons have evolved over the last century and remain very popular today. However, market realities are challenging for new editorial cartoonists. The profession has traditionally been tied to print journalism, and in the past few years, newspapers have had massive layoffs and cutbacks. But like comic strips, editorial cartoons are thriving on the Internet, and unlike their print counterparts, the Web versions are done in full color, and some are even animated. Check out Chapter 11 for more info on editorial cartoons.

Delivering the punch line: Gag cartoons

Gag cartoons are another popular category. *Gag cartoons* may look similar to comic strips, but in fact they're quite different. Unlike comic strips, most gag strips don't have a regular set of characters or story lines, and they're usually single-paneled. Each new cartoon is a brand new gag or visual punch line delivered in a single frame or box.

Despite not having regular characters, gag cartoons do have advantages over comic strips. One main advantage is that they're marketable to publications and Web sites that want a lighthearted, joke-of-the-day feature that a strip with characters may not fulfill. Gag cartoons tend to be more generic and better suited for these markets. One of the most well-known gag cartoons, *The Far Side,* set the bar high for the genre, and the next-generation successor to *Far Side* creator Gary Larson has yet to surface, so get busy, before someone else beats you to it!

The comic strip's close cousin: Comic books

As the other cartooning genres face the challenges of a shrinking and evolving newsprint industry, one cartooning genre closely related to comic strips is becoming so big, so fast that it dominates not only the cartoonist business but the whole entertainment industry as well. Comic books have exploded in popularity in the last decade, and you have to look no further than the top movies in the last few years as proof.

The following is a list of movies based on comic books or graphic novels, along with each film's worldwide box office sales numbers as of 2009:

You can see by the numbers that these movies grossed more than $8 *billion*. That kind of financial success guarantees that Hollywood will make many more movies based on comic books in the future.

The comic book/graphic novel industry continues to thrive. If you have the skills necessary to enter this popular market, go for it — it's a worthwhile and potentially lucrative market to consider. Although comic books merit an entire book of their own, I focus this book more on cartooning and comic strips. But even if you're more interested in creating comic books, you can still use many of the core pieces of advice that I offer about character development, humor, background, lettering, and so on.

The first four *Batman* movies	$1.3 billion
Batman Begins/The Dark Knight	$1.5 billion
Three *Spider-Man* movies	$2.5 billion
Iron Man	$582 million
Hulk and *The Incredible Hulk*	$509 million
Sin City	$159 million
300	$456 million
The first three *X-Men* movies	$1.2 billion

Getting Started with Drawing

To begin drawing your cartoons, you need decent quality supplies and a designated workspace. Chapter 3 goes into the art of setting up an office, cubicle, or corner for your art and which supplies you need.

Before you go to the store and spend any money on supplies, keep in mind that although expensive drawing tools are great, they won't help you at all if you don't have a little talent and a strong commitment to practice. Your best bet is to try different drawing supplies to see what works best for you. And whatever supplies you end up getting, just be sure to draw, draw, draw!

Reminiscing over the history of cartoons

Cartooning is far from a new art form. Cartoons go back a lot earlier than Charlie Brown, or even the earliest cartoon newspaper strips.

The word *cartoon* comes from the Italian word *cartone*, which means "large paper." The earliest cartoons can be traced back to some very large canvases — prehistoric cave drawings discovered in the late 19th century. These images were painted on the side of a cave and reflected the daily life of early humans.

Centuries after people drew all over their cave walls to tell a story, cartoon-style drawing continued to evolve, and by the early 1300s,

Egyptians were creating large murals with a series of images that told a story. These images were simple and easy for the observer to comprehend. This form of communication proved to be very popular and has continued in one form or another up to the present day.

However, it was the 20th century and the invention of the modern newspaper that brought most forms of modern cartooning into existence. Although newspapers today are struggling, the art of cartooning isn't about to die with the death of newsprint; like the news media, cartoonists have found a new outlet for their work on the Internet.

Drawing a basic character's head

Your character's head is the focal point for the reader, so you need to understand a few simple basics in the construction and design of the cartoon noggin:

- ✔ **Start at the top with the head shape:** Begin with a simple shape, usually an oval or small circle. In cartooning, almost every detail is exaggerated, particularly when drawing from the neck up. In real life the human head is disproportionally larger in kids than adults and gets smaller in proportion to our bodies as we grow. In Chapter 6, I spell out the steps necessary for the basics when drawing your character's head, whether you're drawing a child or a senior citizen.

- ✔ **Fill in facial features and expressions:** The face is the epicenter of all expression, and cartooning is all about exaggerating expressions for effect and drama. In Chapter 6, I show you numerous examples of expressions and their relationship to the different facial features. In addition, I explore the options you have regarding the size, shape, and position of the facial features, as well as the different types associated with male and female characters.

Sketching a character's body

Designing a cartoon character's body is always a challenge, and in many ways it's not unlike building or designing anything else. You have many different parts, and as a designer you're in charge of how they fit together to

achieve the best design result. Cartoon characters can be created in an assortment of different sizes and shapes. In Chapters 7, 8, 9, and 10, I discuss the basics of character body types and overall construction and the options you have regarding male, female, and creature shapes and sizes.

Honing your skills

To get better at anything, especially a physical skill like drawing, you need to practice. And practice. And practice some more. Consider these basics when honing your skills:

- **When first starting out, it doesn't matter what you draw — just draw something.** After you have the drawing basics down, you can concentrate on your content.

- **Persistence is the key, and you'll get better over time.** Practice makes perfect.

- **Copying the art of other cartoonists when you're young and learning to draw is okay as long as you never claim it as your own.** Make sure you develop your own style and ideas if you want to be a professional.

- **Try and create something fresh while still being marketable.** Your mind works in a way different from any other human being's. Take advantage of your unique perspective on the world to find something different, but not so far out there that it's unmarketable except to the very odd.

- **Don't be afraid to ask others for advice, especially if they're cartoonists themselves.** And remember, your mom isn't the best person to critically judge your work, although she's great for your ego.

Not sure how to improve your art? Check out Chapters 4 through 11 for more specifics on drawing everything from parents and kids to the family pet and the family car.

Peering into the Future of Cartoons

For many years the syndicate model has been the primary way cartoons have been marketed. With this model, syndicates sell comic strips to newspapers to build readership for their features. However, this business model is changing, and quickly. This section takes a closer look at how things are changing and what the future holds.

Understanding the changes

Newspapers are going through an evolutionary period, and the end result may not be encouraging for newsprint. The Internet has become a more and more popular venue for aspiring cartoonists and even veteran cartoonists to upload their cartoons.

Two factors have hit newspapers hard in recent years:

- ✔ **The economy and its effect on advertising.** Advertising is one of the largest streams of income for newspapers, and without it they're forced to make big cutbacks, layoffs, and in some cases fold altogether.

- ✔ **The generational shift to getting news from the Internet.** This has had a profound effect on newsprint, and not for the better. Although newspapers have made the shift to the Internet, the operations are more scaled down and pale in comparison to the print editions.

One problem with marketing online is that the traditional syndicate model doesn't work on the Internet like it does in newsprint. For example, newspapers cater to and service individual markets, so a syndicate could take the same comic feature and sell it to multiple newspapers. This worked because the people in Denver weren't reading the same newspaper that the people in New Jersey were reading, so it didn't matter that the same cartoon content ran in each paper. The syndicate could essentially sell the same feature content over and over again.

The Internet basically destroys this model. Unlike newspapers, which represent many markets across the country and throughout the world, the Internet by comparison is one big market. Why would a newspaper's Web site pay for content that can seen by the same set of eyes elsewhere just by clicking a button? The Internet puts access to almost every newspaper in the world right at your fingertips.

The answer to this changing market is exclusivity. One comic feature is put in one place and all readers must come to it, instead of the old syndicate way of the cartoon going out to readers via their local paper. This model changes the dynamic considerably and points to webcomics as an eventual successor to traditional comic strips.

What the Web offers that syndicates don't

Many webcomics are similar to comic strips you read in the newspaper, except that they're only available on the Web. They're also only available on one Web site that the cartoonist creates. If people want to read the webcomic, they must go to that site.

Cartoonists can generate revenue from webcomics in a couple of ways:

- ✔ **Advertising:** The more people come to read the comic, the more traffic the Web site gets and the more likely it is to pick up a small amount of revenue from advertising.
- ✔ **Merchandise and books sold on the Web site:** Many online print-on-demand (POD) companies cater to Web sites that can offer books for sale as well as other merchandise such as T-shirts.

The creator of a webcomic has more control over his feature than a traditional cartoonist does, but he also must bear more responsibility. Webcomic creators are like small businessmen. They're responsible for not only writing and drawing the comic feature — just like if they partnered with a syndicate — but also the Web site design, advertising, marketing, and sales of related merchandise. The upside is the webcomic creator keeps 100 percent of the revenues instead of giving half to the syndicate.

The Internet has a vast sea of popular webcomics. They're done by amateurs and professionals alike, who take advantage of the ability to publish anything on the Internet. The more advanced webcomic creators display their features in full color and even use some animation.

The future of cartooning has more to do with the public's appetite than with newsprint. The future of comic strips is in transition. Many of the newsprint-based comics may die along with print. As long as the public loves to read comics in all their forms, cartooning will live on indefinitely. New strips will take their place on the Internet. There's no indication that the public will stop reading or that those who have the cartooning bug will stop drawing. The future may seem uncertain on one hand, but on the other hand, an exciting new frontier is just waiting to be explored. The Internet is a vast, relatively new place where cartoons of all kinds will be born and will flourish.

Chapter 2

Looking at the Different Cartooning Genres

. .

. .

Cartoons are as old as man. Just take a look at the walls of early cave dwellers. Although you don't find any talking woolly mammoths, you do find something intrinsic to all cartooning — simplification. The very heart of cartooning is the simplification that allows an image to communicate across almost any barrier — race, gender, culture, and beyond. And therein lies the power of a cartoon — instant familiarity.

A cartoonist uses this kind of shorthand to achieve an entire spectrum of effects — from primitive doodles to detailed comic book art. It's astounding when you think of all the permutations the simple cartoon has spawned. The major categories are single-panel cartoons, multipanel comic strips, editorial cartoons, humorous illustrations, and comic books. But with subcategories such as journal comics, webcomics, clip-art comics, graphic novels, manga, and photo comics, it's clear that cartoons have dug deeply into how we communicate.

The world of cartooning is vast, so try to expose yourself to all the possibilities by working in all the genres. At the very least, you'll pick up some tricks in one form that you can apply to another. More important, by experimenting with different genres, you may find out that you have an aptitude for a category that you hadn't originally considered.

Getting Funny with the Standard: Comic Strips

Comic strips are a true American art form. The format is a short series of panels that communicate a brief story — usually ending with a punch line. Most strips have recurring characters, and some feature an underlying story line that continues from strip to strip.

The power of the American comic strip is most evident on the Web. In a medium whose craft has no limits whatsoever, it's no coincidence that the simple, three-to-four-panel strip dominates the landscape. This section takes a closer look at comic strips, including what they are, where they come from, and why they're so popular.

Eyeing a comic strip's characteristics

The comic strip is the format that readers of newspaper comics are most familiar with. *Garfield, Dilbert,* and *Peanuts* are all comic strips. Comic strips have a deceptively potent ability to develop strong bonds between readers and recurring characters, as each new strip over the course of time adds layers of meaning to those characters — making them more real than perhaps any other characters in fiction.

The following are the characteristics of a comic strip that make it easily identifiable:

- **Consecutive panels:** A comic strip uses consecutive panels to tell a short story. Usually, but not always, this story ends in a punch line.

- **Iconography:** A comic strip uses all the standard cartooning iconography — word balloons, narration boxes, movement lines, and so on — to convey its message.

- **Recurring characters:** Often, a comic strip's characters return throughout the strip's life. Sometimes the strip has only three or four recurring characters, and sometimes — as in the case of *Doonesbury* — the cast is seemingly endless.

Watching the birth of an American art form

From the late 19th century on, newspaper publishers like William Randolph Hearst and Joseph Pulitzer understood that comics sell papers. The big papers of the day competed fiercely for the best comic strips. These strips

quickly gained popularity, and newspapers added more as time went on. This tradition is what we call the "funny pages," and you can find it in every large newspaper today.

Hearst realized that he could get more bang for his buck by distributing the comics he bought for one newspaper to all the newspapers in his chain. He started the Newspaper Feature Service in 1913 to do just that. Its success was monumental, and it was soon spun off into a separate entity, serving newspapers beyond the Hearst chain. In 1915, it was renamed the King Features Syndicate.

The newspaper syndicates of today operate the very same way: They develop distinctive titles to offer to publications on a subscription basis. As a result, cartoonists can reap the rewards of having their comics printed in several papers across the country (after the syndicate takes its cut, of course). Unfortunately, because of the poor health of the American newspaper industry, this has become an increasingly dim prospect. I discuss syndication more fully in Chapter 19.

Many comic strips have come and gone over the last century, but a few pioneers are worth discussing, because they contributed greatly to the art of cartooning as it exists today. The following are two early strips that have important lessons you can apply to your own cartooning.

Pogo by Walt Kelly

Pogo, perhaps the first comic strip to employ many of the traits of the best-written editorial cartoons, was groundbreaking in many ways. *Pogo* stood out from other cartoons of the day for the following reasons:

- ✔ **It had masterful art by Kelly.** One of the primary reasons for the strip's appeal was the special attention Kelly paid to the art. In comparison to the rigidly illustrated panels of other comic strips of the era, *Pogo* featured a loose, expressive line that belied the nonconformity of the strip's content.

- ✔ **It broke accepted conventions.** In *Pogo,* characters might lean against the edge of a panel, allowing it to stretch, as if to convey flexibility or movement. Albert the alligator would strike a match against the nearest panel edge to light his cigar. These characters were aware of their presence in a comic strip, and that added to the strip's countercultural attitude.

- ✔ **It used sharp political satire.** Political commentary was virtually unheard of in the funny pages, but in *Pogo,* Kelly presented his stories from the viewpoint of his social and political beliefs. Politicians often walked into the strip disguised as fellow denizens of the famed Okefenokee Swamp. Perhaps most notably, Senator Joseph McCarthy was lampooned as a wildcat named Simple J. Malarkey during the height of his red-scare-era influence.

Although *Pogo* is more than 50 years old, you can discover an awful lot about modern cartooning by examining it. Studying Kelly's work can help you

- ✔ **Be a better caricaturist.** With a few deft lines, Kelly was able to graft the features of a widely known politician onto the visage of an animal. It's no small feat, but in isolating dominant facial characteristics, he conveyed the image gracefully.

- ✔ **Become a better artist.** Kelly's attention to texture and perspective gave his art a keen realism, even as his expressive lines and playful compositions pushed toward the surreal.

- ✔ **Appreciate language more deeply.** Sure, schoolteachers cringed, but Kelly's dialogue read more like poetry than prose. His characters' thick Southern accents were laid out phonetically for all the world to see. Kelly used the way his characters delivered their lines to convey as much expression as the words themselves.

- ✔ **Appreciate social satire.** Kelly wrote from a distinct political and social viewpoint. He used his targets' own gestures and syntax against them as he lampooned them not only as politicians but also as archetypes. Rarely heavy-handed, Kelly typically delivered his thoughts quietly — he never shouted.

Peanuts by Charles Schulz

The most successful comic strip of all time centers around a boy and his dog. It may be called *Peanuts,* but its overall influence has been anything but! With this quiet comic strip, Charles Schulz dramatically changed the landscape of American comics. In large part, the *Peanuts* mystique can be distilled to the following:

- ✔ **It had simple, accessible art.** The entire *Peanuts* universe is drawn in an almost childish manner. As I discuss earlier in the chapter, simple images allow people from all walks of life to project their interpretations into the drawings. In other words, we see so much in Charlie Brown because we put so much there to begin with.

- ✔ **It used philosophical humor.** Although the drawings were simple, the writing was complex. The standard *Peanuts* gag is far from the slapstick frolic you'd expect about a group of children. Instead, the kids deal with angst and feelings of insecurity. They brood and they sigh. Schulz's observations were powerful and provocative — making the reader laugh and then think.

As a beginning cartoonist, you can take away several lessons from a study of Schulz's work. You can

- ✔ **Gain a better understanding of the appeal of creating characters that readers can relate to.** Schulz used the concept of archetypes in developing his characters. In other words, Linus represented the young, questioning philosopher, Charlie Brown was the lonesome loser, Lucy was a bully, and Snoopy was an embodiment of wild abandon. By providing

his characters with such strong personality traits, Schulz made them instantly familiar to his readers — all of whom surely had met their share of philosophers, losers, bullies, and crazies.

✔ **Understand the ways you can incorporate your own personality traits into your characters.** *Peanuts* wasn't an instant success. In fact, it took years for readers to appreciate the quiet philosophy present in Schulz's humor. But instead of trying to change to please popular tastes, Schulz stayed true to his inner voice. In many ways, instead of adapting to his readers, Schulz was able to convince readers to adapt to him.

✔ **Grasp an appreciation of the beauty in minimalist art.** Schulz is a wonderful counterpoint to the lush, textured illustration style of Walt Kelly. Schulz's drawings are geometric and somewhat rough. He uses no perspective and little in the way of nuance. It's a perfect counterpoint to the writing's complexity — almost reassuring the reader that nothing is as bad as it may seem. After all, it's hard to get too worked up about your own feelings of inadequacy when the issue is being raised by a kid with a round head sporting a single, curly strand of hair.

The Peanuts' creator in a nutshell

Charles Schulz, the creator of *Peanuts,* was born in Minneapolis, Minnesota, in 1922. Schulz loved to read the comics section of the newspaper so much that his father gave him the nickname Sparky after Sparkplug, the horse in a popular comic strip of the day, *Barney Google*.

Schulz was a gifted child who skipped two grades and copied pictures of his favorite cartoon characters from the newspaper. Recognizing his passion for drawing, his mother enrolled him in a correspondence course from an art instruction school. Following a stint in the army, Schulz had his new comic strip picked up by United Features. He originally called his strip *Li'l Folks,* but the strip was renamed *Peanuts* without Schulz's knowledge. The first strips focused on the iconic characters like Charlie Brown, Shermy, Patty, and Snoopy. Within the year, *Peanuts* was appearing in 35 papers, and by 1956, that number increased to well over 100.

By the 1960s, *Peanuts* was appearing in over 2,300 newspapers, and Schulz was famous worldwide. The cartoon branched out into TV, and in 1965, the classic Christmas special "A Charlie Brown Christmas" premiered to an entire generation of young children, followed by several others. Many volumes of Schulz's work were published over the years, and many made the *New York Times* Best Seller list.

In 1999, Schulz was diagnosed with cancer and subsequently announced that he would retire the following year. He died on February 12th, 2000, the night before his farewell strip was set to run in newspapers.

The success of *Peanuts* has inspired the creation of clothes, stationery, toys, games, and other merchandise. The financial success of *Peanuts* and the wealth it brought Schulz was unprecedented in the comics world. At the peak of his earnings, *Forbes* magazine estimated his annual income at $30–$50 million a year. And Schulz would have made considerably more if it had not been the custom of the day to sell the rights to your feature as part of the syndicate contract.

The modern funny papers

Comic strips have been around for over 100 years since the first strip, *Mutt and Jeff,* appeared in print, and readers continue to revel in their favorites. Today, the comic strip landscape is populated with such luminaries as Garry Trudeau *(Doonesbury),* Berkeley Breathed *(Bloom County),* Bill Amend *(FoxTrot),* Lynn Johnston *(For Better or For Worse),* Bill Watterson *(Calvin and Hobbes),* and Scott Adams *(Dilbert).*

Cartoonists such as these stand above the rest in their ability to form strong bonds with their readers through their work. For Trudeau and Breathed, that bond is built on satire and political opinion. For cartoonists like Amend, Johnston, and Watterson, the connection comes from their ability to communicate a unique view of family life. And Adams lampoons the sometimes absurd inner workings of the modern workplace, which many readers can relate to.

The next sections take a closer look at the work of Watterson and Adams.

Bill Watterson's Calvin and Hobbes

Calvin and Hobbes, by cartoonist Bill Watterson, was a comic strip about a young boy and the stuffed tiger that came to life in the boy's imagination. Although there had been many previous strips about kids and family, *Calvin and Hobbes* was fundamentally different:

- **Its art expressed as much as the writing.** Watterson was an expert draftsman, capturing the frenetic energy of 6-year-old Calvin in his lines. His graceful touch with watercolors made its way into the Sunday features, and they were beautifully and colorfully rendered, harking back to strips of another era. Watterson combined attention to illustrative detail with an appealing brush quality and fun character design.

- **Its emphasis was on a child's imagination.** Watterson presented most of the strip from the viewpoint of Calvin's overactive imagination. When Calvin was alone, his stuffed tiger Hobbes sprang to life as a rambunctious — if not more thoughtful — playmate. In school, his teacher was often seen as a hideous monster whom Calvin — sometimes in the persona of Spaceman Spiff — was constantly trying to thwart. In a clear homage to Winsor McCay's *Little Nemo in Slumberland,* daydreams and reality often collided — with hysterical results.

- **It presented a decidedly postmodern view of family.** Calvin's dad often remarked that, if it were up to him, they would have had a puppy instead of a child! This strip didn't present the shiny, happy, *Family Circus* family; rather, it showed a frustrated father, an overworked mother, and a hyperactive kid. In the heyday of the strip's run — late 80s/early 90s — many parents could relate.

Studying the work of Watterson can help you

✔ **Appreciate how pushing the limits of your creative imagination can benefit you as an artist.** In *Calvin and Hobbes,* Watterson accepted the challenge of delivering the frantic imaginings of a 6-year-old boy seven days a week. To stay true to his character, he couldn't rely on repetitive gags. Even when he returned to certain themes (Spaceman Spiff, Calvin as a dinosaur, Calvinball, and so on), Watterson avoided retreading old ground — challenging himself instead to push the ideas further.

✔ **Build confidence in your own vision as an artist.** Watterson was against any type of licensing or merchandizing of *Calvin and Hobbes*. He also fought for — and won — the right to stop his Sunday comic from being forced to follow a decades-old format that allowed newspaper editors to resize Sunday funnies several different ways. Despite the fact that these decisions made him unpopular with executives at newspapers and syndicates alike, his strip was wildly successful — critically *and* financially.

✔ **Appreciate the power of a simple concept executed well.** Every budding cartoonist grapples with a new comic strip with: "Has this already been done?" Take a lesson from Watterson. *Calvin and Hobbes* was not a new concept. It had been done in popular culture dozens of times, from *Winnie the Pooh* to *Little Nemo in Slumberland*. But Watterson knew that it's not the idea; it's the delivery that truly makes a comic great. He took an old concept and brought to it something new and original.

Scott Adams and Dilbert

Scott Adams's comic strip *Dilbert* originally revolved around Dilbert and his dog Dogbert in their home. However, Adams moved the primary location of most of the action to Dilbert's workplace at a large technology company. It was only after this shift that the strip began to take off and gain a much larger readership.

The success of *Dilbert* comes from some of the following:

✔ **It portrays corporate culture as a world filled with red tape and bureaucracy,** lives consumed with office politics, and a place where employees' skills and efforts are ignored and busywork is rewarded. Many American employees can relate to this!

✔ **It accentuates the absurdity of the cubicle and corporate workplace.** Much of the humor and insightfulness of the strip comes from the reader seeing characters making absurd, nonsensical decisions that are the result of directives given by misguided managers.

Studying the work of Scott Adams helps you

✔ **Understand the priority and importance of strong writing over art.** No one can accuse Adams of being a brilliant artist, but no one can deny that he's a tremendously skillful humor writer. His fantastic abilities to write solid, consistent humor keep his readers returning, not his crude artistic style.

✔ **Build the confidence to write what you know.** Before becoming a cartoonist, Adams worked at Pacific Bell, occupying a cubicle that's all-too-familiar to the *Dilbert* landscape. His writing was always good, but it didn't truly resonate with readers until he started sharing his experiences as a white-collar office-dweller. After he started writing from personal history, his work reached an entirely different level.

✔ **Appreciate the workings of the cartoonist/businessperson.** Adams is a perfect antithesis to Bill Watterson. Where Watterson focused on the art of comics, Adams focused on comics as a business. The licensing and merchandizing of *Dilbert* has been breathtaking — from microwave burritos to a TV sitcom. Adams has been able to leverage his success as a cartoonist into countless lucrative opportunities for himself — without sacrificing the quality of his daily comic.

Grasping why comics are still popular

In this day of digital everything, hand-drawn (okay, possibly digitally enhanced!) cartoons are still the first thing that many people turn to when they open the daily news. So what makes comic strips so popular? Their longevity is based on the following reasons:

✔ **Comic strips don't change.** Unlike live-action TV shows, where the characters age and the kids grow up, comic strip characters can stay frozen in time (although some cartoonists do "age" their characters). Cartoon characters may stay the same, but the material is always new. You see this not only in comic strips but also in popular animated TV shows like *The Simpsons,* which is now more than 20 years old, making it the longest-running scripted comedy show in history.

✔ **People don't change.** Although society has changed and communication methods have changed, people still find family, pets, and work amusing — at least part of the time. People relate to the familiar, and most cartoons are based on familiar situations.

✔ **Comic strips have something for everyone.** Whether you're liberal or conservative, a family person or a single guy, an office drone or a construction worker, you can find a cartoon to appeal to your tastes.

Some still-popular cartoons are more than 50 years old, although most of their characters haven't aged a day over that time period. Here are a few examples of long-running comic strips, along with the year that they began:

- ✔ *Blondie* 1930
- ✔ *Doonesbury* 1970
- ✔ *Garfield* 1978
- ✔ *Gasoline Alley* 1918
- ✔ *Hagar the Horrible* 1973
- ✔ *Marmaduke* 1954

- ✔ *Mary Worth* 1938
- ✔ *Nancy* 1922
- ✔ *Peanuts* 1950
- ✔ *Shoe* 1977
- ✔ *Wizard of ID* 1964
- ✔ *Ziggy* 1971
- ✔ *Zippy the Pinhead* 1976

These cartoons still rank high in reader polls. A few of them are close to 100 years old! Even the youngest of these classics is more than 30 years old.

Making Readers Think: Editorial Cartoons

The primary intent of an *editorial cartoon* is to present an opinion. But more than simply *present* an opinion, an editorial cartoonist uses strong satire, caricature, and parody to drive home her point as strongly as possible. In short, editorial cartooning isn't a game for the weak-willed, middle-of-the-road thinker. This kind of cartooning takes sides and asks no forgiveness. Needless to say, America has a long, rich tradition of editorial cartooning.

The next sections look at the characteristics of editorial cartooning and how they've evolved over the last two centuries in the United States.

Eyeing an editorial cartoon's traits

The editorial cartoon is a mainstay of a newspaper's opinion pages. The reason for this is simple: People respond strongly to an editorial cartoon's ability to present a complex argument using an image and a few short sentences. In a way, this short, punchy delivery defines the art form itself.

Unlike comic strips, editorial cartoons don't have recurring characters (unless you count politicians). Here are some other characteristics of editorial cartoons:

✔ **They're usually one-panel comics.** Most editorial cartoons consist of a single panel presenting a solitary scene. A few practitioners (Tom Toles of *The Washington Post,* most notably) choose to divide the space into comic-strip-style panels, but overwhelmingly, an editorial cartoon relies on a single illustration of a key moment or scene.

✔ **They make strong use of visual metaphor.** Editorial cartoonists don't *say* it, they *show*. If a politician is accused of stealing money from a government fund, you can bet that a cartoonist will draw him with his hand in the proverbial cookie jar. Because editorial cartoonists convey so much information visually, their words can be short and direct. The combination of the two can pack a wallop.

✔ **They draw from a long history of icons.** Editorial cartoonists can deliver parts of their message by using an entire repository of icons that have been developed over decades of cartooning. Donkeys represent Democrats, and elephants are Republicans. The United States can be represented by Uncle Sam, the Statue of Liberty, or an eagle — depending on which is most appropriate. Sometimes cartoonists incorporate these icons into the visual metaphor to make the message even stronger.

✔ **They use caricature to ridicule their targets.** Editorial cartoonists aren't polite. If a subject has somewhat large ears, their cartoon image may closely resemble Dumbo. Because their primary targets are people in authoritative positions, the use of harsh caricature may have the useful psychological benefit of making the subjects seem less powerful. Of course, psychology aside, such imagery also makes for prime comedy.

✔ **They often rely heavily on satire to make their point.** One good and well-known example of satire in a political cartoon is a cartoon acknowledged to be the first political cartoon in America, written by Ben Franklin. His "Join or Die," which depicts a snake whose severed parts represent the American colonies, is based on a common superstition of the day that stated that a dead snake would come back to life if the pieces were placed next to one another. Franklin's main editorial point was that the new American colonies would always be one in spirit, despite attempts by the British to disrupt and break up the colonies' quest for independence as a new country. Franklin's snake became an iconic image that ended up being used on the "Don't Tread on Me" battle flag.

Editorial cartooning: An American tradition

The mid-to-late 20th century ushered in a new school of political cartooning. This approach moved away from the single panel/grease pencil style that had been in vogue for nearly 50 years and gave it more of a modern look and feel.

The new method was heavily influenced by the styles and tone of the British tradition of cartooning and focused more on vicious caricature, subtle humor, and sly wit while moving away from the iconic and sometimes patriotic or sentimental images seen in political cartoons in the earlier part of the century.

Two cartoonists were at the forefront of this new wave. They made a significant impact on editorial cartooning and strongly influenced what it has become today. They are as follows:

✔ **Pat Oliphant:** Oliphant played an enormous role in reshaping the way editorial cartoons look and feel today. His approach was new and fresh, and the young cartoonists of the day immediately began to emulate his brushy line quality. Oliphant's cartoons were more derivative of the *Mad* magazine school of satire than the more serious cartoons that appeared in the 1950s and before. Check out the nearby sidebar for more on Oliphant.

His style, like that found on the pages of *Mad,* was appealing to younger cartoonists just starting out, and it spurred a whole generation of Oliphant "clones." Aspiring editorial cartoonists who follow Oliphant's work can

• **Understand great political caricature.** Oliphant's caricature is grotesque to the point of being almost cruel. But that's exactly what a caricature is supposed to be. Oliphant knows how to exploit dominant physical characteristics to engender an emotional response in the reader.

• **See how the cartoon's art can communicate to the reader.** The overwhelming strength of Oliphant's work lies in its imagery. More often than not, he lets the tone, content, and implication of his illustrations carry his meaning, allowing the words to simply underscore the point. It's not the "Follow me" punch line delivered as Oliphant's childlike George W. Bush (sporting a 24-gallon cowboy hat) proudly marches off the edge of a cliff; it's the headless, hulking juggernaut stomping dutifully in tow, representing Bush's supporters, that carries Oliphant's true message.

• **Feel the ferocity of political and social satire.** Oliphant's work is indicative of the finest traditions of editorial cartooning — vicious satire. Even-handed reasoning is best left to columnists and essayists who have time to weigh both sides of an issue. An editorial cartoonist like Oliphant comes down on one side — *hard* — and delivers his points with the power of a sledgehammer.

✔ **Jeff MacNelly:** MacNelly was a three-time winner of the Pulitzer Prize, best known for his long-running comic strip *Shoe.* Aspiring editorial cartoonists who follow MacNelly's work can

• **Understand great character style.** MacNelly's illustrations are replete with detail. Each person in the scene, including any innocent bystanders and onlookers, is a fully realized being with

personality and character. MacNelly's detailed character design speaks volumes about the people he draws — from pencil-necked geeks to denim-clad good-ol'-boys.

- **See how whimsical art can be fun and appealing to the reader.** Like his contemporary Pat Oliphant, MacNelly created imagery that evokes as much meaning as the words used in the cartoon. But where Oliphant favored heavy, dark, brooding scenes, MacNelly's work emphasized the expressiveness of the brush strokes he used to build the scenes. The result is an almost buoyant lift to his illustrations — an emotion often belied by the cutting satire of the cartoon.

- **Grasp the subtle aspects of political and social satire.** MacNelly was more than capable of brutal satire, but often he favored a more subtle approach, allowing understatement to carry the day. For example, in a scene depicting a meeting of the "Evil Empires," representatives of Cuba, North Korea, Vietnam, and China occupy a gigantic table with dozens of empty chairs. "Move that we dispense with the calling of the roll," deadpans the Chinese diplomat.

The influence of Oliphant and MacNelly has been so great that it has spurred critics to name this style the "Olinelly" style and to label those cartoonists who've followed them as "Olinelly clones." Regardless, their work represents a vital, legitimate form of social commentary with a long, rich tradition that continues to thrive.

Sophisticated Humor: Gag Cartoons

Cartoons can be sophisticated; just peek at *The New Yorker* and other magazines known for their urbane, highbrow humor. Although not as common as down-home, family-humor cartoons, comics that run in glossy magazines are often subtle and thought-provoking. This kind of cartoon, often called a *gag cartoon,* favors a quick punch line and a brief scene — rather than the multi-panel, build-to-punch-line approach of a comic strip.

Defining gag cartoon traits

While comic strips and editorial cartoons rule the world of newspapers, gag cartoons dominate the landscape of magazines. They can be inserted on a page and stand on their own strengths, requiring no explanation or back story. For this reason, they're perfect for monthly publications such as *The New Yorker* and *Cosmopolitan,* which use gags to enliven pages and underscore the tone of the publication without expecting readers to remember installments of the cartoons delivered 30 days prior.

Gag cartoons are identified by the following:

- ✓ **Single panel images:** Gag cartoons aren't divided into panels; rather, they rely on a single illustration to drive home the punch line.

- ✓ **Captions:** Unlike comic strips, in which the text is carried in word balloons inside the panels, the pervading practice in gag cartoons is to present the text in a caption below the panel.

- ✓ **Quick, concise humor:** The content of a gag cartoon is always humorous. Moreover, they cut directly to the punch line, with little or no time spent on building tension. More often than not, the caption is a single sentence that, along with the image, contains all the context needed to deliver the humor. The result is a lightning-fast joke — as the term "gag" implies.

- ✓ **Stand-alone stories:** Gag cartoons have no recurring characters and no previous story lines. They're completely independent vignettes that don't rely on previous episodes for readers to understand them. For this reason, gag cartoons have tremendous "refrigerator appeal" — they're the kinds of comics you're most likely to find affixed to your neighbor's fridge or a coworker's cubicle.

Identifying two influential gaggers

Gag cartoonists are among the most talented cartoonists in the spectrum of the art. They must deliver the humor with a single image and one sentence — *maybe* two. This is a staggering feat to achieve, but not surprisingly, gag cartoonists who can hit the mark with consistency are among the best-loved comic creators in American pop culture.

- ✓ **Charles Addams:** Charles Addams was among the very finest of the pantheon of gag cartoonists whose work was featured in *The New Yorker*. His beautifully rendered panels and wicked sense of humor made his work some of the most pervasive humor of the 1950s. The TV sitcom *The Addams Family* was based on a series of his gag comics that portrayed a family of well-meaning, if not twisted, ghouls. Addams's work holds plenty of lessons for a novice gag cartoonist:

 - **Use tone to carry a message.** Addams's images were rendered in an ink-wash style — painted in tones of grey created by diluting ink with different amounts of water. Under his brush, he used this method to create moody and evocative scenes. When the grisly family prepares to dump hot oil on a gathering of holiday carolers from the rooftop of their aging mansion, the ominous drawing of the building itself — with its classic haunted-house features — sets a perfect tone for the inevitable outcome.

- **Learn comedy patterns.** Obviously, no formula exists for writing good humor, but comedy does tend to follow certain patterns. One of these patterns is something bizarre carried out with the air of normalcy.

- **Appreciate the power of composition.** Many of Addams's strongest cartoons are scenes in which the punch line is carried by the image rather than the text. To accomplish this, you have to learn how a reader's eyes follow the composition of a scene. The trick is to delay the reader from seeing the crucial bit of visual evidence until the last moment. Done right, the effects are sublime, such as the Addams cartoon featuring a crowded theater of guffawing patrons — among whom is hidden a Mona Lisa, her half-smile a perfect foil to the surrounding hysteria.

✔ **Gary Larson:** No gag cartoonist has come to define the genre the way Gary Larson has (see the sidebar, "Going far out and out on top" in this chapter). Although he hung up his pens way back in 1995, no subsequent newspaper gagger who has achieved a degree of quality in her work has been able to avoid the derisive tag of "Larson wannabe." Ten years after his final, syndicated panel, Larson's reprints still grace calendars, coffee mugs, and books. Larson's approach to gag cartooning is indicative of much of the best to be found in the genre:

 - **Write from your strength.** From zoology to chemistry, Larson has an overriding love of and fascination for science. And he brought that passion to his work in a way that laypeople could enjoy, just for the sheer silliness of it.

 - **Great writing can support simplistic art.** Larson falls squarely into the category of the cartoonist whose art is secondary to his humor. Although his drawings aren't crude — like fellow gagger James Thurber — they certainly lack the detailed opulence of Addams. Regardless, his minimalist imagery is supported fully by a tremendous wit.

 - **When in doubt, get weirder.** Larson's work is defined by a daring weirdness. He rarely approaches standard topics like family life or office politics except through the lens of a family of cobras or an office inhabited by sheep and wolves. Many of the best gag cartoonists take an idea and push it past odd, headlong into bizarre, and that hyperbole is what provides the energy behind the comedy.

New Yorker cartoons

Although it often focuses on the cultural life of New York City, *The New Yorker* magazine, which began life in the 1920s, has a wide audience outside of New York. The magazine has a long, rich tradition of publishing commentary, criticism, essays, fiction, satire, and poetry. But it's perhaps most famous for its signature cartoons.

Going far out and out on top

Gary Larson grew up in the Seattle, Washington area. While he was a young man working in a music store he discovered he had surplus time to draw and doodle. He decided to try his hand at cartooning and drew several cartoons, submitting them to a Seattle-based magazine. He followed by contributing to a small local Seattle paper, and later to the *Seattle Times.* The paper liked his work and began publishing it on a weekly basis under the title *Nature's Way.*

In an effort to make some extra money from cartooning, Larson pitched his work to the *San Francisco Chronicle,* which bought the strip and sponsored it for syndication through its own Chronicle Features syndicate. The syndicate also suggested he change the name to *The Far Side.*

The Far Side ran for 15 years, ending with the announcement of Larson's retirement on January 1, 1995. Larson chose to end the cartoon because he didn't want to fall into predictability. Larson went out on top, and as of 1995, *The Far Side* was carried by nearly 2,000 daily newspapers, had been collected into 22 books, and was reproduced extensively on greeting cards, which continue to be popular today. In addition, two animated specials were produced for TV. Most recently, Larson published a 2009 calendar and is donating all his author royalties to conservational organizations.

The magazine's stable of cartoonists has included many important talents in American humor, including Charles Addams, George Booth, Richard Decker, Ed Koren, George Price, Charles Saxon, William Steig, Saul Steinberg, James Thurber, and Gahan Wilson, just to name a few.

The New Yorker employs its own cartoon editor who oversees the selection of cartoons in each individual issue. Perhaps the first notable cartoon editor was Lee Lorenz, himself a cartoonist and contributor going back to 1956. Lorenz remained in the cartoon editor position until his retirement in 1998, after which it was assumed by Robert Mankoff, who continues as the cartoon editor today.

New Yorker-style cartoons are recognizable for the following characteristics:

- ✔ **They focus more on the sophisticated nature of the subtle punch line and less on slapstick.** Instead of Larsonesque hyperbole, New Yorker cartoons are defined by a much more cerebral, quieter wit. Often, the punch lines aren't built around humorous concepts so much as on the nuances of words and attitudes. In a Thurber classic, a giant seal is perched above the headboard of a couple's bed. The wife growls, "All right, have it your way — you heard a seal bark."

- ✔ **They generally eschew an overly cartoony style of art.** The drawing style can range from minimalist line art to sophisticated and elaborate charcoal pencil drawings depicting Gothic architecture.

Getting a cartoon printed in *The New Yorker* is an especially prestigious honor for many cartoonists, and the competition is fierce. In addition to its regular magazine, *The New Yorker* has published numerous cartooning collections over the years, and each of these compilations has been ranked at the top of the *New York Times* Best Seller list.

The influence of *Mad* magazine

Perhaps no other single magazine has had so much influence on cartoonists (as well as comedy writers, stand-up comics, animators, gag writers, and the criminally insane) as *Mad* magazine. *Mad* first appeared on newsstands in October 1952. The first issue spoofed comics by genre: It featured mock stories about crime and horror. The stories poked fun at the standards of traditional comics. The artwork, by a variety of early *Mad* regulars, established the wild, satirical comic style that would dominate *Mad;* visual sight gags and wacky reinterpretations of conventional mainstream values played out on every page.

The magazine originally went by the title of *Tales Calculated to Drive You Mad*. It wasn't until after issue # 17 that those first five words would be dropped and the magazine would from there on out be known only as *Mad*. The first several issues didn't sell particularly well. However, issue #4 in the spring of 1953 featured *Mad*'s first parody of a specific character, "Superduperman!" Teenagers loved the witty parody, and magazine sales started to pick up as *Mad* gained a loyal audience.

This issue also marked the first time *Mad* ran into legal problems over its parodies and off-the-wall humor. After *Mad* poked fun at DC Comics premiere superhero Superman, DC Comics threatened to sue. *Mad* argued that parody was protected by the U.S. Constitution. The case never came to court because DC never bothered to push the matter. As a result, *Mad* subsequently made its reputation by zeroing in on other iconic cartoon characters, celebrities, advertisers, name brands, and the movie business.

What made *Mad* a hit and a symbol of its time? All the following, plus more:

- *Mad* **connected with teenagers, in particular.** The postwar culture of the 1950s tended to take itself very seriously, and *Mad* began skewering this father-knows-best world, in which citizens had become consumers and advertising dictated the public's taste.

- *Mad* **hired incredibly talented people.** The creative and inventive team of writers and cartoonists turned out high quality, innovative work.

Over the years *Mad*'s layout and look have been updated. Over time the once-subversive magazine became an institution and, in a less hegemonic and more Internet-obsessed culture, it seemed less culturally significant. Most of the "original gang of idiots" (as the original legendary staff called themselves) are no longer with the magazine. In their place are a new, younger batch of cartoonists. Most people agree that the original lineup would be hard to duplicate.

Citing a challenging economy and falling sales, *Mad*'s parent company announced in the beginning of 2009 that *Mad* would cease its monthly publication schedule and now only appear quarterly. Nevertheless, *Mad* has played a crucial role in influencing an entire generation of young cartoonists working today. Without its contributions it's safe to say that many of the great comic features we see today may never have been.

Budding cartoonists can benefit from studying the work of *New Yorker* cartoonists by

- ✔ **Understanding how intelligent writing can be funny, too.** In some ways, hyperbole can become a crutch to a novice humorist. *New Yorker* cartoons show how a slight nuance — an appreciation for the subtle connotations of words and phrases — can lead to very satisfying writing. In one Gahan Wilson scene, a man comes home to see a "Happy Birthday" banner hanging above a table set for a party. His wife, seated, reading a newspaper, drones, "This was supposed to be a surprise party for you, but nobody showed up."

- ✔ **Seeing how the tone of the art can prepare the reader.** *New Yorker* cartoons are almost singularly identified by their light, airy images and graceful economy of line. This underscores the sophisticated tone of the comics — almost preparing the reader for a quiet quip rather than a powerful punch.

- ✔ **Recognizing the importance of observational humor.** So much of the *New Yorker* repertoire is based on observations of everyday life. This kind of humor is driven almost entirely by the excitement of the reader being presented something she commonly experiences that's contextualized in a unique way. For example, in a David Sipress vignette, as a couple greets another couple farther down the sidewalk, the panicked husband whispers to his wife: "Quick! Remind me — are they handshakers, huggers, single kissers, or kissers on both cheeks?"

Web Cartooning

As the Internet continues to define the delivery of news and entertainment, it's only fitting that a new breed of cartoonists has sprung up to take advantage of this exciting time. The Web allows cartoonists to self-publish their work to a worldwide audience with extremely meager means. On the Internet, a young cartoonist doesn't answer to an editor, nor does she wait for the approval of a syndicate. If the work is good enough, it finds its own success on the Web.

Webcomics are defined more by their medium — and the effect that medium has on their work — than by the format or theme of the cartoons. Webcomics can take the form of any of the previously mentioned genres of cartooning — strips, gags, or editorials — and push beyond with such things as interactive features and animations.

Some of the significant characteristics of Web cartoonists include

- ✔ **They build a community.** Perhaps the most striking characteristic of a webcomic is the strong bonds between the creator and the readers. In addition to being able to e-mail their reaction directly to cartoonists, readers of webcomics can become intimately involved in the world created by the cartoonist through blogs, message boards, and social networking

media. As a result, readers not only form relationships with cartoonist but also build a community with the other readers of that comic.

✔ **They make money by giving their work away for free.** As strange as it sounds, that's the driving force behind the webcomics business model. Most Web cartoonists offer the entire archive of their work on their site, free for anyone to peruse. Sites rarely, if ever, have subscription fees. Web cartoonists are able to generate an income through selling advertising on their sites and selling books and other licensed merchandise based on their work.

✔ **They're largely do-it-yourselfers.** Because webcomics don't involve syndicates or publishers — and because advances such as print-on-demand publishing have allowed the beginner to self-publish books without a huge outlay of money — Web cartoonists don't need a large corporation to back their work. As a result, any money that cartoonists make can be kept in its entirety, without requiring a split between, say, syndicate and creator. With this expanded profit margin, Web cartoonists can make much more money by selling much less merchandise and advertising.

✔ **They may appeal to a niche.** Because Web cartoonists can make more money by selling less, it's more possible for them to cast a smaller net in terms of their subject matter. In other words, although a comic strip about librarians written *for* librarians would never appeal to a newspaper syndicate, *Unshelved* by Bill Barnes and Gene Ambaum has found tremendous (and lucrative) success on the Web.

Two examples of successful webcomics include

✔ **PvP:** *PvP* (www.pvponline.com) is one of the oldest webcomics still in production, and certainly one of the more successful. Cartoonist Scott Kurtz has built it from a generic webcomic about video games into a five-day-a-week office comedy that focuses on a small cast of beloved characters. His work on *PvP* (an abbreviation for the video game term *player versus player*) has earned him significant crossover success in the world of print comics. Image Comics publishes a monthly *PvP* comic book, and Kurtz has earned the Will Eisner Award, the highest honor given in the comic book industry. Studying Kurtz's *PvP* can shed light on the concept of webcomics.

✔ **Penny Arcade:** *Penny Arcade* (www.penny-arcade.com) is by far the most successful webcomic on the Internet. Writer Jerry Holkins and artist Mike Krahulik collaborate on a three-day-a-week comic that focuses on the video game industry. As with the vast majority of webcomics, their site and access to their entire archive (it dates back to 1998, which is akin to the early Jurassic period in Internet years) is free. Despite this unorthodox business model, *Penny Arcade* generates millions of dollars in annual revenue; operates a charity, Child's Play, to fund worldwide toy drives for children's hospitals; and organizes PAX, an annual convention for the video game industry. *Penny Arcade* presents a chance to understand webcomics more deeply.

Chapter 3

Getting Your Workspace Ready to Go

*I*n order to be able to draw cartoons on a regular basis, you need a little area devoted to your craft. Although drawing cartoons at the kitchen table is perfectly okay, having a dedicated area set up for drawing is not only more efficient — it's also more fun! The right lighting, a well-appointed drawing table, a comfortable chair, and the proper tools and supplies — which today include a good computer and artist-oriented software — make cartooning easier and the results more professional. This chapter helps you set up your workspace and helps you decide which tools to buy to make your cartooning simpler and more enjoyable.

Searching for a Workspace

Setting up an organized and well-equipped workspace is an important task for every artist. Locating the right workspace can go a long way toward increasing your efficiency and creative output when it's time to get down to work. But even more important, you want to create a location that's a fun place to spend a lot of time doing what you love to do . . . draw!

So, where do you even begin your search for a workspace? A workspace should be a place in your home that allows you to escape the distractions and interruptions of daily life so that you can concentrate on getting down to

work. This section walks you through the options available to you when setting up a place to get creative, even if you don't have a lot of space available. You don't have to break the bank when setting up your workspace, either; the following sections tell you what you should spend big on, and when skimping is okay.

Looking at your options

When creating a designated work space, you're limited only by the size of your house and the amount of empty space you have available. Of course, the best workspace is one where you can go in and shut the door. A spare bedroom or den makes a great office studio; utilizing these spaces, you'll almost certainly have a way to shut out the outside world and may even have your own bathroom!

If you aren't fortunate enough to have an unused spare room, a corner of the basement or even a garage that doesn't get used by cars can make a great workspace. You may need to do a little remodeling or updating in order to make these areas comfortable to work in, like improving the lighting, heating, or esthetics of the areas. No one wants to work in a space that's physically depressing! If you're also a good handyman type, putting in some simple creature comforts can give you a place to work at little cost.

Utilizing a small space

If you live in an apartment or dorm and designating a separate space for a studio isn't an option, don't despair — a workspace can fit into the smallest of living situations! Setting up a studio in the corner of your bedroom is a great solution if you're short on space. A walk-in closet may make a great small studio and may even have its own light fixture and door.

The fact of the matter is, any available corner or wall space in a small apartment can be a good designated place to set up a small art table and file cabinet. You're limited only by your imagination and ingenuity.

Setting Up Your Workspace

After you decide where you want your workspace, you need to set it up so that you can begin drawing. However, before you head out to the store, take some time and do some planning. Make a list of what you need for your workspace. Although everyone's list will be a little different, most artists' workspaces include some of the basic equipment I discuss in this section.

Making your workspace ergonomic

When you're setting up the actual layout and design of your office, think ergonomically. No, not economically — although that's not a bad idea either. *Ergonomics* is the design process that involves arranging the environment to fit the individual using it. Ergonomics, also called *human engineering,* is essentially the science of creating an environment that makes work enjoyable by reducing stress and strain on your body. An ergonomic environment should increase output and decrease frustration.

To make your workspace ergonomic, try the following:

- ✓ **Place your equipment, art supplies, and drawing area within easy reach and access.** You don't want to constantly have to reach, bend, or twist to reach your supplies.

- ✓ **Buy the right chair.** You can buy a chair made specifically for working at a desk or drawing table, and if you can afford one, go for it. The money spent is a good investment. Make sure you try out several chairs before choosing one, because what fits someone else may not fit you comfortably at all. If you can't afford a well-engineered but expensive chair, make sure the chair you're using is comfortable for long time periods. (Check out the "Buying a chair that won't break your back" section later in this chapter for more information.)

- ✓ **Check your body position.** The way you sit in the chair in relation to the angle of the table top and the access to the equipment you use often makes a big difference in your overall comfort. If your chair is comfortable but it sits at right angles to your workspace, you're going to end up with a sore back and a stiff neck!

- ✓ **Sit up at the table.** Hunching over your workspace will have your back screaming for mercy in no time.

- ✓ **Adjust the angle of your table.** If you have a table that can be angled, adjust it so that you can place your paper on top and work comfortably, but not on so much of an angle that your work constantly slides off onto the floor. Obviously, this won't work if the kitchen table is your workspace!

Choosing a practical workspace surface

Selecting the right workspace surface is paramount. This surface is the heart and center of all the things you create, even in the digital age. If you have space in your home or apartment, the ideal way to go is a table devoted specifically to drawing.

You basically have two types of options when picking a worktable: an art table or a professional drafting table (see Figure 3-1). This section takes a closer look at these two types and touches on some pros and cons for each kind of table.

Figure 3-1:
An art table (left) and a professional drafting table (right).

If you simply don't have the space in your small living area for an art table, I suggest you use a portable drafting top that can be placed on any table top. These are available at bigger art supply stores, or you can order one online. If you're handy, you can get creative and build your own. Use a smooth surface material that's strong enough to support your working on it. Cut it down to about 2 x 2 feet and place some books behind it to prop it up so that it's tilted at an angle.

Option No. 1: Smaller art table

Art tables tend to be compact, with small surfaces. You can usually find a smaller art table at most art supply stores for under $200.

If you're contemplating purchasing an art table, consider these advantages:

- **Affordability:** They tend to be less expensive than professional drafting tables.
- **Space saving:** Because they tend to be smaller, they work well in the corner of a small room.
- **Ability to tilt:** They can be tilted to your convenience; some can tilt up to 90 degrees, allowing you more flexibility.

Some disadvantages to using an art table include:

- **Small surface area:** Their tops are small, which means a restricted work area.

✔ **Lack of stability:** Their construction can be flimsy, and they can move under hard erasing.

✔ **No storage space:** They typically have no drawer for storage.

Option No. 2: Professional drafting table

Professional drafting tables are larger and heavier and used in more commercial applications. The larger drafting tables are available only in higher end art supply stores and design supply centers. They range in cost from a few hundred dollars up to several thousand dollars.

If you're considering a professional drafting table, keep the following advantages in mind:

✔ **Large surface area:** Their tops are large, which means a bigger area to draw.

✔ **Stability:** They're sturdily constructed and usually made out of solid oak or steel.

✔ **Storage:** They usually have many options for storage, like built-in drawers and/or shelves.

The cons of a professional drafting table include:

✔ **Expense:** They cost more than smaller art tables.

✔ **Weight:** They're heavy and hard to move around.

✔ **Bulkiness:** They're large and bulky and usually work best in a designated room or area.

If you're serious about making cartooning a career or even a serious hobby, invest in the best table you can afford. If you want something that will last for years to come, I recommend buying a sturdy, commercial-type table. The long-term benefits will outweigh any initial costs.

Buying a chair that won't break your back

When you furnish your workspace with a chair, you want to make sure you find one that's comfortable. The good news: Most drafting chairs are designed with ergonomics in mind. As you look for different chairs, make sure you sit in each and give it a whirl. Try it out and experiment with it. Ask yourself how you feel. Are you relaxed? Would you like sitting in this chair for long periods of time?

If you're comfortable sitting in the chair despite working for long hours, then the chair is probably right for you. However, after sitting for hours don't forget to take a few breaks and stretch out your legs. This may even help your creativity so that when you come back you're refreshed and ready to go.

When shopping for a chair, keep the following characteristics in mind. A good work chair

- ✔ **Provides ample support for the muscles of the back, the arms, and the legs.** You're going to be sitting in the chair sometimes for hours, so it's important that it's comfortable and doesn't create any extra fatigue on your body.

- ✔ **Avoids restricting pressure points.** Restricting pressure points can hamper blood circulation and cause cramps or nerve damage. For example, avoid a chair that digs into your back or legs, or that has an armrest that leaves dents or creases on your arm when you rest on it.

- ✔ **Is well constructed.** Look at how sturdy the weld is that holds the seat plate to the seat post. In the past, I've had chairs that break at the weld area and I've had to have them re-welded. This is partly because I spend a lot of time in the chair in different positions — sitting, leaning back, rolling around. The welds crack and I have to fix them — and I'm a skinny guy!

- ✔ **Is movable.** Get a chair with good wheels and one that rotates and spins effortlessly so that you can move around and reach other areas of your studio without much strain.

Lighting your way

Good lighting is important because you have to be able to see what you're drawing and you don't want to strain your eyes more than you have to. You also don't want to cast shadows on your drawing. To ensure your workspace has appropriate lighting to help you see, a good swivel arm lamp that attaches to your drafting table is the best way to go. In my workspace, I use two adjustable swing arm lamps that you can purchase at any art supply store.

Bulbs with 60 to 100 watts can provide you with plenty of light to suit your needs in your workspace. The best type and least expensive to use is a simple incandescent light bulb. Use a lower wattage bulb if your workspace is small to avoid too much heat, and stay away from halogen lights, because they get especially hot.

Organizing your space

Trying to keep your workspace neat and organized is important. Doing so is particularly important when drawing cartoons and comics, because you don't want to waste time looking for things when you could be drawing, especially if you're under a deadline. You'll notice I said *try,* because the papers and clutter can get out of control rather quickly and build up around you before you know it. It was once said that a messy office is a sign of genius . . . in that case, I'm Albert Einstein!

Keep yourself organized by following these simple-sounding but not always easy-to-apply ideas:

- ✔ **Have a place for everything.** Visit a container store or the storage section of any big box store and you'll be amazed at the number of different storage containers available. Pens, pencils, brushes, and ink should have their own storage areas. These can be as simple or as elaborate as you want to make them. Label each container so you can easily determine the contents. You may also consider having a divider in each container so that you can separate things like brushes and pens from each other.

- ✔ **Clean.** Get out your cleaning supplies and go to it. Clean your monitor, keyboard, desk, and any other work areas.

- ✔ **Clear away the clutter.** Throw away any unnecessary papers or other mess from your desk. If some paperwork is important but you don't need it right now, file it in well-marked folders.

- ✔ **Use filing cabinets or storage drawers to keep your cartoons and other art organized.** They're a good idea because they can help you protect your original art.

- ✔ **Use traditional, blueprint-style drafting cabinets with wide, shallow drawers to hold large sheets of paper.** Often called *flat files,* they're perfect for storing original art because the drawers aren't deep and you can easily access the art you're searching for.

Getting the Right Supplies

Having the necessary drawing supplies at hand is as important to a cartoonist as having the right equipment in the operating room is to a surgeon. Various types of pens and pencils, art charcoal, pastels, art markers, and inks are available and cover a wide artistic range when it comes to drawing.

When you walk into an arts and crafts store, you'll see tons of different options. You want to be versatile with the tools you practice and sketch with so that you continue experimenting and improving. However, you don't want

to overdo it and buy too much. Some supplies can be expensive, so when first starting out, purchase just what you need. As you get more experience, you can buy the supplies that you really want.

Not sure what basic supplies to purchase when setting up your workspace? No worries. This section walks you through the supplies you need to get your workspace up and running.

Picking pens and pencils

Start off with pens and pencils, the most basic drawing tools. Explore the numerous types on the market to see what you're comfortable drawing with, starting with some of the following:

- **Pencils:** Pencils are great for sketching because they provide a nice soft line that you can easily go over with ink. Don't use a pencil that's too dark, because you want the pencil lines to be easy to erase and you don't want them to be noticeable when the cartoon is reproduced, scanned, or copied. In fact, a simple, everyday pencil can do the job, though I prefer to use nonphoto blue pencils, because I don't have to erase my lines after I ink them.

 When choosing a pencil, keep in mind that the higher the B# of a pencil, the softer the graphite and the harder it is to erase. The higher H# of a pencil, the harder the graphite is.

 However, if your style is such that you want to just use a pencil and not ink over the lines, then the computer can come in handy. You can draw with a pencil, scan that drawing into the computer, and convert the lines to true black. This technique also allows your work to have a nice sketchy look as opposed to the smoother, cleaner look of inked lines. Take time to experiment.

- **Dip pens:** Dip pens have a metal nib and are usually mounted on a wooden handle. You dip the metal end nib into a bottle of ink. The dip pen has been a standard among cartoonists throughout history. This type of pen works well and produces nice dark lines, although you must be careful not to smear the lines before they dry.

- **Pigma Micron pens:** Most cartoonists use these pens in some capacity, for drawing or for lettering. They come in a variety of sizes and contain a long-lasting, nonfading archival ink.

Cartooning is a commercial style of art, and professionals must always consider how their art will reproduce when choosing a drawing tool. For example, it's probably not practical to use a charcoal pencil to draw cartoons with, as charcoal doesn't reproduce as well as a sharp pen or a brush and ink does.

Other drawing supplies

Writing utensils aren't the only thing on your shopping list when stocking your work station. You also need a few other supplies specific to drawing, such as the items in this section.

The right paper

Paper to use for drawing is imperative to have on hand, and different papers produce different results. Having good drawing paper is essential because its performance is crucial to the line art you end up producing.

The industry standard for drawing paper is Strathmore Bristol drawing paper. This paper is heavy and provides a strong surface to work on without the need for mounting. Bristol comes in a variety of finishes that are best suited for different types of media. Smooth finish is good for pen and ink and allows for the use of washes and even airbrushing. The vellum is good for all pencil work as well as charcoal or pastels.

These come in pads of usually 20–25 sheets and range in sizes from 9 x 12 up to over 22 x 28 inches. Generally, the smooth finish is best for drawing cartoons. The only drawback can be cost in relation to the number of actual sheets of paper you get.

If you're just starting out, you may want to consider drawing on copy paper. You can get 500 sheets of copy paper for half the cost of 20 sheets of Bristol drawing paper, so if you make a mistake or change your mind, it won't cost you much to throw the sheet away and start over (but do be good to Mother Nature and recycle). I used to use Bristol drawing paper but switched to using cheap copy paper. I made this decision several years ago when I realized that it really didn't matter what kind of paper I drew on because I was going to scan it into the computer, and the computer file would ultimately be the final piece of art.

Brushes

Most professional artists and cartoonists use a brush, although no brushes are made specifically for cartooning. Many cartoonists commonly use watercolor brushes. More specifically, the Winsor & Newton Sceptre Gold II brushes work best for inking and are relatively inexpensive. They're made for watercolors but work great for use with ink.

When shopping for a brush, ask other cartoonists what they like to use. You can also ask the clerk in the arts and crafts store for a recommendation. Before you make a purchase, try out a couple of different brushes. Find a brush whose bristles don't fray and that can hold a nice sharp point.

Ink

Inking, the term for going over a pencil sketch with black ink, is typically the final step in the drawing process. Inking gives that final spark of life to the drawing and makes the art crisp and tight. Inking over your work with a nice black line creates artwork that can be easily reproduced. Higgins waterproof black India ink is pretty much the standard ink used by most cartoonists. You can get it in small bottles or larger 32-ounce bottles that you can use to pour into a small bottle to dip your brush in.

You may also want to take the cap off and let it set out for a while. Like a good wine, ink that's allowed to breathe tends to perform better.

Visiting the Computer Store

When you think about cartooning, a computer may not be the first thing that comes to mind. But computers in today's cartoon world are as important a tool as the pencil. Although you may still draw all your art on paper using the traditional pen and ink technique, a computer enables you to scan in your cartoons, e-mail art files, and color your comics.

Furthermore, many artists, cartoonists, and graphic designers don't use paper at all anymore — they actually draw right in the computer! In this section, I look at several hardware devices and software programs that cartoonists and artists commonly use.

Selecting the right computer

Choosing the right computer is a crucial decision that's based on many factors, including size, speed, power, and, of course, cost. When choosing a computer, you need to consider its reliability, memory and CPU speed, and storage.

Although personal computers (PCs) dominate the business world, Apple Macintosh computers dominate the creative art world, including the world of cartooning and comics. Macs tend to be a bit more user-friendly than PCs and geared toward a more creative user, with a more colorful and easy-to-understand desktop.

Macs also *plug and play* more easily than PCs. *Plug and play* basically means that you can just plug in an external device like a printer or scanner without having to do any extensive programming to get the device to work, other than loading the manufacturer's software. Although you can plug and play using a PC, Mac's plug and play capacities are more user-friendly.

If you're interested in buying a Mac computer, the best resource for more information or to place an order is the Apple Web site (www.apple.com). You can also visit any one of the numerous Apple stores to try out one of the computers in person.

Customizing your hardware

If you're under 30, you were seemingly born hardwired to use computers. If you're a little older, though, or if you really want to get the most out of your computer, you need to know some hardware fundamentals.

Hard drives

Computers hold a tremendous amount of information, which has to be stored someplace. That's what *hard drives* are for — they permanently store your computer's information — at least until you decide to delete it. Obviously, a larger hard drive can hold more information, including more high resolution cartoon files that, over time, can take up lots and lots of space. Hard drive space comes in what's known as *gigs,* which is short for *gigabyte* (abbreviated *GB*). When you're starting out, I suggest you get an 80GB hard drive; it should last you many years.

External hard drive

If you need additional storage space, an *external hard drive* for around $100 can provide you with hundreds of GBs of storage. More important, you need to buy an external hard drive so that you can back up all your files. *Backing up* files means making a copy of them onto another hard drive. Doing so can save your life if you misplace a file or, heaven forbid, your main hard drive crashes and you can't access it. If you have an external drive you have everything saved, which gives you peace of mind.

RAM

Random access memory, or *RAM* for short, is like your computer's short-term memory bank. Information stored as RAM includes application programs, operating systems, and current data. RAM is much faster to read from and write to than the other kinds of storage in a computer, like the hard disk or a CD-ROM, but when you turn your computer off, the data in RAM is lost and has to be reloaded from the hard drive by your computer when you turn it back on.

The more RAM your computer has, the faster it can process things — like commands in Photoshop, for example. You should start out with at least 2GB of RAM; you can purchase additional RAM pretty cheap these days, so I'd recommend not skimping on it. If you want more memory than the computer comes with, you can get a GB of RAM for under $100 and install it yourself in most modern Macs. A good online resource for ordering additional RAM is a company called Crucial (www.crucial.com).

CPU speed

A *Central Processing Unit,* or *CPU,* is usually known simply as your computer's processor. You can upload files, surf the Internet, and work in a program like Photoshop all at the same time if your computer has a fast CPU. CPU speed is generally measured in gigahertz, or GHz. The current crop of Macs range from 1.6 GHz all the way up to 3.2 GHz, which is pretty darn fast. This kind of speed can handle full video or animation without any problems.

If you're just starting out it's best to begin with a computer that may have too much CPU speed and memory. You will eventually use it up, trust me!

CD/DVD drives

CD/DVD drives are devices used to store and back up your work, especially if you need to copy an image onto a disc and send it to a potential editor or freelance client. You can either order a CD/DVD drive at the time you order your computer or buy an aftermarket portable drive. Disc drives are indispensible for burning files on a compact disc for storage or for sending art files to clients, for example. Blank CDs are cheap (as little as 15 cents apiece if you buy in bulk), so you can send them out to clients without worrying about getting them back. If your computer has a DVD drive, you can use DVDs to store backup files, as they have a lot more storage than CDs.

The best thing to do is get a *combo drive,* which can read and write CDs and read (and sometimes write) DVDs, because you get the best of both worlds in one drive. On all Macs except the entry-level Mac Mini, the *SuperDrive,* a CD/DVD reader/writer, comes standard.

Modem or wireless Internet connection

You gotta stay connected in today's global market. Fast, reliable Internet access is a must for staying in contact with clients and other contacts, uploading and downloading files, and research. Today, most computers come with built-in internal modems and wireless capability, so you can stay connected wherever you are. Check with your local Internet service provider (ISP) to see what modem and access connection options are available in your area and for remote connections.

Scanners

As far as cartoonists are concerned, a scanner is an absolute must. A *scanner* is a handy computer peripheral designed to transform images from real-life photos, drawings, and text into a digitized document. A scanner reads an image and converts it into a collection of dots that can be stored as a file on a hard disk. With special software like Photoshop, you can edit and manipulate the image.

A scanner works on the principle of light reflection. Imagine, for instance, a light shining on a page of a magazine. The white background reflects light, the black text absorbs it, and the shades of gray (or colors) in a photograph reflect the light in varying degrees, depending on their densities. Think of a scanner as a digital copy machine that, instead of copying the image on a piece of paper that pops out of the slot on the side of the machine, copies the image and it pops up on the computer screen instead.

See Chapter 16 for more information about cartooning using scanners and computer equipment.

Printer

A printer is an incredibly important tool for your cartooning work station. After you finish scanning in your sketches and reworking them on your computer, you need to have a hard copy. A printer allows you to print out your work that you may have colored using a computer program so that you can have something to show people. You can also print out samples to send to potential editors or freelance clients.

When choosing a printer, you basically have two choices:

- ✔ **Color ink jet printer:** This option remains the best all-around choice for many casual users. Ink jet printers are ideal for home users who need to print text pages, color graphics (such as greeting cards or flyers), and color photos. An ink jet printer is an especially good choice if you already own a flatbed color scanner. With a scanner, you suddenly have the equivalent of a multifunction printer — for a whole lot less.

- ✔ **Laser printer:** A laser printer is another option. Much like the ink jet printer, the laser printer is capable of printing out nice clean copies of your work. Choosing a printer also depends on the hardware you're using and which printers are most compatible with your particular computer.

Rather than take up valuable office space with multiple individual pieces of equipment, consider saving both money and space by buying an all-in-one device that combines a printer, copier, scanner, and fax machine into one handy unit.

Monitor

A computer monitor can be expensive, but it's well worth it to invest in a good one that offers the best resolution and is large enough to use as a working desktop. Computer monitors have evolved in recent years, and just like TVs, they come in a variety of formats.

You basically have two types of configurations to look for when purchasing a computer monitor:

- **Cathode ray tube (CRT) monitor:** CRT monitors are an affordable solution; however, they're bulky and very heavy.

- **Flat panel/Liquid crystal display (LCD) monitor:** These monitors are similar to what you'd find on a laptop computer. Bottom line: Go with the LCD because, overall, they generally display sharper images, are lighter, and are more space-efficient because they're thin, like a plasma TV. Despite these advantages, they're a little more expensive, although costs are coming down all the time.

Tablet

A *tablet* is a device that has a flat plastic surface which you draw on with a stylus. The *stylus* is an instrument that you hold in your hand, just like you would a pen. The stylus leaves no mark on the tablet, but the tablet is sensitive to the position of the stylus and moves a cursor on the computer monitor, which acts as a brush or pencil and can fill in areas of color on a page.

Although tricky to get the hang of at first, the hand and eye quickly get used to this drawing method, and most cartoonists enjoy working this way (it's far easier to draw this way than with a mouse). You can achieve very similar effects to traditional ways of drawing with a tablet. One of the most popular and common models of tablets is the Wacom Tablet, which costs between $300 to $5,000 depending on the model and options you choose.

Identifying the software you need

Computer programs are an important tool for cartooning in a digital age. It's safe to say that in today's world, most cartoonists — whether they draw comic strips, editorial cartoons, panel cartoons, comic books, greeting cards, webcomics, or animation — use computer programs in some fashion. The following sections focus on the three most commonly used software programs available.

Using Photoshop

Photoshop is the program most cartoonists use. It enables you to do all sorts of cool things to alter images like photos, downloaded icons, and scanned artwork. *Altering* an image includes changing its colors, modifying its size and scale, and putting one picture within another. Image alteration or modification also includes technical adjustments such as changing the mode of image compression from one type to another, or changing the number of bits used per pixel.

In addition to altering images, Photoshop has a vast array of tools that help you create images from scratch. On the Web, you often need to make custom icons, buttons, lines, balls, or text art. Photoshop makes all this excessively easy and fun.

Photoshop is not a "classic" drawing or image creation program. Unlike a drawing program that stores information about images as mathematical expressions (called *vectors*), when Photoshop draws a line, the line is converted into little dots, called *pixels*. (See the "Comprehending vectors" sidebar for an explanation of the difference between vectors and pixels.) When small enough, and with blended colors, these dots can come to look like lines. Of course, when magnified or reduced, the optical illusion is dispelled and you get ugly, choppy lines. Check out Chapter 16 for more info on using Photoshop.

Using Adobe Illustrator

Photoshop isn't the only Adobe game in town. Illustrator, another Adobe product, is primarily used to create graphics and logos, but like Photoshop, it can also manipulate, color, or enhance existing images or artwork. The difference between how Illustrator and Photoshop create images has to do with what's known as vectors.

The primary advantage in using a vector-based program like Illustrator is that the image you create can be blown up as big as you want and it won't show any pixilation or distortion. This is especially helpful when you need to blow up an image or logo the size of a billboard, for example.

Using Painter by Corel

Painter, a program produced by a company called Corel, is very much like Photoshop. And like Photoshop, it's gaining popularity among cartoonists. Painter also uses the layering process and has similar tools and the same abilities to import images into the program and then change, copy, color, and manipulate them. The difference between the two comes down to personal preference. If you can afford it, buy them both!

Comprehending vectors

Computer displays are made up of small dots called *pixels*. The picture is built up from these dots. The smaller the dots are and the closer they are together, the better the quality of the image, but the bigger the file needed to store the data. If the image is magnified, the resolution deteriorates and it becomes grainy — our eyes are able to pick out individual pixels.

In contrast, a vector graphics program uses a mathematical sequence to construct the screen image with graphics files that store the lines, shapes, and colors of the image. The mathematical data determines where the dots that make up the image should be placed for the best quality image possible.

Chapter 4

Starting with the Drawing Basics

. .

. .

*F*or many artists, drawing is instinctive — they pick up a pencil and can easily draw impressive sketches. If you're like that — if you already have a firm grasp on drawing basics — then this chapter is probably a tad simple for you.

However, if you weren't born with natural drawing ability but you've always liked to doodle or wanted to better develop your drawing skills, then this chapter is for you. Even if you don't have an ounce of artistic talent, you can greatly improve your ability to draw cartoons and comics by trying your hand at these techniques. And even if you do have a firm foundation for drawing, you still may want to review some of these techniques before jumping into sketching cartoons. However, always remember that cartooning is a creative undertaking with room for personal interpretation and experimentation. Make sure you have fun, or spending time drawing isn't worth your time.

In this chapter, I show you how to start cartooning by drawing three-dimensionally and then advance to techniques that enhance your cartoons, such as inking, shading, crosshatching, and fixing your inevitable mistakes without destroying your entire cartoon.

Putting Pencil to Paper

If you're like many artists, you've probably been drawing since you could first hold a pencil. But even if you've been drawing for years, putting pencil to paper for the first time in a professional manner can be intimidating. Not to worry, though — I'm here to help. Your goal is to get to the point where drawing cartoons comes so naturally that you don't have to think about what you draw. This section gives you tips on making cartooning as natural as writing your name.

On the other hand, you may be picking up a pencil to cartoon for the first time. Perhaps you're just addressing an interest in drawing that you've ignored for quite some time, or maybe you want to take up a new hobby. This section provides you the basic tools to start cartooning and perfect your art over time. Figuring out how to draw is mostly a matter of practice, so start simple and advance your art using the information in this chapter to get a more professional look.

Knowing what pencil (and paper) to use

You may be ready to pick up a pencil but have questions about what type of pencil to use. Is any old pencil you pull out of the junk drawer okay? If you're planning to get serious about drawing, choosing a pencil and paper is a matter of personal preference. Go to an art store, ask the sales associate for some assistance, buy a few types and experiment until you find what feels most comfortable to you. The best bet is to try out many different types to see what works.

You'll probably be using a pencil to do light sketching and then inking over the light sketch with either a pen or brush and ink. With that in mind, I suggest you use a pencil that isn't too dark when applied to the paper and that you can easily erase after you've inked your line art.

Likewise, the paper you choose should feel good to you when you're drawing on it. The paper should provide the right surface for the tools you're using and help you achieve the type of line quality and performance you desire. Check out Chapter 3 for more discussion on the types of pencils, brushes, and paper available.

Going from lines to making shapes

Drawing isn't rocket science. You don't need to have an advanced degree to be able to sketch interesting and compelling characters and drawings. You just need to know how to start with some simple shapes — circles, squares, triangles, and rectangles — and then build on them. These shapes translate into basic cartoon designs and forms — like heads, bodies, and buildings — when you put them together. Everything you draw is essentially based on simple shapes.

After you master simple shapes and the different ways they can be put together, you'll be better able to understand more complex things like perspective. Get a feel for drawing shapes so you can draw and manipulate them easily and have fun doing it.

After you feel comfortable drawing basic shapes, you can start to turn them into more complex objects and give them dimension. In real life, when you look at an object, you see it in three dimensions, meaning you can see some part of the front, side, and top, all at the same time. (If you see more than three sides, you're either looking in a mirror or you're an alien with more than two eyes!)

For example, start with a square, or box. A simple square appears flat (as in Figure 4-1), which is okay for some objects you draw, but not for others. (Most of the time, you want your basic square to have a three-dimensional look.)

Figure 4-1:
This square appears flat and one-dimensional.

If you want to draw a television, for instance, drawing a flat square shape doesn't give you a realistic look (see Figure 4-2).

Figure 4-2:
The TV looks flat and one-dimensional.

To draw a three-dimensional box shape, follow these steps:

1. **Draw a box shape approximately 3 x 3 inches in diameter (see Figure 4-3a).**

2. **Draw another box shape that overlaps the first box, as in Figure 4-3b.**

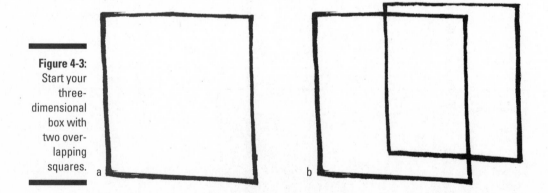

Figure 4-3:
Start your three-dimensional box with two over-lapping squares.

3. **Connect each corner of the first box diagonally to each corresponding corner of the second box, like in Figure 4-4a.**

Now you have a three-dimensional box!

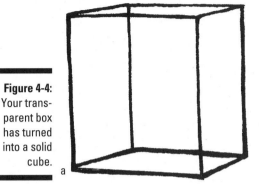

Figure 4-4:
Your trans-
parent box
has turned
into a solid
cube.

a b

4. **Erase all the inside lines on the front, top, and side of the box (refer to Figure 4-4b).**

 Erase the inside lines and your framed cube suddenly becomes a solid object. This is necessary if the object you're drawing is actually solid, like a TV for example. If you don't erase the lines, the object appears like a frame you can see through, and it won't be a solid object.

5. **After you have a solid box to work with, you can make it into any number of objects.**

 One classic boxed-shaped object is a TV. To turn your box into a TV, draw a smaller square shape inside the front of the box cube to create your TV screen.

6. **Add the finishing details to make it look like a TV.**

 Next to the TV screen, add a few knobs and a long rectangle to represent the speaker, as in Figure 4-5.

Figure 4-5:
Your TV now
has a three-
dimensional
look.

Doing rough sketches

Rough sketches are the visual note-taking of the cartoon world. Just as a writer jots down many, many notes in preparation for writing the next great American novel, the cartoonist draws many, many rough sketches.

Rough sketches should be just what they say they are — rough. Don't spend too much time on them, because they're just meant to capture the basic idea and layout of your composition so you have it when you want to develop the idea further.

Making rough sketches doesn't require you to follow any specific rules. Rough sketches may be little more than a series of stick figures or other loose scribbles quickly jotted down on a scrap piece of paper or on the back of an envelope, as in Figure 4-6. Do what works best for you.

Figure 4-6:
Rough
sketches
are loose
and simple.

Ideas may come to you at any time and any place, so make sure you're prepared to put them down on paper in the form of a rough sketch by always having paper and pencil with you. (Chapter 5 gives you some hands-on direction about the ins and outs of rough sketching.) Then later, when you're in your workspace ready to draw your next creation, you can quickly refer to the rough sketches so that you don't forget any of your ideas.

Tightening up your sketch

After you make a rough sketch and like the idea and are ready to move on, the next step is to tighten up your sketch. *Tightening up* a sketch means to define the lines so that the characters, word balloons, background, and

overall composition are clearer and more defined. This is the stage when the final composition comes into focus and you can see how the line art will look prior to beginning the inking process (see Figure 4-7).

When you tighten up your sketch, you simply go over your first loose sketch and darken it up while further defining the characters. This is the stage where your drawings become cleaner and come into focus.

Figure 4-7:
As you tighten up the sketch, your cartoon becomes more defined.

Grasping the Art of Inking

Inking is the final stage in the black-and-white drawing process. *Inking* is simply taking the pencil sketch and using it as a guide to complete the illustration, so that the finished product is a crisp, clean, black-and-white line art drawing. You can use a brush and ink or a pen to ink your work; which tools you choose is a matter of personal preference. Experiment to see what works best for you.

The purpose of inking in cartoons relates mainly to reproduction. Cartoons are generally reprinted in newspapers, magazines, and books. But art that's done only in pencil doesn't always reproduce well because the lines can drop out or get overexposed and look darker than they should. Inking allows for the best possible reproduced art, because black-and-white line art that's inked usually comes out looking just as you created it. Inking with a brush allows you to achieve a line art quality that you simply can't achieve using any other tool or medium.

Using a brush and ink is also fun! Most cartoonists view the inking stage as the most enjoyable because it's when your art begins to come alive and jump off the page. This section helps you get a firm grasp of inking basics.

Understanding how using a brush differs from pens and pencils

The inking process is a bit different from other steps in the drawing process. Using a brush to ink is different from using other drawing tools like pens and pencils because you have to control the brush in a totally different manner.

Using pens and pencils is all about keeping constant contact between the end of the tool and the paper. When you draw with a pen or pencil, you typically apply a constant amount of pressure so that you're always producing an unvaried, consistent line on the paper.

However, using a brush is quite different. If you apply the same amount of pressure to the brush as you do to a pen, you end up with a huge mess and a frayed brush. The key to using a brush is in the wrist; applying varying amounts of pressure to the brush produces light but varied lines — thin lines when desired and thicker ones when and where you choose.

Getting comfortable with using a brush

Before you can get a firm grasp on inking, I have one important piece of advice: Make the brush your friend and use it. To get better at inking, you need to practice and practice some more. It can be frustrating at first, but you'll find that the rewards far outweigh the suffering you go through trying to master this tool.

A fairly inexpensive good brush to start with is a Winsor Newton Sceptre Gold II watercolor brush. This brush has a pretty standard bristle size and is good for detailing as well as achieving thick line variations.

Inking 101: The how-to

To actually use a brush to ink your sketches, follow these steps:

1. **Before using your new brush, dip it in a brush cleaner and twirl the end so that it acquires a sharp pointed edge.**

 Leave it out overnight. Doing so allows the individual bristles to form to a nice pointed shape and prevents any loose bristles from fraying.

2. **After you're satisfied that the brush tip is nice and sharp, dip about $^3/_4$ of the brush into an open ink bottle so that you pick up a sufficient amount of ink.**

Don't dip the brush all the way in because you'll get ink up around the base, and when this dries it will cause the brush to fray. In between dips to load your brush with ink, dip your brush in a small container of water and shake it to clean out any excess ink before it has time to dry.

3. **To draw a thin line, apply the brush to the paper using a light amount of pressure.**

 This action feels much different than using a pencil. Glide the brush across the paper rather than pushing it.

4. **To make your line thicker, just add more pressure.**

However, don't go too heavy or you'll have a big mess on your hands. It takes lots of practice. The key to success is to combine thick and thin lines to produce a drawing composed of varied line thickness throughout, as in Figure 4-8.

Figure 4-8: Varied line thickness adds interest and appeal to your line art.

One way to begin to get the hang of inking is to simply get out a piece of scrap paper (I like using 11-x-17-inch copy paper) and repeatedly draw lines in a variety of lengths and thicknesses. This is a good way to master the relationship between the amount of pressure you apply and the kind of line thickness it will produce. The lines on the left in Figure 4-9 are the result of slight pressure, while the lines on the right are the result of a heavier amount of pressure.

If you study the works of Walt Kelly, Pat Oliphant, or Bill Watterson, you notice that they have a wonderful line quality that gives their art an energetic, vibrant character. Many people find this part of their cartoons exciting, even if they don't quite fathom how it's done. But you can achieve the same results with your brush. Just experiment. Try different methods until one works best for you.

Figure 4-9:
Applying mixed pressure to the brush creates a varied line quality.

Erasing sketch lines

After you ink your drawing, you need to get rid of your original sketch lines for the following reasons:

- ✔ **The ink lines don't always cover them.** The point of the pencil sketch was just to have a loose guide for you to use in the inking process.
- ✔ **If you scan your work into the computer, the scanner may pick up the pencil lines.** The lines may appear as little dots or lines along your inked line art. It's best to erase them, or do what I do and use a nonphoto blue pencil to sketch with that doesn't reproduce.

To get rid of the sketch lines easily and effectively, try these ideas:

- ✔ Sketch your pencil lines lightly so you won't have to work too hard to erase them later.
- ✔ Make sure you use a permanent, waterproof ink that doesn't smear when dried so you avoid smears when erasing the pencil sketch underneath.
- ✔ Use a kneaded eraser, which is best suited for removing graphite pencil lines.
- ✔ Consider using a nonphoto blue pencil so you won't have to erase the pencil lines at all. Nonphoto blue isn't picked up by a scanner or camera.

Creating Tone and Texture

Tone and texture can add depth and help a flat drawing look more dimensional. Because cartoons deal primarily with black-and-white line art, utilizing techniques such as shading and crosshatching creates tone and texture.

Tone and texture help define the shape you're drawing and add depth to the art. Without tone and texture, the line art looks flat and bare and may not covey the right perspective, dimension, or relationship to the other elements drawn around it. This section shows you how to do both techniques.

Shading

You can use shading to add depth and dimension to your sketch. *Shading* is the process of darkening an area of your sketch to give the impression of depth. The specific shading technique you use depends on the type of medium you use to create your drawing.

Although the computer has become the device of choice to shade and color cartoons in the modern age (I discuss shading using a computer in Chapter 16), you may want to be a bit more hands-on with your shading when you're first starting to draw. If so, the following traditional methods and techniques are still in use and worth examining.

With a pencil

Shading with a pencil is pretty straightforward. If you draw a cube with a pencil, shading the cube on one side to add depth is easy because a pencil is a soft medium and is able to produce gray, shade-type tones (see Figure 4-10). To shade with a pencil, use the side of the pencil lead. Doing so creates a softer line quality as you move it back and forth in the area you're shading.

Figure 4-10:
Shading
with a
pencil can
give you
nice gray
tones.

With ink

If you decide to shade with ink, you don't get the same effect as with a pencil because ink isn't transparent in its natural form. Ink is solid and reproduces as a dark solid value when it's printed. To shade with ink, simply fill in the

area you're shading so that it's totally black. This can create a dramatic light/dark effect. Don't do this, however, if you need some tonal gradation in the area you're shading, because it will be uniformly dark.

Inking in one side of a square-shaped object works better (see Figure 4-11a) than inking in a side of a round-shaped object. On a round object, a solid black area can lack the gradient quality needed to convey an accurate three-dimensional form (see Figure 4-11b). To address this problem, see the "Crosshatching" section later in this chapter.

Figure 4-11: Shading in solid black can create a dramatic effect.

With washes

Washes are methods that have been used for hundreds of years to create shade and tonal value in illustrations and other art destined for newsprint. Washes, which are gray in color, are used to shade an illustration.

Washes are generally ink that's been watered down until it's a much lighter, transparent consistency. To apply a wash, you use a watercolor brush to dip into the wash and cover over the areas you want to shade, usually on a watercolor-based paper. To achieve the right gray shade, mix water in with a small amount of ink until you get the shade you want (see Figure 4-12).

The results of washes are very similar to watercolor except that washes are always some shade of gray. The technique is still very much in use in cartoons that are regularly published in *The New Yorker* magazine, among others. The technique results in a toned-down, more sophisticated looking composition.

If you're coloring your sketches in Photoshop, you can rely on several filters and brush options to achieve a similar effect digitally. Check out Chapter 16 for more on shading with Photoshop.

Figure 4-12:
Washes can create a soft tonal shade quality similar to traditional watercolors.

With markers

If you want to shade your sketches with markers, you have a wide variety of *design markers* on the market to choose from to create bold lines that are perfect for shading. They come in a variety of colors as well as several different shades of gray, which are great for shading.

To shade with design markers, you basically color in the areas designated to be shaded. The more you go over the first layer, the darker your shading will be. Design markers have traditionally been used in design-specific professions like architecture, fashion, and interior design. They produce a predictable, modular line quality, like in Figure 4-13. You can use them in a quick, loose manner to create a stylized shading technique.

Figure 4-13:
Design markers are a quick, reliable tool for shading rough sketches.

Crosshatching

If you want to create a tonal quality using black and white, you can use a technique called crosshatching. Just as the name implies, *crosshatching* means to draw vertical lines in one direction and then cross over them with diagonal or horizontal lines.

Crosshatching is a technique best suited for applications in which other forms of shading may not reproduce well. This is especially true with regard to newsprint. Most newspapers print their pages in black and white, so shading your art using a gray wash or even color won't turn out well. Also, newspapers have a tendency to run images smaller than the cartoonist originally intended. If you color your art or use a watercolor wash, when the image is reduced down and reproduced on the page, the shading technique fails as the area appears solid and the image may lose any tonal quality.

When a crosshatched image is reduced, the quality of the reproduced and scaled-down art is much better. This is one reason why crosshatching became popular among editorial cartoonists and newsprint political illustrators.

Crosshatching creates a darker tone but not a solid one. You can vary your tones by changing the number of lines you draw and where you place them. If you want to add a slight tonal value to a shape, simply drawing lines on one side of the shape adds an element of dimension. For example, the figure on the right in Figure 4-14 is what the box looks like before you begin to crosshatch. The more lines you draw in a diagonal direction over the previous lines, the darker the crosshatching gets and the more dimension you can give a shape, as shown in the figure on the left in Figure 4-14.

Figure 4-14: Crosshatching can give depth to elements in your drawing.

Fixing Mistakes

Nobody's perfect; every artist makes mistakes. And most cartoonists change their mind at least once when they're sketching out an idea. The more you draw, the more you'll change your mind.

When you do make a mistake or change your mind, don't panic. Although the easiest and fastest way to deal with a change is to start over with a fresh piece of paper, you're probably not interested in killing a small rainforest while sketching, right? You don't have to throw your sketch away and start from scratch. Most mistakes usually have an easy solution.

This section examines some tried and true methods for fixing your mistakes. Some of these methods and techniques may seem primitive, but they get the job done!

Using an eraser

You've probably been using an eraser since you were in kindergarten. Erasers are pretty easy to use to take care of small mistakes. You need to include a traditional rubber eraser as well as a kneaded eraser in your arsenal of tools to meet any erasing challenge. A *kneaded eraser* is a pliable material that has the consistency of putty. It doesn't wear away and leave behind eraser "crumbs"; as a result, it lasts much longer than other erasers. Kneaded erasers can be shaped by hand for erasing minute details.

Kneaded erasers are commonly used to remove light charcoal or graphite marks and in subtractive drawing techniques (when you want to erase out white lines against a dark or completely blacked-out background). However, they're ill-suited for completely erasing large areas, and they may smear or stick if they get too warm. Though they don't wear away like other erasers, they can become exhausted and unable to absorb any more graphite or charcoal. When this happens, they should be replaced with a fresh kneaded eraser.

One simple thing to remember when erasing is to be sure to wait until the ink has fully dried before erasing pencil lines. If you start erasing and the inked line art starts to smear, you may have a huge problem on your hands and one that's very difficult to fix.

Mastering cut and paste

After you ink your drawing, you may discover that you don't like the way a part of it looks. You've probably invested several hours in the inking process, and you may have done so using expensive drawing paper — not something you want to throw out unless you have to.

If so, you can cut and paste a new sketch over an area you want to change. The quickest way to do this is to redraw the portion of the cartoon you want to edit on another scrap piece of paper. Simply cut out the image and paste it over the area you want changed.

For example (and I speak from experience here), say that you draw a face and decide that you want it to look in a different direction after you ink it up. You can draw the face on a separate piece of paper — preferably a light bond copy paper — and then cut it out and paste it over the area you want to change.

Using light bond copy paper allows you to adhere the patch onto the master drawing without creating a bulky lump that may hinder your ability to place the original face down on a scanner later on. You can then scan it in your computer and the image looks like one image. You can make any necessary tweaks in Photoshop (see Chapter 16).

The joys of white correction fluid

Of all the correction methods I use, the one I use most often is white correction fluid. Correction fluids are opaque fluids originally created to be applied to paper to mask errors in text, specifically those made by a typewriter. However, they're also excellent for covering up mistakes made in black ink. The correction fluid generally has great coverage so you can correct the mistake in one smooth layer.

Correction fluid is typically packaged in small bottles. The lid has a small, attached, triangular foam brush that dips into the bottle and is used to apply the fluid onto the paper. When the correction fluid dries, it creates a glass-smooth finish that's easy to draw over with waterproof black India ink, making the original mistake almost undetectable.

More recently, correction fluid has become available in pen form. The pen is spring-loaded and, when dabbed onto the paper, releases a small amount of fluid. The pen allows for a more precise correction area compared to the bottled form. The major drawback, however, is that the pen doesn't cover large areas like the foam brush does.

Chapter 5

Coming Up with Ideas

. .

. .

Creating a cartoon involves more than just drawing a couple of characters and having them interact with each other on the page. Most people want to be entertained when they read cartoons, so you need to create an interesting story that readers want to read. And by the very nature of most comic strips, you want to include something humorous in your artwork. If you think you can come up with something funny and original to say, then you're off to a great start in becoming a cartoonist. Even if you don't, no need to worry. You can develop a knack for finding creative ideas and including humor with just a little work.

You've come to the right place if you want to start writing fresh and funny story lines. This chapter looks at where to find ideas (don't worry, they're everywhere!) and what to do with them. I show you ways to set up a joke and how to master the art of comedic timing. I also give you tips for coming up with ideas when the well runs dry, and I explore the possibilities and pitfalls of thinking outside the cartoon box.

Getting Inspired for Storyline Ideas: Just Open Your Eyes

The most frequent question professional cartoonists get asked is, "Where do you get your ideas?" This question is asked so frequently that I know several colleagues who provide canned responses like, "There's a guy in Newark you can write to for ideas. But he won't send you any unless you promise him your sister." The other famous retort is, "From the Idea Fairy."

The real answer to the question is almost as silly as these responses. The truth is, ideas are free. All you have to do is open your eyes and look around you. They can pop in your head from out of thin air, yours for the taking. Just about anything you see, hear, read, or experience can spark an idea if you know how to look for them in everyday life.

This section helps you get started in coming up with funny ideas for your cartoons and then recording them so you don't forget them. Use this material as a springboard to dive into a wide array of hilarious ideas and themes right at your fingertips.

Looking for and keeping track of ideas

Coming up with good ideas isn't really difficult. You're sitting on some right now and don't even know it. You just need to realize that almost anything in life can be funny if it's presented correctly.

If you can't think of anything funny off the top of your head, try looking at any of the following sources for some ideas. Just be receptive and keep your antennae up:

- ✔ Newspaper and magazine articles
- ✔ TV news
- ✔ Things your parents did, once upon a time — start really listening to their stories!
- ✔ Things your kids do — really, they're funny in retrospect
- ✔ Things your pets do — ditto!
- ✔ Your own childhood memories
- ✔ Funny conversations — we all have them, it's just a matter of remembering them
- ✔ Interesting situations or experiences (we all have these, too)
- ✔ Fascinating people you know or meet
- ✔ Tragic events (yes, tragedy can be funny, if it's handled right)
- ✔ Mundane activities of life — remember, it's all about the spin you put on things

After you find a good topic or issue that sparks your interest, try some free association to come up with a list of humorous ideas related to that topic. What comes to mind when you think of offices, family life, or your childhood?

Doodling a little art around your ideas helps bring new ideas to the surface as you dig for diamonds in what can sometimes be a big lump of coal mined from your experiences and subconscious.

After an interesting idea pops into your head, you need to be ready to write it down immediately to help you remember it. If you don't write it down, you'll lose it in the deep crevices of your brain forever. Be prepared to take notes at any time — on the train, in the car (pull over first!), at work, in the store, or wherever else life takes you. Taking notes becomes a habit — the more often you do it, the more ideas will come to you.

Your ideas probably won't arrive fully formed, so write down all your idea fragments — you may be able to develop them into something later. Anything will do as a means of transfer from your brain to a more permanent source of recollection: napkins, scrap paper, candy wrappers, or whatever else is available at the given moment.

If you actually remember to carry a small notebook with you, even better! Or buy a pocket calendar with a lot of white space. Don't forget something to write with also; while writing with a mustard bottle is possible, it's not practical in the long run. Keep a pen with you at all times. Remember that taking notes isn't like a homework assignment. Jotting down notes and ideas should be fun and not too complicated.

After you're in the habit of writing down ideas on a regular basis, it's important to not only take notes but take good notes. You need to develop a visual shorthand, pattern, style, or format that works for you. Stick figures and quick little scribbles are usually all you need; you don't have to go into great detail or be elaborate. The trick is to just write down a quick outline or even just a phrase — whatever will remind you of the idea later.

Connecting ideas to your cartoon's theme

When devising ideas for your cartoon, one of the best ways to add humor is to include it as part of the cartoon's theme. The *theme* involves the actions or events that are ongoing and repeated. Every comic strip has a theme; it may be family life, work life, life in the forest, life on another planet, or any combination of the most common themes.

The main idea for your comic strip comes from the characters and the plot of the story. For example, say your cartoon centers on a single father and his kids. You can expand the idea and have the father and kids live on a spaceship, which would give your cartoon a high-tech/futuristic/outer space

theme to go along with its family theme. Those themes mean that the cartoon would involve the ongoing and amusing challenges of a family living in outer space.

Your cartoon's theme determines its type of humor, because different characters find different things amusing. To add humor to your cartoon's theme, look at the situations in your characters' daily lives. You can find humor in even the most ordinary life events if you can identify the element of the characters that people can relate to and make that funny.

One reason why comics about kids have always been popular is because almost everyone can understand and appreciate the humor. After all, everyone was a kid once! It's a cliché, but kids do say the darnedest things. If you have kids as characters, their mispronunciations, malapropisms, and misunderstandings provide lots of fodder for funny lines. Animals capture readers' attention for the same reasons — many people have or have had pets and can identify with their often outrageous behaviors.

Eyeing some do's and don'ts to writing believable story lines

Writing funny story lines creates characters that people can not only turn to for comic relief but also will become attached to over time. Interesting story lines allow your characters to develop into individual voices that, when separated from the bunch, can offer insight and subtle humor, but together offer real synergy. In other words, the sum is greater than the parts.

Whether your comic strip appears in the newspaper or on the Web, you may have to create a new story line on a daily basis. Because maintaining a believable level of constant hilarity is almost impossible, the humor you inject will probably be more subtle than slapstick. Some points you may want to consider when writing humorous story lines include:

✔ **Write story lines that draw upon the characters' strengths or weaknesses.** You can exploit your characters' strengths and (especially) weaknesses to provide humor and to have something that reoccurs in future story lines. Examples include characters that have a hang-up with food, like Garfield and lasagna or Homer Simpson and donuts.

✔ **Write story lines based on common humorous themes and ideas that readers can relate to and recognize in their own life.** One example is Dilbert and the company he works for. Readers can relate to having to go to work with boring coworkers in a mundane job.

✔ **Write story lines that are funny but not too abstract.** If readers don't get the humor, the only person who will think the cartoon is funny is you.

Peeking inside a few famous sketchbooks

The most famous artist sketchbooks are those of Leonardo da Vinci. His sketchbooks are filled with drawings, diagrams, and notes on his ideas. Of particular interest are the pages in his sketchbooks devoted to gliders and flying machines. Leonardo designed most of his aerial machines after he studied birds. For this reason, he designed the machines to generate their forward motion by mechanisms that flap the wings.

Leonardo's ideas came from simply observing what he saw around him. Remarkably, da Vinci did these sketches over 400 years before the Wright Brothers invented modern flight. It pays to sketch your ideas!

Picasso also produced several hundred sketchbooks in his lifetime. He often used his sketchbooks to explore themes and make compositional studies until he found the right idea and subject for a larger painting masterpiece.

Meanwhile, some things to avoid:

- **Don't write story lines that require the reader to have read yesterday's cartoon in order to understand the one you wrote today.** It's okay to continue story lines over time, but make sure each one can stand on its own.

- **Don't write story lines that are too conceptual.** Stick with story lines that revolve around basic human interactions and relationships that ordinary readers can follow, relate to, and appreciate. For example, if your comic is based in outer space, don't write story lines that require the reader to know everything about rocket ships or the solar system.

Keeping Your Sketchbook Close By

Your notebook for jotting down quick ideas or images (which I discuss in the section "Looking for and keeping track of ideas") can also be used as a sketchbook. A sketchbook is beneficial because it keeps you drawing, and the more you draw, the better you get at it. Unlike the idea entries in your notebook, your sketchbook entries may not be tied to any particular idea. You may see an interesting building, person on the street, or street scene and decide to sketch it — not because it relates to any particular idea but just because it's interesting.

If you're short of pocket space, you can use the same spiral notebook to do double duty for specific ideas and general, "maybe this will come in handy someday" sketches. Or you can keep two different books. In either case,

having something handy to write on or draw on is much better than using an old napkin or your shirt sleeve! This section covers the importance of sketching in further detail.

TIP

Purchase a simple, spiral-bound sketchbook and drawing pencil from an art supply store. You can also personalize your sketchbook by drawing your own cartoon character or a caricature of yourself on the cover.

Why constant sketching keeps you sharp

When you turn on a hot water faucet, the water usually takes a few minutes to warm up, depending on how cold the pipes are. But if you turn the faucet on again soon after, the water gets hot much more quickly this time.

Creativity is really no different. The longer you let the creative juices flow, the hotter the ideas are that come pouring out. The next time you turn on your creativity faucet, the easier the ideas flow. So to stay creatively sharp, sketch often and sketch everything. By doing so, you may draw something that triggers an idea that may never have come to you otherwise.

Your sketchbook should be filled with all sorts of sketches and doodles from things you may see, hear, or observe. Though these doodles may be nothing more than exercises in free association, they're a gold mine that you can go back to and dig through later. The little doodles can be the seeds that grow into a bigger idea down the line.

For example, you may be sitting in a park and hear the roar of a motorcycle as it goes by. Later on, you may be sitting in the lobby of an auto shop waiting for your car to be fixed. While you're there, you may glance out the window and see a man get out of his car. All these experiences are opportunities to scribble something down in your sketchbook.

An example of this is the sketch in Figure 5-1, which I did several years ago. In this sketch/doodle, I drew a big semi truck going over an uncompleted freeway overpass. Now, I didn't actually see a big rig going over a bridge, but I had been looking at a freeway being built by the school I was attending and had seen numerous semi trucks go by. The drawing came out of my observations and my attempts at drawing something from an unusual angle or perspective. The large concrete pillars that hold up freeways are massive and, when looked at from directly below, create a dramatic perspective.

Figure 5-1:
The pages of your sketchbook should be a place to help formulate your rough ideas.

A few months ago I was thinking about different ideas I had for an editorial cartoon I wanted to do about the failing U.S. auto industry. The story had been all over the news about how the U.S. automakers were suffering big losses and were in danger of possibly filing for bankruptcy.

It seemed to me that one of the car companies' major problems was producing huge SUVs that people no longer wanted to buy (unlike a few years ago). Yet they continued to build them; it was as if they were willingly driving themselves off a cliff. With that idea in mind I remembered a sketch I did showing a big truck going over a bridge. I looked up the sketch I had done over five years before and used it as the basis of the finished editorial cartoon in Figure 5-2.

Figure 5-2:
Using the
rough
sketches
from your
sketchbook
can help
you with
ideas
later on.

Drawing stick figures: Cartooning shorthand

When sketching or doodling your ideas, you can draw the simplest and roughest kind of sketch just to remind yourself later of what you were thinking at that moment. These stick figure sketches act as a handy reminder so that you can reference that filing cabinet between your ears later on. The point is just to get something down quickly.

For example, say you have an idea for an editorial cartoon about rising oil prices. You want to express the desire for the U.S. to become more reliant on domestic fuel sources and less dependent on foreign oil. You realize that environmentalists and preservationists are opposed to drilling for oil in the U.S. because they fear a natural disaster and possible harm to certain wildlife. However, you feel that perhaps the risk is worth it in an effort to become more energy self-sufficient, and that it would be better for national security.

You know you want to depict an environmentalist in the cartoon and think that maybe it would be funny to have one of the animals arguing with the environmentalist in favor of drilling in the face of record oil prices. The idea

is pretty clear in your head, and you just need to get the basic rough sketch quickly down on paper. You can jot down a stick figure sketch to remind you of the idea later on (see Figure 5-3).

Reviewing the stick figure sketch as a reference at a later date will remind you of the idea so that you can develop it into a more elaborate sketch (see Figure 5-4).

Figure 5-3:
A quick stick figure sketch helps you remember an idea later on.

Now you can take the roughed-out sketch and use it to complete the idea as a finished cartoon. You can see from Figure 5-5 that I made many choices as to layout and placement of the characters, but the basic idea from my original stick figure sketch is still there.

Figure 5-4:
What was once just a quick stick figure sketch is now a more elaborate, roughed-out idea.

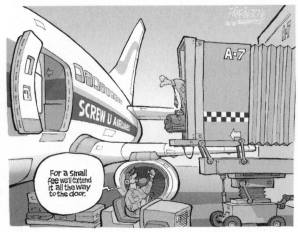

Adding Humor to Your Story Lines: Good Writing Trumps Bad Art

One of the most fundamental principles in the comics industry is that good writing always trumps bad art. Basically, you can spend all the time in the world drawing your comics and sketching your characters in all sorts of elaborate and wonderful ways, but unless you can come up with innovative and fresh ideas, write well, have good comic timing, and have something funny to say, you're bound for the trash heap of history.

The history of cartoons is filled with the carcasses of dead comic strips and characters that lived a very short life, died, and were quickly forgotten. The primary reason: These comic strips weren't well-written or funny enough on a consistent basis, and even fantastic art can't save poorly written cartoons.

In comparison, many comic strips that have been around for decades have art, backgrounds, and characters that are drawn in a very simple style. Yet some of these comics are very successful. Some examples include *Peanuts, Dilbert, Cathy,* and *Pearls Before Swine.* The commonality among these cartoons is that although their art has a simple, minimalist quality, they're all very well-written on a consistent basis.

You don't want your cartoon to be thrown on the pile of dead comic strips, do you? I didn't think so. The good news is that this section gives you the lowdown on incorporating good writing with your interesting characters and backgrounds to create a cartoon that people can relate to.

What constitutes a good joke: Timing is everything

When writing your cartoons, make sure you use timing to your advantage. *Comic timing* is the use of rhythm and tempo to enhance the humor aspects of a joke or story. Ask anyone who practices comedic writing — including stand-up comedians and writers of TV monologues and variety sketch shows — and they'll say that the pacing of a joke's delivery can make or break the joke. The same is true for cartoons.

Writing a good joke is something that takes a lot of practice, so don't get frustrated if you have a difficult time coming up with something humorous. In order to keep timing in mind, make sure you apply the following concepts to your writing.

Pauses

You take a pause for the purposes of comic timing, often to allow the reader time to recognize the joke and react, or to heighten the suspense before delivery of the expected punch line. This is manifested in a comic strip by the way the cartoonist arranges the panels and how he delivers the script in each individual panel.

Pregnant pause

A pause is an effective tool that you can use to disclose subtext or even unconscious content — that is, what the character is really thinking about. More specifically, a *pregnant pause* is a technique of comic timing you use to accentuate a comedic element, usually involving a character who pauses at the end of a phrase to build up anticipation. Pregnant pauses are often used at the end of a comically awkward statement or after a seemingly noncomic phrase to build up a comeback. An example of a pregnant pause in a stand-up comedy act would go something like this:

> "Congratulations are in order for George W. Bush. Now that he's retired and has time on his hands, he plans on writing his memoirs . . . " (pause) "but first he needs to find enough crayons to do it."

You can apply the same thing to a cartoon strip or multipanel editorial cartoon by using a blank (wordless) panel for the pregnant pause (see Figure 5-6).

Criticism can't curtail *Cathy*

One important distinction to make here regarding the "good writing trumps bad art" philosophy is the comic strip *Cathy*. *Cathy* has been quite successful for over two decades, but it has also been the target of much criticism and ridicule over the years. Much of the criticism has been directed at the artwork and sometimes crude character and design layout.

However, *Cathy* has remained successful because it's well written in the context of its theme of the foibles of modern womanhood. Readers, the majority of them women, have become huge fans because they can relate to the characters and story lines.

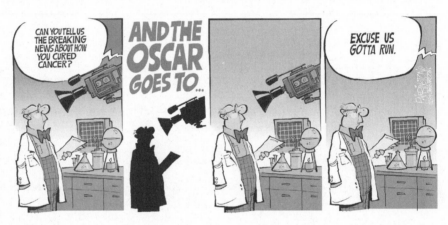

Figure 5-6:
Correct comic timing is important when writing your comic strip.

Setup

A good joke starts with a good setup. The *setup* is the action or dialogue that occurs before the punch line is delivered. One thing you want to avoid is the desire to rush through the story line so you can get to the punch line. Part of what sells the joke is having a good mental image of the characters involved. If they're established characters that are already familiar to the reader, then you can move a little faster.

Make sure you write each comic strip to stand on its own so that it doesn't have to rely on a setup from a previous strip. You can't guarantee that readers will have read the previous strip or gag.

Deciding whether cartoons have to be funny

When writing your cartoons, don't fall into the trap of thinking that everything has to be funny. Cartoons are also very effective when they're thought-provoking or poignant. A cartoon doesn't always have to be roll-in-the-aisles funny to be effective.

In determining the tone of the cartoon, you first must determine what you want the cartoon to say. If the story line evolves into something on the more serious side and the story line is strong and compelling, then perhaps being funny may not be appropriate. Editorial cartoons are a prime example of comics that are often more serious and poignant than they are funny. However, a cartoon can certainly be both witty and serious to make an editorial point.

Using loved ones to test your material

When writing story lines and dialogue for your characters, it's easy to get caught up in the work and lose perspective on whether what you're writing is really funny to other people or just your own private inside joke. Having someone else take an objective look at your work can be helpful, allowing you to see whether you're going in the right direction. This is especially important if you have a particularly warped or unusual sense of humor.

So as you're writing your jokes and text, test your material before sending it out into the world. And who better to be your guinea pigs than your nearest and dearest — the people who can't say no — your friends and family! Getting a second opinion never hurts, as long as it's an honest opinion, so tell them not to hold back about the positives and negatives of your cartoon.

However, be careful not to take what others say too seriously. Criticism is healthy, but it can also cause you to lose faith in your own abilities. Take what others say with a grain of salt, and make sure you ask more than one person for an opinion. If everyone in your writing group, all your friends at work, and everyone in your family say it's bad, maybe you should go back to the drawing board. In general, though, you're the best judge of your own writing.

Your biggest fan will probably be your own mother; after all, that's her job. Her opinion is biased (hopefully in your favor), so don't use her as your only critic!

Taking Action When the Ideas Run Dry

Coming up with fresh, funny ideas isn't always the easiest thing to do. Sometimes you just won't be able to think of anything new or fresh, and it may seem as though the idea well has run dry. But that's the time to really get creative when coming up with new ways of looking at things. This section helps you uncover some ideas even after you're at your wits' end.

Tying two topics together

One tried and true method in the field of editorial cartooning is known as a *two-fer-one*. Quite simply, this means taking two separate issues and tying them together to get one idea (and one cartoon). This method works particularly well when you want to talk about a current event and tie it to another, unrelated current event to come up with a new perspective on an idea. Using your sketchbook, you can do a series of quick doodles and some word association that may help you find something in common between the two events (see Figure 5-7).

For example, perhaps you want to comment on the bad state of the economy. The news is filled with stories of layoffs, bankruptcies, store closings, and house foreclosures. This topic isn't really funny — it involves a lot of pain for a lot of people. How can you add a little humor to this?

Around the same time, say a new Batman movie comes out and is a really big hit at the box office. Here's an opportunity to tie together these two topics while they're fresh in the minds of readers. Now, Batman has nothing to do with a bad economy, of course. The topics are totally unrelated. So how can you tie the two together?

Figure 5-7:
Quick sketches and word associations can help you combine two unrelated topics.

Some ideas jump out at you:

- What if you show Batman filing for unemployment?
- What if the Batmobile gets repossessed?
- What if the Batcave gets foreclosed on?

All these ideas could potentially work, and depicting them can be a clever or funny way to relate something to readers. I thought it would be really funny if I showed Batman sitting up on a building while the night cleaning lady sticks her head out in an effort to console him about his recent misfortune (see Figure 5-8).

The punch line works because it incorporates Batman's true identity — that of billionaire Bruce Wayne. The fact that the cleaning lady doesn't know his true identity is what makes the cartoon ironic and funny. Misery loves company, as they say.

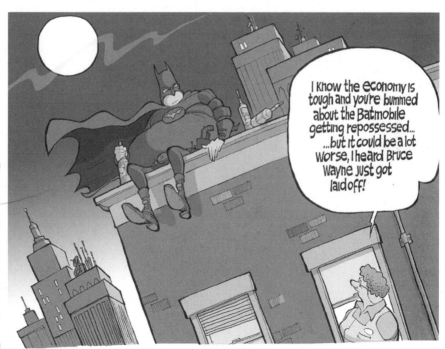

Figure 5-8:
This cartoon is an example of tying two unrelated events together to form one humorous idea.

Thinking outside the box versus conventionality

Creating funny ideas often requires that you look outside the box of conventional thinking, which means you have to employ unconventional ways of looking at things where conventional thinking may fail.

Thinking outside the box has its caveats, however:

- Unorthodox thinking has recently become so popular that thinking inside the box is starting to become more unconventional. Basically, what was once new is now old and what was old is now new again.

- In an effort to come up with something so new and fresh, you risk the possibility of being too abstract. If you're too abstract, you may not connect with readers.

For example, many comics on the Web are geared toward certain niche audiences, such as people into fantasy gaming. These comics have had success on the Web precisely because the Internet is where they can reach their specific audience. But many of these niche comics have failed in print because typical print readers find the topics and story lines too abstract and out of the mainstream.

On the other hand, one thing to remember, particularly about comic strips, is that conventionality typically works better than nonconventionality. The most popular comic strips in the past 30 years have all been conventionally rooted in some way:

- *Peanuts* is based on childhood and the simple, mundane struggles that all kids experience.

- *Baby Blues* is based on the experiences of a young couple starting a family.

- *Calvin and Hobbes* is based on the wonders of childhood imagination, which anyone who has ever been a child (as in, everyone) can relate to.

All these comic strips have universal themes that readers can identify with. They were all consistently well written, laugh-out-loud funny, and occasionally poignant. So in the end, conventionality sells.

Part II
Creating Cartoon Characters

The 5th Wave By Rich Tennant

"Oh, Taylor, I love the way you draw close-ups of people yelling. You draw the cutest esophagus."

In this part . . .

Choosing characters that you enjoy drawing — and don't mind drawing over and over — is an important aspect of cartooning. In this part, I explore some of the different types of interesting characters you can create and the step-by-step process of creating them, along with characters that are out of the ordinary, such as household appliances and creatures from outer space! I also cover the often tough, dog-eat-dog world of editorial cartoons, and I explain how to survive a career that includes cartoons that make a political statement.

Chapter 6

Starting from the Top

*T*he part of your cartoons that readers will most identify with is your character's face. Even the shape of a character's nose and the placement of her ears say a great deal about her personality and way of thinking. In other words, facial characteristics express feeling and attitude. Faces give your readers insight into your character's inner being; they're a nonverbal shorthand into your character's makeup.

Classic cartoon characters have faces much like the people you see on the street — in other words, the possibilities are endless! That doesn't mean expressive faces are easy to draw, however. Creating a face requires some understanding of how to draw realistic looking eyes, nose, teeth, mouth, glasses, hair, and ears.

More important, creating a character with a distinctive face requires that you understand how to take all the individual facial elements and put them together for a cohesive look; you don't want a character whose mouth says one thing while her eyes say another. When it comes to your character's face, a picture is worth much more than a thousand words! In this chapter, I explain every aspect of drawing character facial features that speak volumes before your character ever opens her mouth.

Drawing the Head

Chances are that when you begin to create your cartoon character, you start with the head. The head is a vital element to character design because it's probably the most frequently drawn part of the character.

When you draw characters in full form, you draw them in a head and body shot (for information on how to draw the body, check out Chapter 7). But if you have a multipanel comic strip or webcomic and your character has a lot

of dialogue in one panel, the only thing you may choose to draw (or have room for) is a headshot. So when designing your character's head, don't lose yours! Choose a head shape that makes a recognizable statement about who your character is right from the beginning. The next section explains how.

Creating basic head shapes

Designing a head shape requires a familiarity with basic shapes and how to draw them. Though you've probably been drawing circles and squares since grade school, you may not know how to relate them to certain head shapes and the stereotypes associated with each. All you have to do is draw the basic head shape and then add the facial features you want to match your character's personality (check out the sections later in this chapter for clear directions on drawing eyes, ears, a nose, and so on). This section looks at some of these basic head shapes and shows some simple faces that fit certain types of characters.

You may have noticed that, throughout the entire book, head shapes like ovals or circles have both a horizontal and vertical line drawn across them. These lines are known as the *center guidelines* and can help you place the facial features in a symmetrical manner. The placement of these lines changes depending on the way you position the character and the angle from which you draw the head. Center guidelines are important; don't skip the step of sketching them onto your basic head shapes from the beginning.

Round head shape

Round head shapes are often best suited for characters who have small bodies. Kids fall into this category — Charlie Brown or the kids from *Family Circus,* for example, have round heads. Other cartoon characters with round heads include Mickey Mouse and the Powerpuff Girls. All these characters have large, round heads and small bodies. Just draw a circle to start and then add the facial features you want to match your character's personality. Figure 6-1 shows an example.

Figure 6-1: A basic round shape may be best for your character.

Oval head shape

Another option for your character's head is an oval shape. You can draw an oval shape either tall and elongated or squatty and wide. An oval shape that's elongated can give the impression that your character is really goofy or nerdy; a wide oval shape suggests that the character is heavy. Experiment with the shapes and positioning of the oval shape and adding the different facial details. See Figure 6-2 for an example.

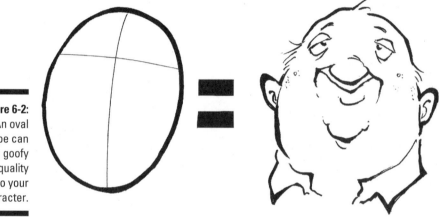

Figure 6-2:
An oval shape can add a goofy quality to your character.

Square head shape

You can also use a simple square to create your cartoon character's head. A square head is best suited for characters that have boxy body types or who are big, muscle body types like sports jocks. Sketch the square and then draw the facial details to match your character. Figure 6-3 shows an example.

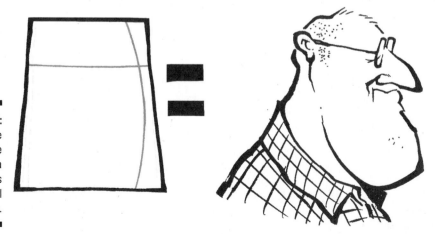

Figure 6-3:
A square head shape conveys a character's physical strength.

Triangle head shape

The last main option you have for drawing heads is the triangle. The triangle head has multiple purposes. Like the square shape, the triangle shape is well suited for a character who's large or one who has a big jaw or neck area. In contrast, if turned upside down, the triangle can give a character a nerdy look. Determine the look you want for your character, draw the triangle, and then add the facial features. See Figure 6-4 for an example.

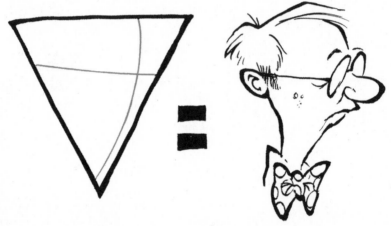

Figure 6-4: A triangle head shape can be used to create a variety of character types.

Exaggerating and distorting the head

One of the great things about cartooning is the ability to stretch and distort things in a way that helps give life to the art. You can distort your character's head to convey emotion, expressions, and exaggerated reactions to what's happening around him. If a character is yelling, for example, exaggerating the length of the head as the character's mouth widens and opens can visually express to the reader how loud the yelling is.

Figure 6-5 shows an example of a distorted head at rest. A head at rest is one that's not talking or moving around or listening to another character talk, for example. However, the head in Figure 6-5 stretches even more, giving the impression that the yelling is getting louder. You can draw this in a series of panels in a comic for effectiveness.

You can also distort a head to express an exaggerated emotion. Figure 6-6 shows an angry figure who's yelling. Notice how distorted the shape of the head is. Also notice how the mouth is wide open in exaggerated fashion. The head is also leaning slightly forward in an aggressive manner, which gives the reader the sense that the character is really upset and screaming loudly.

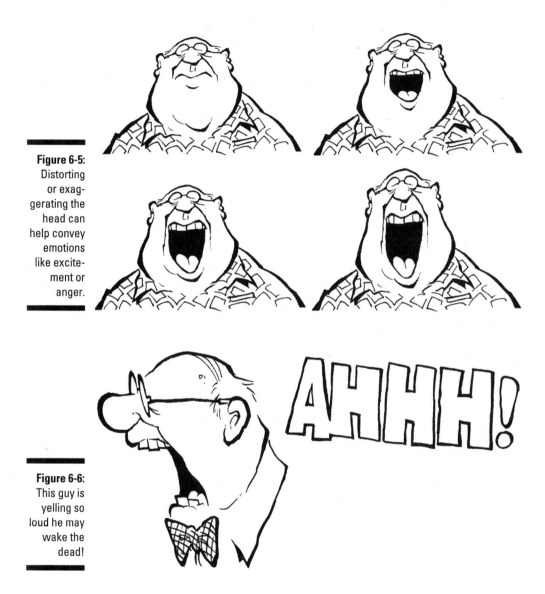

Figure 6-5:
Distorting or exag-gerating the head can help convey emotions like excite-ment or anger.

Figure 6-6:
This guy is yelling so loud he may wake the dead!

Placing the features

What determines attractiveness? Personal taste aside, the placement of facial features determines our perception of how attractive or ugly someone is. Like head shapes, the placement of features can go a long way in conveying your character's mood and image.

The size and placement of your character's features depend on the look you're trying to give him. If your character is a strong, superhero type, then the features will probably suggest classic Greek features. However, the style may be cartoonier, and the placement of the features may be squished and exaggerated.

This section looks at two points to consider as you place the facial features on your cartoon characters.

The features' actual location on the head

Unless you're drawing Martians, you usually place facial features in the middle of the head area. The center guidelines can help you place the feature correctly. However, the placement of these lines changes depending on the angle of the head and the way you position the character.

For example, start with an oval head shape and see how the character changes just by moving the features around. In Figure 6-7a, you can see that the head looks somewhat normal. By moving the center guidelines down and centering the facial features on both the vertical and horizontal lines far down on the head, the character takes on a whole new look and feel, as shown in Figure 6-7b.The character on the right looks as though he's looking down at you, and the character on the left looks as though he's looking up at you. Notice the change in position of the center guidelines and how the facial features reflect this.

You can also draw facial features in different placements from a profile view to give your characters a different look. Figure 6-8 shows an example of two heads in profile. Moving the facial features far down on the head of the character on the left gives him a different look and feel. The character on the right looks as though his neck is stretched out as if he's trying to look over something.

Figure 6-7: Placement of the facial features can give a character different looks.

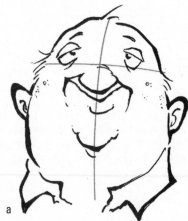 a

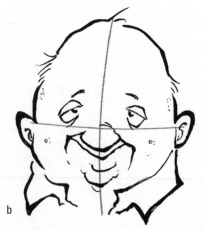 b

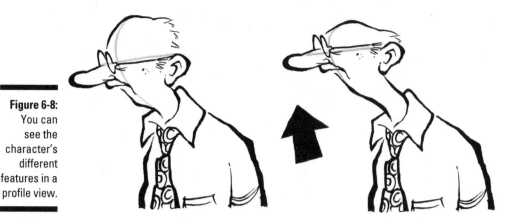

Figure 6-8:
You can
see the
character's
different
features in a
profile view.

Drawing the head from all angles

Drawing a head from different angles is an important element of layout and also impacts the way characters visually communicate with one another. For example, having a character in the foreground talk with a character drawn in the background requires that the character in the foreground turn around and face the background character. Visually, you draw the back of the head of the characters in the foreground. Figure 6-9 demonstrates an example. In this cartoon the character is looking out a window and talking to another character standing outside.

Sketching the character's head from this angle adds visual interest to the drawing while allowing the reader to look past the character in the foreground and see the character in the background effectively. It also adds a sense of realism, because this is actually what you would see if you were standing behind the character with his back to you; it allows the reader to be more a part of the cartoon. Small things like drawing the character's head at the correct angle add up to better storytelling.

The rear view isn't the only visually interesting variant you can play up in your cartoons. You can draw the head, or any object, from many different angles. If you were to have someone take a picture of your head each time you moved it around a quarter inch to the right, and your head was 24 inches around, then they would end up taking 336 pictures. So you can see that drawing the head from many different angles can add dimension to your cartoon characters. Unfortunately, I don't have the space to show you that many, so I focus on four basic head directions and angles. Focus on these four angles and their relationship to the center guidelines.

Figure 6-9:
The character's head in the middle foreground is shown from a rear view.

Figure 6-10a demonstrates the head from about a three-fourths right rear view. Your character may look like this if he were turning and looking back toward the right. To draw the head in this angle you need to line up the center guidelines so that the vertical line runs down the back of his head on the far left, as opposed to running down the front of his head if he were facing forward. The horizontal line runs across the middle as shown. From this angle you can see only the right side of his glasses from a rear view looking forward. In addition, you can see slightly behind his right ear.

Figure 6-10b shows the character's head as he faces right in a profile and slightly three-fourths view facing forward. From this view you can see both sides of his glasses with the center guideline running down the front centered between them. The horizontal line runs across and is at eyeglass level.

Figure 6-10c is shown from about a three-fourths left rear view. This angle shows the character turning and looking back toward the left. To draw the head from this angle you need to line up the center guidelines so that the vertical line runs down the back of his head on the far right and the horizontal line runs across the middle as shown.

Figure 6-10d shows the head of the character facing to the left in a profile and slightly three-fourths view facing forward. From this view you can see both sides of his glasses with the center guideline centered between them and running down the front left side of the face.

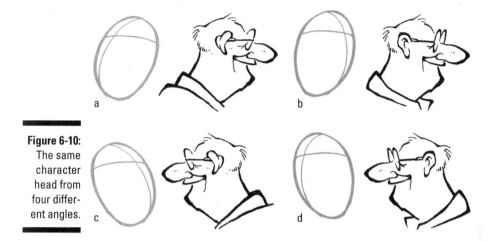

Figure 6-10:
The same
character
head from
four differ-
ent angles.

Dotting the Eyes

The eyes are very important to your cartoon characters and play a major role in communicating to the reader and the other characters in the strip. The eyes are certainly the windows to the soul, but in the cartoon world they can also be the window to wackiness! You can draw eyes in a realistic fashion and then distort or enlarge them to show emotions like terror or frustration. Distorted or exaggerated eyes are a cartooning hallmark. This section walks you through how to draw basic eyes and how to distort them for full effect.

Sketching the basic eye

Before you can draw a cartoon eye, make sure you understand how to draw a realistic looking eye and all its parts. In this section, I look only at drawing an eye in black and white, because adding coloring to eyes is a more complicated process. (Check out Chapter 15 for ways to add color to your cartoons.)

Follow these steps to draw a realistic looking eye:

1. **Start with eyelids.**

 Concentrate on the shape of the lids. Think of the lids as the frame of the eye. They frame the entire look. Sketch the eyelid by drawing a horizontal line across and another one that curves upwards towards the eye socket. See Figure 6-11.

2. Imagine the eyeball.

Think of the eyeball as a sphere set into and under the lids, but don't draw an actual eyeball. Beginners often make the mistake of drawing the eyeball. The eyeball is merely suggested by how you draw the eyelids and surrounding elements.

3. Draw the center of the eye.

The center of the eye includes the pupil, iris, and the cornea. To do so, draw a thin, dark ring, a colored ring, and a black circle in the middle.

4. Add the finishing details.

Draw the tear duct on the corner and the eyelashes. The tear duct is very important to the look of a realistic eye, as it represents the suggested corner of the eye.

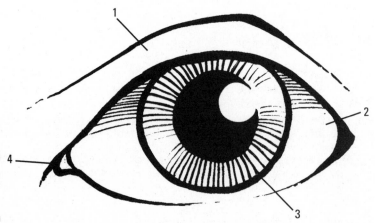

Figure 6-11:
The parts of
a basic eye.

Buggin' out eyes

Saturday morning cartoons we watched as kids wouldn't be the same without someone's eyes bugging out! This is a trait usually reserved for characters who see something they can't believe they're seeing, like a ghost or monster, or a picture of a really pretty girl. You can see this technique in Bugs Bunny cartoons from the 1940s as well as the *SpongeBob SquarePants* cartoons of today. It's a classic technique and one that's just plain fun to watch.

To draw this effect, you need to exaggerate your character's facial expression so that the mouth is wide open. To draw the bugged-out eyes, draw two oval shapes that look like eggs extending out past the face so that they appear to be popping out. Bugged-out eyes work best when your character is in profile. This allows the reader to see the bugging out effect to its full extent. Figure 6-12 shows an example of bugged-out eyes.

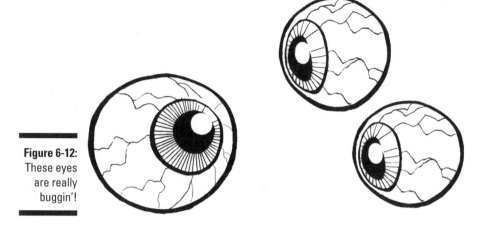

Figure 6-12:
These eyes
are really
buggin'!

Wearing glasses

Glasses set the mood of a character and help convey certain things about her personality. Classic characters with glasses are usually thought of as intelligent, like the class bookworm or nerdy brainiac.

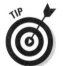

To draw glasses, you simply find the center guidelines and position the glasses so that each lens falls on one side of the vertical center guidelines. The left lens falls on the left side and the right lens falls on the right side. This is true no matter what position the face is in. Always make sure the glasses and other features are lined up with the guidelines; doing so ensures the correct facial proportion and angle of the head.

Round glasses are usually easiest to draw and look more like wire frames, the same kind a bookworm would wear! Figure 6-13 shows an example of different sizes and styles of glasses you may want to put on your own cartoon characters.

Figure 6-13:
Glasses for
your
characters
can come in
all shapes
and sizes.

Raising an eyebrow

Eyebrows are an important detail that you shouldn't overlook. Eyebrows can help convey a subtle emotion or reaction that readers can easily recognize. Using a character's eyebrows is a great way to make subtle statements without having to be too elaborate.

To create eyebrows, draw a line above the eye that curves upwards and follows the curvature of the eye socket. The bigger the movement upwards the more expression the character will have.

Figure 6-14a shows a character who isn't expressing any emotion with his eyebrows. Figure 6-16b shows the same character moving one eyebrow up without moving any other facial feature. Doing so effectively conveys to the reader that the character is suspicious, surprised, excited, or skeptical about something.

Figure 6-14:
This guy's behavior is bound to raise some eyebrows.

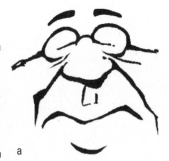

a

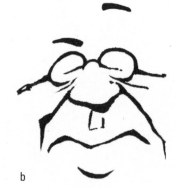

b

Just by a Nose: Sketching the Schnoz

The nose can be a defining characteristic and can say a lot about your character. Noses come in all shapes and sizes, and the sky's the limit when it comes to creating the perfect honker. This section gives you the lowdown on drawing your character's nose and the different shapes and sizes you can go with.

Drawing a basic nose

Before you can sketch a nose, you need to know a nose's parts. The basic nose is made up of two distinct parts:

✔ The bridge of the nose (or top)

✔ The nostril

To draw a nose, follow these steps:

1. **Start with the bridge and draw a line down and then a sharp turn under to form the basic nose shape.**

 This shape is generally a 45-degree angle, but it can vary depending on how you draw it.

2. **Move to the nostrils.**

 When drawing nostrils you can simplify things by curving the bottom line of the nose back around so that it forms a small "c" shape. However, as shown in Figure 6-15, you can separate the nostril as its own shape. You still draw it as if it were a small "c" shape, but at the bottom you thicken the line a little bit to give the impression of the nostril opening.

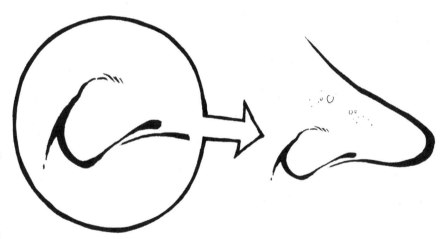

Figure 6-15: Breaking down the nose.

Considering various sizes and shapes

Like most things in the world of cartooning, you won't find fast or firm rules when it comes to creating a nose. Choosing a shape and size is up to you, but the nose should be appropriate to the character and his personality and should be in keeping with your own cartooning style. As in the real world, nose shapes and sizes are often specific to men and women, the young and the old, and the fat and the thin.

Sniffing out the male nose

Males tend to have large noses; the older a man gets, the bigger his nose can become, in the real world as well as the cartoon world! To draw a male character's nose, you generally want to follow an angle that's close to 45 degrees. Sizes vary, and so does the angle. The older a man gets the less sharp his nose becomes in profile and the more rounded it gets. He may also have age spots and hair coming out of the large nostrils. Figure 6-16a shows a middle-aged man's nose and Figure 6-16b shows an older man's nose.

Figure 6-16:
Men's noses can vary depending on age and character type.

a b

Drawing a female nose and a baby's nose

Female noses are generally smaller and daintier than male noses. They're sharper, and the nostrils are small compared to male characters. You can also turn up female noses slightly at the end. To draw a female character's nose, remember that female noses aren't as big at the base and therefore don't cover as much facial area as a man's. If you draw a female nose in profile, draw it at less than a 45 degree angle.

Meanwhile, a baby's nose is also different. It's much smaller than an adult nose; that's why it's often called a *button* nose. Children's noses are under-developed and have years to go before they grow. When drawing a kid character, keeping the nose small helps convey to the reader that the character is young. Like kids, babies also have a small nose, especially compared to their oversized eyes.

Figure 6-17a shows an example of a grandmother's nose. It's long and pointed, and it's smaller than a man's at the base. In contrast, Figure 6-17b shows a baby's nose.

Figure 6-17: Who nose best?

a b

Can You Hear Me? Crafting the Ears

Like noses, ears can tell readers a lot about your cartoon characters. Ears can give a specific impression and help define the character's personality. This section gives you a rundown on drawing ears.

As with the other facial features like the eyes, nose, and mouth, you also line up the ears with the center guidelines. Most of the time you line up the ears with the eyes. So if the eyes rest on top of the horizontal guidelines, you generally center the ears on the same line, especially as viewed in profile.

Drawing the actual ear

When drawing the ear, don't overlook the inside of the ear. Capturing the inside of the ear accurately makes your character's ears look believable. From the outside, the ear is made up of a couple of parts:

- **Pinnas:** It forms the outer ear shape with the earlobe at the bottom.
- **Meatus:** The inner part of the ear and the ear canal where your eardrum is located.

Figure 6-18 shows an example of a completed left ear with a close-up of the inner part of the ear. You draw the right ear the same way, only mirrored and in reverse.

To draw an ear, follow the question-mark pattern shown in Figure 6-19a. The outer ear curves around and is large or even pointed at the top compared to the bottom. When drawing the outer ear, you may choose to enlarge the ear-lobe at the bottom and even have it hang down lower. To draw the inside of the ear, draw the S-shape pattern in Figure 6-19b. When drawing the inner part of the ear, it's important to keep some space in between the outer and inner ear.

Getting the right shape is important, because if you draw the ears incorrectly, they won't look right to the reader. The ear is one of those body parts that can be exaggerated but still needs to incorporate basic elements to look right.

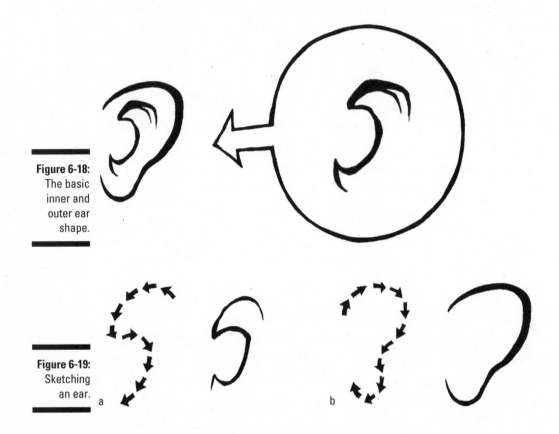

Figure 6-18:
The basic inner and outer ear shape.

Figure 6-19:
Sketching an ear.

a

b

Looking at ear shapes and sizes

You can create all kinds of shapes and sizes for ears. When drawing your character's ears, their look and shape can say a lot about the character. Big ears make your character look goofy, while pointed ears can make your character look sinister or even otherworldly, like a vampire — or a Vulcan! Ears are a very noticeable feature; if you draw them too big or oddly, they may be the dominating feature that readers see. Figure 6-20 shows an assortment of ear shapes and sizes for you to consider when drawing your character's ears.

Figure 6-20:
Now hear
this: Ears
can be fun
to draw.

Furthermore, like noses, ears change shape and can grow with age. For example, young children tend to have small, round ears that aren't usually their main facial feature. By comparison, an old man has large ears that have drooped over the years. Check out Figure 6-21, which shows a child's ear and a grandpa's ear. Notice how the earlobes on the grandpa character are large and hang down, while the kid's earlobes are smaller and more rounded. You can even add some hair in your old man's ears for extra detail.

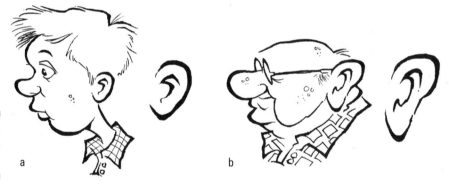

Figure 6-21:
Ears vary
with age. a b

Drawing the Mouth

Your cartoon character's mouth is a facial feature that you'll become very familiar with, especially if your characters talk a lot. Despite being nothing more than a simple line you draw just below the nose, the mouth of your character is very important. It can be very expressive and instrumental in communicating nonverbal emotion to the reader. Here I show you different styles and elements of the mouth for you to consider and study when creating a mouth for your own characters.

Crafting the mouth: The how-to

The mouth is one of a character's most expressive facial features. To draw a mouth in various expressions, follow these guidelines:

✓ **Smiling or smirking:** To draw a mouth with a smile, begin by drawing a line directly under the nose that curves up gradually on both ends. At the corners of each side of the mouth, pull back the laugh lines and connect each side of the mouth to them, as in Figure 6-22a.

✓ **Sad:** To draw a mouth on a sad face, begin by drawing a line directly under the nose that curves down on both ends. At the end of each side of the mouth, pull back the laugh lines around the corner of the mouth, but don't let them touch, as in Figure 6-22b.

✓ **Happy:** To draw a mouth that's laughing, begin by drawing a line directly under the nose that curves up sharply on both ends. At the corners of each side of the mouth, pull back the laugh lines past the bottom of the nose and connect each side of the mouth to them. The tongue is visible, as well as any teeth you may want to add, as in Figure 6-22c.

✓ **Angry:** To draw a mouth that's angry, begin by drawing a line directly under the nose that curves up gradually on both ends and back around again, forming a large figure-eight shape. Continue by drawing a horizontal line across the opening for the mouth to display all the teeth, which are clenched and visible. Find the center of the mouth and draw a vertical line in the middle. Follow that by drawing smaller vertical lines for the rest of the teeth. The laugh lines are pulled back on each side and follow closely around each side of the mouth but don't touch, as in Figure 6-22d.

Check out the "Getting All Emotional: Look in the Mirror" section later in this chapter for advice on putting the mouth together with the entire face to show emotions.

Figure 6-22: The mouth can say a lot.

a b c d

Focusing on all those teeth

A mouth wouldn't be a mouth without teeth (ask any great white shark and he'll tell you the same). A character's teeth can say so much: Nice, straight teeth give the impression that your character is an upstanding, honest

person, while crooked or missing teeth can give the impression that your character may be a hillbilly or a rough bully type who lost some teeth in a fight. And big teeth can give a cartoon character a goofy or wacky look.

To draw teeth, utilize the center guideline so that the upper row of two front teeth line up in the middle with the center of the face. The left teeth should be on the left side of the vertical guideline, and the right teeth should be on the right side of the guideline. The top row of teeth is generally larger than the bottom, and the width of teeth gets slightly thinner as the teeth move toward the corners of the mouth. Figure 6-23 has a variety of styles and shapes of teeth for you to consider and study when creating a set for your own characters. Who knew cartooning and cosmetic dentistry could overlap?!

Figure 6-23:
Don't forget
to floss!

Adding facial hair

Facial hair is an element that can be character-specific and help define a character in a certain stereotype. Facial hair can come in many styles and shapes, ranging from full beards to goatees to sideburns. A mustache is another element that can change the entire look of a character. To draw a mustache or other dominating facial hair, determine how it will affect the character's look.

To draw a mustache, begin at the corners of the outer nose, about level with each left and right nostril. Draw a line that curves slightly upwards as you move out toward the edge of the face. Drop it down so that it's level with the bottom of the earlobe. The lines on each side should evenly fall on each side of the nose and also line up accordingly with the center guidelines. Continue by drawing two more lines directly centered under the nose that begin and follow parallel to each top line outward, meeting at a point on the ends.

Figure 6-24 shows an example of facial hair and how it relates to the character. You can see that the mustache makes stereotyping the character easier in certain ways — there's no mistaking what this guy does for a living. The outfit and hat are good visual elements that help define this guy, but the

choice of mustache really sets the character off and completes his great cowboy look and persona. The mustache is a character all by itself!

Figure 6-24:
That's a tough lookin' 'stache pardner!

Figuring out the jaw

The jaw is a great place to help define your character's look. A weak jaw conveys a wimpy personality, while a square, prominent jaw signifies a strong, tough character. To draw the jaw, begin a line at the bottom of the mouth and curve slightly outward. Angle it sharply back toward the neck. The end of the jaw line and the earlobe meet, although you don't have to show a line connecting them unless you want your character to have a really hard, strong look. Figure 6-25 shows an example of a weak jaw and a strong jaw. Nerdy character types tend to have very weak jaw lines, while superhero characters tend to have strong, square, steel jaw lines.

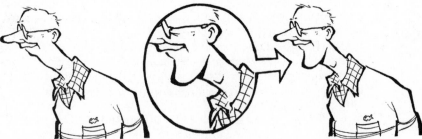

Figure 6-25:
The jaw line says a lot about your character.

Getting All Emotional: Look in the Mirror

Almost every face you draw has some type of emotion attached to it. Your character's expressions should convey important aspects of the storytelling. Nonverbal communication with the reader is important, and certain expressions help the reader understand what the character may be feeling or reacting to. The next sections take a look at how different facial expressions convey different emotions. You can use these as a guide when drawing your own characters.

Mad or angry face

Your characters are bound to get mad or angry sometimes. In fact, one of the most common stereotypes in the cartoon world is the wife who's mad — usually with good reason — at her husband. Where the writers come up with that, no one will ever know . . . right, guys?

If you want to show your character being mad or angry (check out Figure 6-26), incorporate these important facial traits:

- ✓ Eyebrows are turned sharply down.
- ✓ Mouth is open and teeth are exposed like a growling dog.
- ✓ Cheeks are tight and appear to be flexing.
- ✓ Eyes are squinted shut and turned down in the middle.

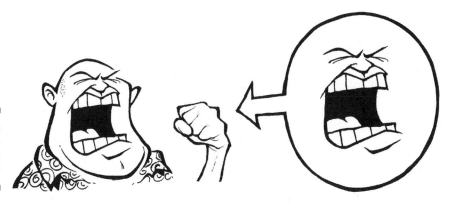

Figure 6-26:
Who made
this guy so
mad?

Sad face

Everybody gets sad. Perhaps a little kid character lost her puppy, or maybe your character is out of beer or donuts! These are good reasons to get a little blue.

If you want to show your character being sad, as in Figure 6-27, incorporate these important facial traits:

- Eyes are drooping and partly closed.
- Mouth is turned down.
- Cheeks appear slacked and drooping.
- Eyes may even have tears coming out of them.

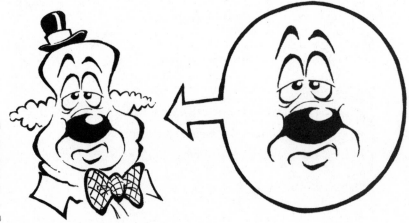

Figure 6-27: Cheer up, it could always be worse.

Happy or laughing face

A happy, smiling, or laughing face is a pleasant face and one your readers will enjoy. A smile can be a simple line you draw all the way across your character's face or a short line right under his nose. A smile can be as big and wide as you want to make it. However, always make sure it turns up at the ends — otherwise it may be a frown!

Happy, smiling, and laughing faces are contagious facial expressions. If you want to show your character with a happy or smiling face, as in Figure 6-28, remember these important facial traits:

✔ Eyes can be wide open with joy or even closed if the character is laughing too hard.

✔ Mouth is wide and can go from ear to ear, and teeth are exposed.

✔ Cheeks are tight and pulled back, and the corners of the mouth run into each cheek.

✔ Ears are pulled back and may be obstructed by the wide mouth and laugh lines.

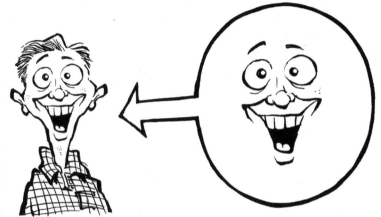

Figure 6-28:
C'mon, get happy!

Scared or surprised face

Everybody likes a good scare! A scared or frightened facial expression on your character brings a sense of nervous anticipation to readers. When they see a dramatically scared expression, they know something spooky is gonna happen . . . boo!

To draw your character with a frightened or surprised facial expression (see Figure 6-29), incorporate these important facial traits:

✔ Eyes are round and may even pop out of the head.

✔ Eyebrows are high and arched and may appear to jump off the face, too.

✔ Mouth is wide open and tongue is exposed.

✔ Hair may stand on end.

✔ Cheeks and laugh lines are pulled back far and wide.

Figure 6-29:
Make your
character
surprised or
scared.

Chapter 7

From the Neck Down

・・・

In This Chapter

▶ Understanding the importance of your character's body type

▶ Using circles as the basis to draw your character's body

▶ Drawing arms, hands, and legs

▶ Dressing up your characters

・・・

*W*hat could be more fun than creating a new body? Not for yourself — for your cartoon characters (if only it were so easy to change our own bods with the flick of a pen!). Choosing the right body type for your cartoon creations defines their character and gives them personality, animates them, and conveys action — even when your character is standing still.

When sketching out your rough drawings, make your sketches very light. The best way to accomplish this is by using a regular pencil and keeping it loose and light on the paper. That way you have less to erase after you ink your drawing.

Consider sketching with a nonphoto blue pencil. The advantage of using a nonphoto blue pencil is that your lines won't reproduce when scanned into a computer or when the cartoon is reprinted for publication. (I discuss different types of drawing implements in detail in Chapter 3.)

In this chapter, I describe the step-by-step process of drawing a body with just the right character.

Giving Your Characters Personality

Your character's body is an integral part of his personality. His body helps define who he is. You can choose to identify your character by giving him a stereotyped look — the jolly fat guy, the braniac little kid — or you can play against the stereotypes, creating a muscleman who's really a big wimp, for example. Both realism and whimsy go into making characters that are unique but also universal.

This section gives you an idea of how important a character's body is in showing your reader who the character is and what she's about.

Making your characters mirror your style

In cartoons, you can exaggerate and distort body types to create a unique set of characters that reflect your own sense of style. However, you also want your characters to be believable so that your reader can relate to them and find them appealing. If you're creating a comic strip about an average family, for example, it's important that they all have one head, two arms, two legs, ten fingers, and ten toes . . . unless the family lives on Mars.

You may find that the characters and cartoons you draw begin to take on certain characteristics that represent your own personal style and input. All the faces you draw may begin to have similarities and subtle attributes that define them as *your* characters; just like human offspring, your character offspring may be easy to identify as your creation.

Caricaturing your characters

On the other hand, you may not want your cartoon characters to look *too* realistic (although some cartoon strips are drawn in this style, such as the old *Mary Worth* cartoon), because part of the fun of cartooning is the opportunity to *caricature* your characters — draw them with realistic but exaggerated qualities to give them personal style and flair. It's a matter of personal drawing preference, though; caricature your characters to the degree that feels right to you and to the degree that fits each character.

Some characters lend themselves more easily to caricature than others. In general, characters whose personality traits fit into an easily recognizable type are easy to caricature. The big bully, the brainy nerd, and the jock are just a few examples that come to mind; mom, dad, the girl next door, and grandma don't bring to mind the same exaggerated characteristics (although, as their creator, you can caricature them to the degree that appeals to you).

Drawing your characters in a caricatured way helps to reveal personality traits before they ever open their mouths. For example, if you draw a character with big, round glasses and a large head, your reader will probably assume, without you specifically saying so, that your character is very intelligent. Conversely, giving your character a large torso and upper body and smaller legs helps exaggerate not only the character's physical nature but also his personality, making him immediately identifiable to your audience.

For instance, you know instantly that the tough guy in Figure 7-1 isn't anyone to mess with — and he probably isn't the hero of your cartoon, either!

Figure 7-1:
Your typical
tough guy
is person-
alized by
caricatur-
ing natural
character-
istics.

Building the Body: Drawing the Standard Character Type

As you begin to sketch your cartoon character's body, every decision you make conveys a little bit of information. You can express the character's emotions and actions through facial expressions and body language. You can convey an amazing degree of animation and information just by the way you position your character's head, by how he holds his arms, or by how he bends his legs. For example, a character with a wide neck, large shoulders, humongous arms, and tattoos probably isn't going to be taken for the church pastor. Readers will know he's a tough cookie — especially if he's sitting on a Harley-Davidson!

Drawing a body so that it telegraphs your character's emotions and actions identifies your character's subtle personality traits and helps you communicate with readers without having to spell out all the details.

When you first start drawing figures, always begin with the main area or focus of the character — usually the torso — because doing so helps you define the rest of your figure. If your character has a big body, drawing the basic torso shape first helps you determine the space your character will take up relative

to the rest of the drawing. If, on the other hand, your character has a bigger head and you're going to emphasize that area, then focus on the head when you start.

After you become more confident in your art skills and familiar with the way you want your characters to look, you can begin the drawing process wherever you want. And as you become more proficient, you develop your own way of drawing and can skip many of the steps I describe in the following sections. But if you're just starting out, follow my basic body-drawing steps.

Starting with circles

If you're an avid reader or fan of comics, you know that most cartoon figures are short and small with a slightly large head. You see this in many classic comic strip characters, like Charlie Brown and Snoopy from *Peanuts* and Calvin from *Calvin and Hobbes.* Most of the modern cartoon characters on TV also have this type of body design.

Drawing a classic cartoon body begins with sketching a basic shape, either a circle or an oval, and building on it. Classic cartoon characters are often kids, and in real life, kids often have disproportionately large heads. In the world of comics you always exaggerate the obvious when caricaturing your subject, so in this section I show you how to start with a large circle for the head to make your character come to life.

Follow these steps to begin your character:

1. **Sketch a large circle or oval in the middle of your paper.**

 The circle doesn't have to be perfectly round — just a rough sketch to define the area you want to use as a guideline (see Figure 7-2).

Figure 7-2: The typical cartoon character drawing starts with a circle or oval.

2. **Add a smaller circle or oval below the large circle (see Figure 7-3).**

 Doing so helps you establish the space for your character's body.

Figure 7-3:
Many classic cartoon
characters
have heads
that are
larger in
proportion
to their
bodies.

3. **Make sure your character's face is centered in comparison to his body.**

 Although this character doesn't look like much yet, you want to improve on his physique, center his face, and properly set the stage for his arms and legs. To do so, follow these steps:

 - **Draw a vertical line down the middle of the larger circle and then draw a horizontal line across the middle.** Doing so helps you center the face if your character is looking straight ahead (see Figure 7-4).

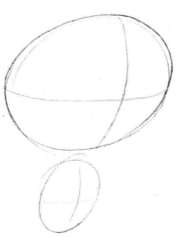

Figure 7-4:
These
vertical and
horizontal
lines can
help cen-
ter your
character's
facial
features
and set
the stage
for limb
placement.

• **Draw a vertical line down the center of the smaller circle, and then draw a horizontal line across the center of the larger circle (as in Figure 7-4).**

This helps you place your character's center of gravity and also acts as a guide when it's time to add arms and legs.

REMEMBER

Notice that the center guidelines aren't exactly centered in the circles, and they appear to be slightly curved. They should follow the curvature of the circumference of the circles, giving the circles a more dimensional look and feel, just like a real head and torso.

TIP

The key to sketching your drawings is to be loose and not too structured, because you're just beginning the process. You just want to get a nice feel for the overall character; you don't have to draw a perfect geometrical shape.

4. **Draw a square or rectangle where the lower body and legs go, below the small circle (see Figure 7-5).**

The square space is important because it establishes the area for the waist and legs.

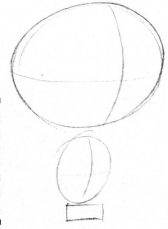

Figure 7-5:
Drawing
a square
below the
torso helps
your leg
placement.

5. **Draw the legs coming down from the square by sketching two vertical lines straight down for each leg.**

The legs in this example are really nothing more than a few straight lines coming down into the character's shoes, which are just two small circles (see Figure 7-6).

6. **Lightly pencil in the details (see Figure 7-7).**

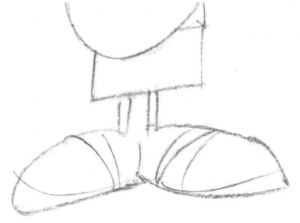

Figure 7-6:
A few lines and two circles become your character's legs and feet/shoes.

Draw light pencil lines to use as a guide so that you have a nice frame to ink over with either your pen or brush when you're ready for more detail. Using the center guidelines, start to fill in the face by adding ears, hair, and glasses. This guy's got real big glasses, which helps convey a book-worm look. For more information about drawing faces, see Chapter 6.

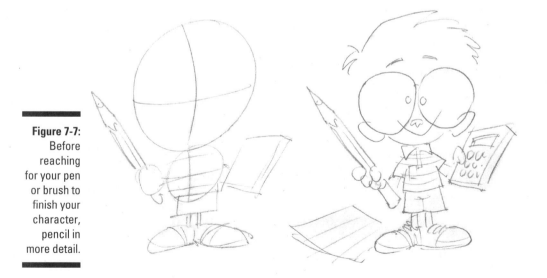

Figure 7-7:
Before reaching for your pen or brush to finish your character, pencil in more detail.

7. **Add more details and accessories to the character to convey his personality (see Figure 7-8).**

As you work on your character's face and clothing, small details start to bring him to life. You can show your character's personality without having to spell it out for readers. The pencil, calculator, and big glasses are good choices for this guy — they give clues about the character's nature. Use your own imagination and creativity and see what you can come up with.

Figure 7-8:
Your readers may instantly recognize your character as a boy genius.

Moving circles for different looks

Although the classic cartoon character typically has a large head and small body, you can simply move those basic shapes around and use them as the building blocks for a totally new character. The example in this section shows you how to move your circles to create the tough guy character I show you at the beginning of the chapter — someone with a big, wide chest and a small waist.

By changing the position of the circles, you can give your character a new look and feel. Just follow these steps:

1. **Sketch a large circle or oval in the middle of your paper.**

 Again, the circle doesn't have to be perfectly round — just a rough sketch to define the area you want to use as a guideline (see Figure 7-9).

2. **On top of the large circle, draw a smaller circle.**

 The angle or direction your character is facing determines where exactly the head area should be. For example, if the character is facing straight on, then draw the head circle so that it's centered directly on top of the larger torso circle (see Figure 7-10).

Figure 7-9:
The larger circle represents the body in the typical tough guy.

Figure 7-10:
To show your character looking straight on, place the smaller circle directly on top of the larger one.

3. Ensure that your character's face is centered with his body.

You want to properly define his face, arms, and legs. To do so, follow these steps while referring to Figures 7-11 and 7-12 (and remember, you don't have to be too precise with this drawing):

- **Draw vertical and horizontal lines across the middle of the smaller circle.** Doing so helps you center your character's face.

- **Draw vertical and horizontal lines across the center of the larger circle.** This helps you place your character's arms and legs.

If the character is facing left or right, draw the center guidelines closer to the edge of the smaller circle on the side that the character is facing. That is, if the character faces left, the guideline should be closest to the circle's left side, and if the character faces right, the guideline should be closest to the circle's right side.

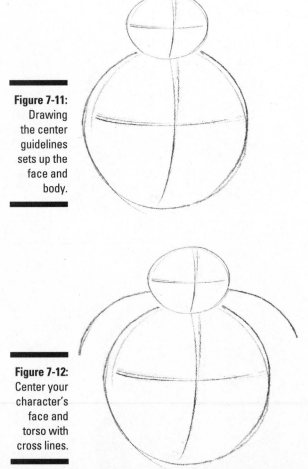

Figure 7-11:
Drawing the center guidelines sets up the face and body.

Figure 7-12:
Center your character's face and torso with cross lines.

The curvature of the center cross lines gives the figure a slightly three-dimensional shape, like one of those Bozo punching bags you used to get for Christmas as a kid.

4. **Coming out of both sides of the smaller circle, sketch lines that follow the curves of the larger circle (see Figure 7-13).**

 These lines are the top of the character's broad shoulders.

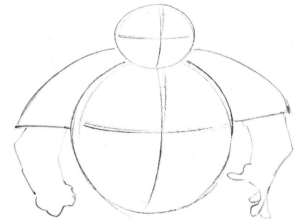

Figure 7-13:
Lines for the tough guy's broad shoulders.

5. **Add arms.**

 You can place the arms at the sides of the upper torso to give the tough guy an aggressive stance, as shown in Figure 7-14.

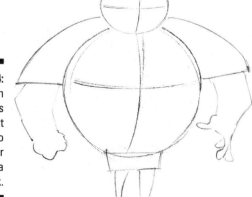

Figure 7-14:
You can place arms at different angles to give your character a certain look.

6. Box in the area just below the torso and add the legs at the bottom.

The key is to draw the tough guy's legs small so that the upper body is exaggerated (see Figure 7-15). You can see that the size of his arms is in proportion to his upper body, but his legs aren't. Despite this, the legs don't look out of place. However, if you were to draw small arms on a large torso, it would look strange.

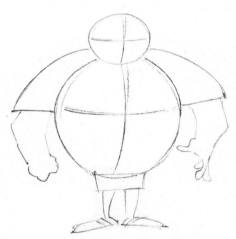

Figure 7-15: Drawing the legs much smaller than the arms exaggerates the tough guy's normal characteristics.

7. Add the feet and shoes by drawing small oval circles at the base of the legs.

You can add details like shoelaces to these circles and they quickly take shape and become shoes! The tough guy's feet are small, but not too tiny (see Figure 7-16). Their shape and size here reflect my personal style. If you think your guy would look better with little girly feet, then that's your decision.

His shoes are also nondescript in contrast to, say, a detailed tennis sneaker. Because the character is top-heavy, putting big, well-defined shoes on him would take away from the main focus, which is his upper bulk. Most of my characters' shoes have a similar look and style. I just like to draw shoes that way; you can draw yours in whatever style suits you.

8. Fill in the defining details and add inking to complete the character, as shown in Figure 7-17.

This guy's narrowed eyes, big bulbous nose, and scowl all contribute to his tough guy personality. (For more details on how to draw a face, refer to Chapter 6.) Don't forget to define the details on his clothes, like the pockets on his pants and his belt line.

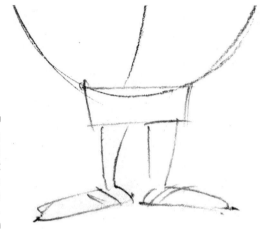

Figure 7-16:
This tough guy's feet are small to match his legs.

At this point, the character's overall frame and shape is in place, and it's time to finish the art. When you add ink, you follow the loose pencil sketch as a guide, and the character really comes alive. Inking requires practice, but the results add great line variation to your work and make it reproduce well in print. Check out Chapter 4 for more specifics about inking your work.

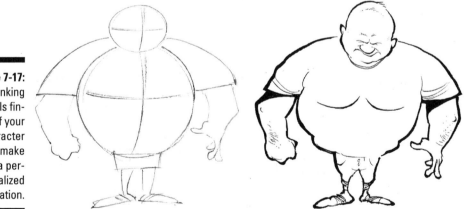

Figure 7-17:
The inking details finish off your character and make him a personalized creation.

Drafting Arms and Hands

Arms, hands, and fingers vary in shape and size, but the right ones always help finish off your character. Arms add to the character's persona and should be appropriately sized for the character's body type. This section shows you how to craft arms, hands, and fingers.

Drawing arms

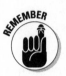

When sketching arms, think of them as tubes, or cylinders (see Figure 7-18). Although arms are divided into upper and lower sections, with the bend at the elbow, cartoon characters typically don't have overly detailed arms with lots of muscle tone and definition. Keeping the arms simple doesn't distract from your overall character design.

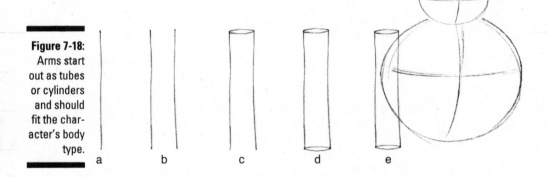

Figure 7-18:
Arms start out as tubes or cylinders and should fit the char- acter's body type.

a b c d e

When drawing a basic arm for your character, follow these steps:

1. **Draw a line that starts at the top of the shoulder and comes down along the side of the torso.**

 This line can be straight or curved, depending on how the character is standing and what the arm is doing. If the character's arm is just hanging by his side, the line should come straight down and end about waist level.

2. **Draw another line the same length next to the first line.**

 Now your arm has two sides.

3. **Draw small ovals at the top between the two lines and at the bottom between the two lines.**

 Make sure each side of each oval connects to each line. You've created a tube or cylinder as a basic guide for your arm, as shown in Figure 7-19a.

4. **Draw another tube that forms a V-shape, or bent arm, as shown in Figure 7-19b.**

5. **For the hand area, sketch out a small, fist-size circle, like in Figure 7-19c.**

6. **Using Figure 7-19c as the basic shape for an arm that's flexing its muscle, fill in the details like the fist with thumb and fingers (see Figure 7-19d).**

 If you bunch up your own hand into a fist, you notice details like the thumb covering the fingers and the thumbnail being visible while the fingernails are tucked away in the fist. The knuckles should be on the top of the fist, depending on the direction of the hand. The middle finger usually has the biggest knuckle.

Figure 7-19: The evolution of the arm, from tubes to a finished drawing.

a b c d

Lending a hand with fingers

Hand positions can express certain emotions and are part of your character's body language. Unlike the arms and feet of the average character, hands are points of interest and can do a lot to communicate to readers.

You can draw hands and fingers in a variety of ways. You may choose the more cartoony approach — like the Mickey Mouse style — or a more realistic approach. The style you choose is based on what kind of character you want to draw. Feel free to add as much detail as you want.

Hands typically flow from the arms and upper torso; if you draw a large upper torso and arms, the hands will usually be large, with thick fingers. By comparison, if you have a skinny body type with thin arms, the hands will be long and lanky, with long, skinny fingers.

Like most things in cartooning, however, no hard and fast rule dictates how you design your characters. Use your own imagination and creativity. If a huge scary guy with dainty hands and pinky rings fits your story line, or a cute little baby with large, grasping hands adds flavor to your cartoon, who's stopping you?

You may want a little more detail for your characters. Animators used to draw hands on their characters with only three fingers for the simple fact that it was faster than drawing them with four!

To draw basic cartoon hands with fingers, do the following:

1. **Sketch a small circle.**

2. **Add the fingers and thumb corresponding to which way the hand is facing, as in Figure 7-20.**

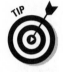

If the palm is facing inward, the thumb goes on the inside of the hand, toward the body. If the palm is facing outward, the thumb goes on the outside of the hand, away from the body. If your character is on the heavy side, her fingers should reflect that and be short and stubby. If she's on the thin side, draw long, skinny fingers to be consistent with the rest of the body.

Figure 7-20:
Draw your
character's
fingers to be
consistent
with her
body type.

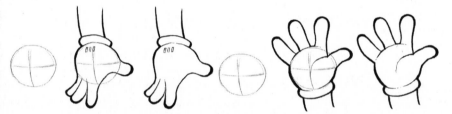

A Leg to Stand on: Drawing Legs and Feet

Legs carry your character, literally and figuratively. Their positioning conveys movement and attitude and helps support the character's unique shape. Many of the characters in this book have a large torso and upper body and smaller legs. However, you can create your character with any legs you want. Figure 7-21 shows a couple of characters with fat and skinny legs; legs should be appropriate to a character's body type and help exaggerate his characteristics.

In this section I give you the lowdown on how to create your character's legs and feet and provide the proper spacing for legs and hips.

Figure 7-21:
A charac-
ter's legs
should
support
his overall
character
develop-
ment.

Starting on the right foot

To draw legs, start by deciding if your character is going to have small legs
or bulky ones. Remember, classic cartoon characters tend to have simplistic
body types and body parts. The legs are often very simple in structure, so
the key is not to overdo it. To draw this type of legs and feet, refer to Figure
7-22 and follow these steps:

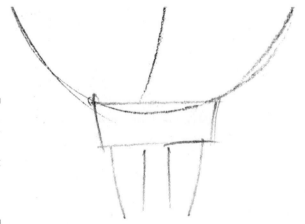

Figure 7-22:
Start your
legs with
two straight
lines and
then fill in
the details.

1. **From the bottom of the torso, draw two lines straight down for the
 left leg.**

The space between the lines determines how thick the leg is.

2. **From the bottom of the torso, draw two more lines straight down for the right leg.**

 Just like with the first leg, the space between the lines determines how thick the leg is.

3. **At the bottom of each leg draw an oval or circle.**

 The size of the ovals determines how big the feet or shoes are.

4. **After you have the general shape in place, add details like shoelaces, or the cuff on the bottom of the pants.**

Spacing the legs and hips

How you space your character's legs and hips depends on the character's body type and stance. Most of the characters I discuss have small legs in relation to their body and generally don't have any discernible hips. Of course, when designing and drawing your character, hips may be important, especially if you're drawing a sexy-type character.

To draw your character's hips:

1. **On each side of the character's lower torso, just below the waist, draw curved lines that look like parentheses: ().**

2. **After you have both sides drawn in, you should have a nice lower torso shape (see Figure 7-23).** If you desire more curves, simply draw the hips in a more curved or cupped fashion. If you're drawing a complete character, fill in details like a pocket and the character's knee caps.

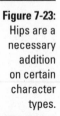

Figure 7-23: Hips are a necessary addition on certain character types.

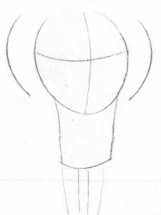

Choosing shoes

Most of the time, your character's actual feet aren't visible, unless they're important for making a certain statement. But if your character's feet are visible, make the shoes part of the story line. A young character probably wears sneakers, and a cowboy probably wears boots, but feel free to break the rules and come up with incongruous combos like the girl next store in Army boots, or a jock in bedroom slippers.

Shoes today are just plain fun to draw because they come in so many colors and have all sorts of pockets, laces, and assorted gadgetry attached to them. Consider observing what modern-day sneakers look like to give you some ideas.

Even so, you don't have to be specific when choosing what types of shoes to draw. I usually prefer to draw my own form of stylized generic shoes, as in the following figure.

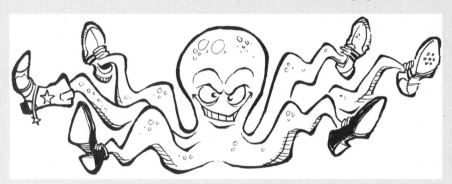

Deciding on Dress

Clothes and costumes identify people in the real world, and it's no different in the cartooning universe. Your characters will probably wear clothes, unless you're drawing an adult-oriented cartoon (a bit beyond the scope of this book).

Your character's clothes need to fit her persona, and almost anything goes in the world of cartooning. However, you should follow a fundamental guideline so that your characters have a universal appeal and readers understand what you're trying to communicate — and that's to keep it simple!

Even if you're drawing animals, nothing's cuter than putting your crocodile or bear in a tutu. Clothes define your characters (see Figure 7-24). For example, blue jeans and cowboy boots convey a different type of character from silk scarves and ascots. This section helps you select the right clothes and accessories for your characters' personalities.

Drawing your character's garb

Clothes are all pretty universal to draw on both men and women characters. Both genders wear pants, shoes, and coats. Generally, only women wear skirts, unless you're drawing a kilt, or a dress on that uncle on your mother's side that no one talks about. I briefly discuss drawing pants earlier in the chapter when I talk about drawing legs and adding details like pockets. When drawing shirts, it's important to capture the details like the collar.

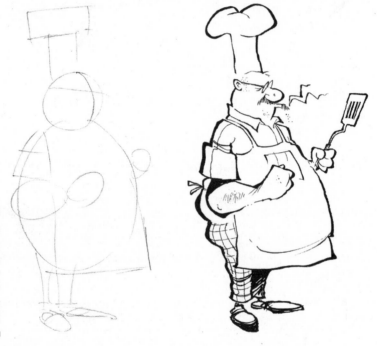

Figure 7-24:
Determining what this character does for a living is easy!

When designing your character's outfit, make sure it's not too complicated, unless the character is something specific — like a pirate, for example. If he's just the average guy next door, his clothes should reflect that and be simple.

To draw a collar on a shirt, follow these steps:

1. **Draw a line across the neck area, as shown in Figure 7-25.**

2. **Continue your line down to a point and then back up again so that it's parallel with the top line.** The point on the collar is located where the bottom meets the front. This should resemble the point you see on your own shirt collar.

3. **Fill in the small, moon-shaped area in black so that it looks as though the collar goes around the back of the neck.**

Figure 7-25:
Finish your
character
with details
like a shirt
collar.

4. **Draw the collar sticking out on the other side of the neck to add
 balance.**

Dressing for the occasion

Clothes make a statement, and they also tell your readers a lot about your
characters. The clothes can convey where the person comes from, what she
does for a living, and how old she is. When selecting clothes for your charac-
ters, be consistent and dress the characters correctly for the situation. For
example, you don't want to dress your characters loudly or over the top if
they're supposed to be a nice, average, middle-class family from the Midwest.

You also want to decide how much emphasis to place on your characters'
clothing. The following two sections look at both sides.

Wearing the same thing all the time

Some characters never change their clothes — literally! They wear the same
outfit every single day. Cartoonists often do this for practical reasons — it
helps identify the character to the reader. Examples of characters wearing the
same thing every day include the casts of *The Simpsons* and *Calvin and Hobbes.*
Peanuts has been running consistently in newspapers for almost 60 years, and
Charlie Brown has never changed his shirt. He must have a closet full of them!

Dressing your characters in the right outfit when you initially design them is
critical, because that outfit may be the one they wear forever! Branding is impor-
tant; if and when your characters become popular, your readers will expect to
see them the same way, every day, for the rest of their lives (and yours!).

The outfit you choose to draw your characters in depends on who your char-
acters are. If they're pirates, they probably won't be wearing bowling shirts.

However, clothing doesn't have to be too specific. You may choose to dress your characters simply so they're easier to draw. Use your imagination and creativity and see what works best for you.

Changing outfits

Although dressing your characters the same way every day is easier, varying the outfits is more fun — just like it's more fun to vary your own! Your characters won't complain if you never change their clothes, but you may get bored drawing the same outfits every day. Giving your characters a closet full of clothes to choose from can be entertaining, and it's also more realistic. Can you imagine wearing the same outfit every day for the rest of your life?

Your characters may wear the same general type of clothes but change them with the seasons, the time of day, or even every day, if you like variety. This is a matter of personal preference for you, because you're in charge of your characters' wardrobe.

Adding accessories

You can draw different accessories for your characters to demonstrate different characteristics and to add authenticity. For example, if your character works at an office, he probably has to wear a tie.

We explain how to draw a collar on a shirt in the earlier section, "Drawing your character's garb." Now we tell you how to add a tie (see Figure 7-26).

1. **Draw a diamond between the two collar points.**

2. **From the bottom of the diamond, draw a straight line down to the middle of the belly.**

3. **From the bottom of the diamond, draw another line down that flares out like an upside-down cone.**

4. **Draw a line in a V shape at the bottom to connect the two lines.**

5. **Add a crazy tie pattern and you're done!**

Figure 7-26: Identifying an office worker is easy — he's wearing a tie!

Chapter 8

Designing Human Cartoon Characters

The ability to create interesting human characters is one of the most enjoyable — and challenging — parts of being a cartoonist. Although the possibilities for character development are endless, common cartoon people tend to fall into certain stereotypical categories. For example, the all-American mom, the forgetful dad, the miserable boss, the smarter-than-all-the-adults little kid, and the babies who talk to each other when no adults are around are all staples of the cartoon world.

In this chapter, I look at some of the most frequently seen male, female, and child inhabitants of the cartoon world and explain how to draw them. Look at how I create my cartoon characters and then use your imagination and creativity to draft your own characters.

Understanding Why Developing a Regular Cast of Characters Is Key

Before you can create your cast of characters, you need to know what they mean to the viability of your cartoon strip. Typically, the characters in your cartoons take the form of people. Although the same people may not appear in every strip, many characters appear frequently over the life of a long-running

cartoon. The characters need to be consistent so your readers can identify with them on a regular basis. If they're not believable, your readers won't be able to relate to them and, in the end, won't read your strip.

This section discusses how to get your readers' attention and hold it by creating a core group of likable main characters and an interesting supporting cast. *Remember:* After you develop a cast of characters, they may be with you for life, so be sure to start out with a group that you can grow with.

Pinpointing the main characters

Most strips have a few central characters that are almost always part of the action. These main characters may include a family, a couple, a group of work buddies, a talking horse, or the dust bunnies that live under the couch. Your main characters are the ones who are on stage the most and are the central focus of the strip. (Check out the "Creating Your Core Group" section later in this chapter for more specific hands-on direction about developing your cast.)

The possibilities for your main character group are limitless; they can live on Mars, at the bottom of the ocean, or in 10,000 BC. Or they can be the people next door — average, everyday situations are full of humorous potential.

Including supporting cast

Most of the time, your core group consists of relatively normal characters so that your readers can easily identify with them. Every cast, however, also includes supporting characters. The *supporting cast* includes the characters who usually aren't the main focus of the story line. A good example is the next door neighbor who pops in occasionally. Supporting characters offer lots of fun chances to create odd or unusual characters, the kind you may not see every day but who really spice up the action when they do appear.

Not all the supporting cast will be strange and exotic, however; the group may also include grandparents, neighbors, and other normal people who drop in from time to time to broaden your story line. When creating your core characters, base their supporting cast on characters who interact well with the main characters and help support key elements in the story line.

Creating Your Core Group

You may already have a good idea of who your core group of main characters is going to be. However, if you're not really sure where to start with your core group of characters, create a group based on what you know best. This isn't a

hard and fast rule; you can create anything you want. But creating something based on what you're familiar with may prove to be a crucial advantage over the long haul when you're trying to write the strip, because you can tap your own experiences for ideas. For example, if you're a father or mother, you may draw inspiration from your own kids or even your crazy family dog.

Or you may draw inspiration from your occupation. For instance, Scott Adams, the creator of *Dilbert,* worked for many years in the cubicles of corporate America before he started his comic strip. He knew the corporate jargon and corporate players well, and out of that came *Dilbert,* which continues in over 2,000 publications today.

In addition to writing what you know, consider these helpful hints when creating your core group of characters:

- ✔ **Find a personality quirk or trait that's amusing.** If you don't think they're funny, no one else will, either.

- ✔ **Focus on characters you enjoy drawing.** You may be drawing them for the rest of your life, so create characters and a setting you won't tire of too soon.

- ✔ **Base your characters on people you know.** Giving your characters realistic reactions and behaviors if you know people like them is easier. Study your friends and family to see how they act in different situations and give similar behavior to your characters, or you can make yourself the star of your cartoon world!

The following sections offer specific suggestions to help you get started on coming up with your core cast.

Centering on the family

Many cartoon strips focus on the family, because a family allows for a multitude of opportunities for development. Cartoon family members are born, go to school, play sports, have pets, get sick, go to work, take vacations, interact with one another, and generally live life just like their real-life counterparts. So when developing your core group of characters, start with a family. The best way to do this is to think about your own family and the funny situations they've found themselves in, and see what story line possibilities you can derive from those situations.

Your family doesn't have to be a traditional mom, dad, kids, and pets, although many are. Creating an atypical family can open more opportunities for different story lines. For example, a single parent may open the door for humorous dating encounters while still supplying material for parent-kid interactions. Not every cartoon family has pets, but many do, because pets do some very funny (in retrospect, at least!) things.

Keeping your characters consistent

Some cartoonists age their characters over the years, but most of the time, characters don't age. *The Simpsons* has been on TV for more than 20 years, and Bart Simpson is still a 10-year-old kid. Charlie Brown should be retiring to Scottsdale by now but doesn't look a day over 9, and SpongeBob hasn't aged a day!

No matter what core group of characters you decide on, you want to ensure that you draw the characters consistently. Doing so is important for two reasons:

- ✔ **Practicality:** Having your characters stay the same age makes your job of drawing them easier. Characters that stay the same age wear the same type of clothing over the years, keep the same hair style, and stay at the same weight. As the years go by and you get more and more familiar with their shape and design, you'll be able to draw them in your sleep.

- ✔ **Marketing:** When developing and drawing your core characters, you also want to keep them consistent for marketing reasons. If you're constantly changing the look of your characters, readers may have a hard time recognizing them. Furthermore, if the style and look of a cartoon character is always changing, promotional material like T-shirts or your Web site design also needs to frequently change. Doing so can be expensive, especially in the modern world of self-publishing. The best plan is to finalize the look and style of your characters before you get serious about marketing.

 Even when characters change, they do so only slightly to keep their brand consistent. For instance, many characters go through what's known as a *face-lift,* in which characters created long ago are modernized by the current round of artists behind them.

One reason fans fall in love with these characters is because they develop a long-term relationship with them that's based on their personality traits. This relationship would be harder to form if the character changed all the time. Readers want to know that the characters will always be there for them, acting in a predictable way and providing a sense of security, much like the blanket gives Linus in *Peanuts*. And over time you find that you, too, become attached to them the way they are, like a favorite old family photo that reminds you of your carefree childhood.

Your characters may very well outlive you; Mickey Mouse looks as young as the day he was created, and Walt Disney has been pushing up daisies for decades. The most important thing is to create characters you enjoy.

Making your characters young again

One interesting and unusual example of a cartoon that aged its characters — and then reversed the aging process to recapture what was perhaps its golden era — is the comic strip *For Better or For Worse,* written by Lynn Johnston. Her core family started as a young married couple with small children and aged to the point where the kids were married with kids of their own. In 2008, Johnston made an unusual decision — she rereleased her original strips but updated the issues to make the strips more relevant to today. Rarely do cartoon characters have the opportunity to relive their youth in this way!

Experimenting with Male Body Types

Most cartoons have a leading male character that readers can relate to. Your core characters can be as eclectic as you want them to be, but most cartoons are home to certain easily recognized stereotypes. Remember that when I talk about stereotypes, I'm talking about personalities and traits that are universal and familial to the specific character and not about negative images or ideas.

For example, the father character always yelling at the teenager to mow the lawn can be true and funny. This stereotype is pretty universally accepted, even though in real life not all fathers yell at their kids. A negative stereotype is anything that focuses on things like race, ethnicity, gender, and so on. You want to avoid negative stereotypes because they're historically counterproductive and play to the lowest common denominator of humor.

You draw the body of all these characters in the same way. First you draw the basic body and the head, add the arms and hands, create the legs and feet, and finally add the accessories that make the character who he is. If you've never drawn characters before, check out Chapters 6 and 7 first; they show you how to sketch the basic face and body. In this section I take a closer look at some of the male characters that are standards of cartooning and describe how to create the details that make them easily recognizable.

Dear old dad

Dear old dad is the cornerstone of any character cast with the family at the core. His body type can be one of many, but the classic body type is best described as "the middle-aged guy look." This guy is perhaps slightly balding on top and a little wide through the middle. All you have to do is look at Homer Simpson, Fred Flintstone, Peter Griffin from *Family Guy,* or perhaps your own dear old dad to see what I mean.

The following are a few traits or patterns that dear old dad possesses:

- ✓ **A slightly bewildered or zoned-out look:** It's normal for dad to be a little overwhelmed by his family!

- ✓ **Comfortable, somewhat out-of-date, or classic clothes:** Dad's not a fancy dresser.

- ✓ **Unstyled hair:** If he has any hair at all!

- ✓ **The start of middle-aged spread:** Dad's usually middle-aged, so his waist is the widest thing on his body.

When drawing dear old dad, keep the preceding traits in mind and follow these steps:

1. **Sketch the main part of dad's body as a large circle, sketch a smaller circle above it for the head, and then draw the center guidelines in both circles (see Figure 8-1).**

 Drawing the center guidelines helps you place the center point for dad's facial features and his clothing. Dad faces left with a three-fourths stance, so you see the right side of his face and only parts of the left side.

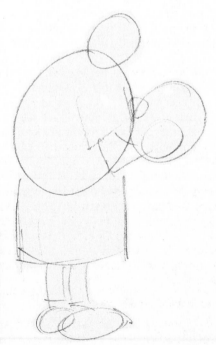

Figure 8-1:
Draw dad by
starting with
two circles
and center
guidelines.

2. **Sketch in dad's arms and legs by placing the arms on the side of, and the legs under, the large circle you drew for the body.**

 In this pose, dad is facing three-fourths to the left, so draw only his right arm and right leg with only part of the left leg showing. Dad's a middle-aged guy and slightly stocky or paunchy, so his arms and legs are a little on the thick side but not muscular (see Figure 8-2).

3. **Begin to draw dad's facial features (see Figure 8-2).**

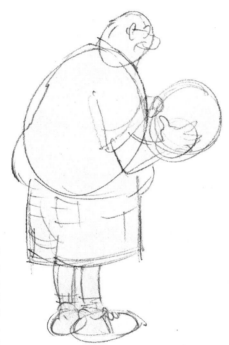

Figure 8-2:
Dad's casual look is part of his persona.

Draw the right side of the glasses with only the left lenses showing just over the bridge of the nose. Dad's nose is a good-sized one but not too big. Dad's mouth is small and located right under the nose. He mumbles a lot under his breath, so his mouth is usually closed. His hairstyle is nondescript because he doesn't have time to go to the hair stylist! He keeps it cut close to his head, almost military-style, reminiscent of the days when he was a cook in the army.

4. **Dress him in that great out-of-date outfit (see Figure 8-3).**

 This particular dad dresses pretty casually, and a bowling shirt with a loud pattern is his choice of formalwear. Start by sketching in his collar and the pocket on his shirt, and then begin drawing the circles

that represent the pattern on his shirt. A random series of small and medium little circles seems to work best and creates a natural-looking texture pattern to his shirt.

Dad likes to wear shorts and tennis shoes while puttering around the house. Look at your own tennis shoes so you can see the details and logo pattern when you draw a character who wears similar footwear. These little details add an extra bit of fun to your characters and make them seem all the more real.

5. **Add a few extra details to complete dad's loafing-around-the-house look.**

 You can add details like a newspaper (because dad still doesn't know how to use a computer!). Draw a few boxes to indicate photos and some lines in columns to indicate text, and the newspaper is ready for dad to read.

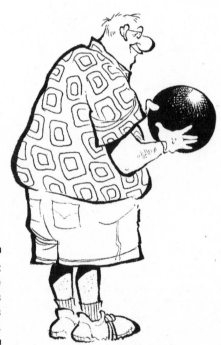

Figure 8-3:
Adding the details gives Dad his final look.

TV news anchor or used car salesman

The TV news anchor or used car salesman is a staple personality in the cartoon world. He's often big, loud, and annoying; nearly everyone can recognize this character. You can also make lots of variations within the stereotype; he's often cast as the obnoxious next-door neighbor.

The TV anchor/salesman is a top-heavy character with a large upper body. He starts out with many of the same body-shape characteristics as the "tough guy" character that I describe in detail in Chapter 7.

The following are a few traits or patterns that the salesman possesses:

✔ **A big, phony smile:** Feel free to add a gold tooth.

✔ **Broad shoulders and a slightly overpowering look.**

✔ **Good looks, but in a slightly sleazy way.**

✔ **Clothes that reflect his loud, obnoxious personality, such as plaid pants and patterned sports jackets.**

When drawing the TV news anchor or used car salesman, keep the preceding traits in mind and follow these steps:

1. **Sketch the main part of his body as a large circle, sketch a smaller circle above it for the head, and draw the center guidelines in both circles (as shown in Figure 8-4).**

 Drawing the center guidelines helps you place the center point for the character's facial features and his clothing. The salesman faces straight on, so he faces you.

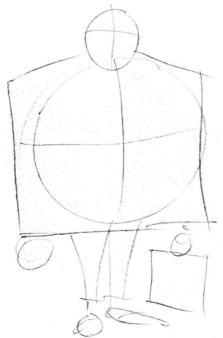

Figure 8-4:
The basic shape of this character begins to emerge.

2. **Square up the large body circle to form a box shape.**

 This guy has really wide shoulders, and his jacket is slightly boxy-looking. The box shape becomes his large upper body and jacket.

3. **Sketch the salesman's arms on each side of the squared area you just drew for the jacket, and then draw the legs coming straight down from the bottom of the large square you drew for the jacket.**

 In this pose, the salesman is facing you straight on. His arms and legs are thin compared to the large, square body area, which adds a sense of bulkiness and gives the impression that he's got a pretty wide chest under that ugly jacket (see Figure 8-5).

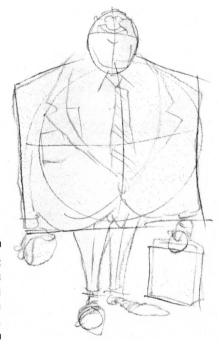

Figure 8-5:
This guy is beginning to come into focus.

4. **Begin to draw the salesman's facial features, and give him that great salesman's smile that he's famous for (see Figure 8-6).**

 The salesman's glasses are small, and you get a glimpse of his squinty stare through the lenses. His nose is wide and straight but not too big. He's got a wide smile, and you can see a few of his teeth through his smirky expression. His hairstyle is slicked back and always neat.

This particular guy dresses in typical used-car-salesman fashion. Sketch in his collar and tie with the pattern of your choice, and if it clashes with the jacket, all the better! Then draw lapels on the jacket and buttons on the jacket and sleeves. After all the details on the jacket are complete, sketch on the plaid or checkered pattern on his coat.

He likes to wear loafers, and his pants are slight high-waters, the kind that James Bond used to wear in all those stylish spy movies from the 1960s.

5. Give him a few extra details to top off his look.

You can add details like a briefcase, because salesmen of all kinds usually carry them, but you don't have to stop there. After you add some distinguishing details, your salesman will be ready for a day on the car lot.

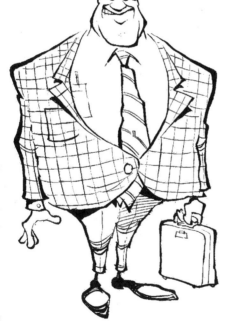

Figure 8-6:
The TV anchor/ used car salesman has wide shoulders and a loud jacket.

The geek/nerdy guy

Everyone knows the geek/nerdy guy — he's probably one of the most fun characters to draw because he's so easy to caricature. Unlike some family staples, this guy is thin and lanky and uncomfortable with other human beings, but he's probably worth a billion dollars in tech stock.

The following are a few traits or patterns that the geek possesses:

✔ **A thin, slightly underfed look.**

✔ **A pale complexion:** He hasn't been out in the sun for years.

✔ **Thick glasses:** He has spent many years reading and squinting at the computer screen.

When drawing the geek or nerdy type, keep the preceding traits in mind and follow these steps:

1. **Sketch the main part of the geek's body as a long oval, sketch a smaller circle above it for the head, and then draw the center guidelines in both, as shown in Figure 8-7.**

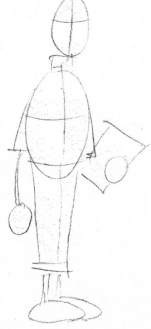

Figure 8-7: Geeks are known for their lack of muscle power and fashion sense.

Unlike the previous characters in this chapter, the geek's torso is a long, narrow oval shape because he's so painfully thin. The geek is looking straight ahead, but his body is facing three-fourths to the left. He's really skinny and lanky, and he's got weak shoulders.

2. **Square off the top of the oval that will become his shoulder, and then draw a line that will be his belt line.**

You can see that he wears his pants too high and that his belt line is just below his chest. Draw the "V" neck line of the vest below his collar. Draw vertical lines at each shoulder so that the vest is outlined, and then draw a horizontal line just above each elbow to indicate how long his shirt sleeves are.

3. **Draw his skinny legs coming straight down.**

 In this pose, the geek is three-fourths to the left, but you can still see both of his legs, although the left one is slightly hidden behind the right one (see Figure 8-8).

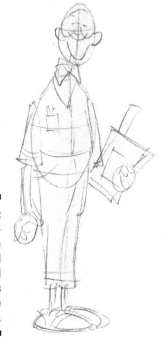

Figure 8-8:
A poor hair-cut, large glasses, and mismatched clothes help define the geek.

4. **Draw his facial features, as shown in Figure 8-9.**

 The geek is facing you so you see all his facial features. His glasses are large and round, and you can see his beady eyes through the lenses. His nose is small and the large glasses make it appear even smaller. His wide smile sits high on his face, and the corners of his mouth touch the sides of his glasses. His hair is cut short on top and buzzed on the side — probably cut by his dad at the kitchen table!

5. **Add his clothing, as shown in Figure 8-9.**

This geek dresses in mismatched shirt and pants. Start by sketching his '70s-style oversized collar and loud shirt pattern. Add the pocket on his vest with the pens sticking out of the top, and add a plaid pattern to his high water pants.

6. **Add a few geeky details to complete his look.**

You can finish by adding details like a small pocket calculator and papers he uses to do his math homework. You can also add a digital calculator watch, because a geek can never have too many calculators!

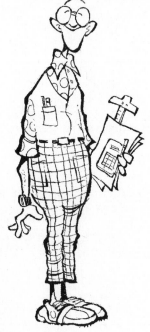

Figure 8-9: The geek is a thin, lanky body type with easy-to-caricature accessories.

Trying Different Female Body Types

Most cartoons also have at least one leading female character that readers can relate to. Women are no less varied in body types than men are and can be equally fun to draw. Just like the male body types, the female body types begin with the same basic frame using the same basic circle shapes. If you've never drawn characters before, check out Chapters 6 and 7 first; they show you how to sketch the basic face and body.

This section shows you how to draw some of my favorite females who frequent many comic strips, including the modern mom and the matronly grandmother.

The modern mom

Many family cartoons have the modern mom at the center of the action. Today's modern mom is really the boss of the family. You only have to glance at every classic cartoon mom to know who wears the pants in the family! The key to capturing the modern mom in your cartoons is to capture her unique body type.

The following are a few traits or patterns that the all-American mom possesses:

- **Appealing but not sexy:** She has definite mom hips.

- **Perky and happy-looking:** Unless she's yelling at someone!

- **Stylish but modest outfits:** She knows how to dress good on a budget.

When drawing the modern mom type, keep the preceding traits in mind and follow these steps:

1. **Sketch the main part of mom's body as a small oval, sketch a smaller circle above it for the head, and then draw the center guidelines in both, as shown in Figure 8-10.**

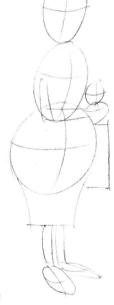

Figure 8-10:
The shapes you use to define mom's body include a hip area.

The key to drawing mom is to draw a body circle right below the small torso oval. This is used for her hip area. The modern mom has a small torso but large hips to help define her body shape; the hips come from producing all those crazy kids running around her cartoon strip!

2. **Sketch the mom's arms and legs.**

 Begin by sketching her arms, which are thin and are part of her narrow shoulders. Next, draw her hips, which are the widest part of her body. Then draw her legs, which are wider at the top and then taper down as they reach her ankles.

 In this pose, her body is facing slightly to the left, which enables you to see both legs but a full view of only the right arm. Her left arm holds the standard mom-issue gear (see Figure 8-11).

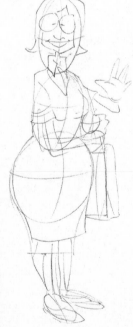

Figure 8-11: The modern mom has an appealing, but not overly sexy, appearance.

3. **Draw the mom's facial features and other details that give her that wonderful, modern, motherly look (see Figure 8-12).**

 She's facing you, so you see all her facial features. She has big, bright eyes that give her a sweet, friendly appearance. She has a small button nose that's straight and even in the middle of her face. She has a big, wide smile that runs to the center of each eye. Her hairstyle is a medium-style bob cut that goes down near her shoulders.

Mom dresses in a sensible, easy-to-wear style. She likes to wear nice slip-on loafers without any heel. She usually wears her loafers with matching socks or no socks at all.

4. **Include a few necessary motherly details to complete her look.**

 Add details like her purse or cellphone. On your own you may want to try and create a few more things that a modern mom might be associated with. Using the basic steps from the previous figures, perhaps you can create a little baby. See the "Talking babies" section later in the chapter for more details on drawing a baby.

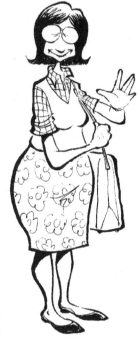

Figure 8-12: The busy modern mom is a staple cartoon figure.

The matronly grandmother

Grandma is unlikely to be the star of the strip, but she often shows up in family cartoons. You'll know grandma's here because she's no fly on the wall. Remember that grandma's other job title is mother-in-law, and they're always fun!

The following are a few traits or patterns that grandma possesses:

- ✔ **A squatty, round body that's fun to hug.**
- ✔ **A short, tight hairstyle that's usually tinted blue.**
- ✔ **Multilayered clothing like sweaters and long dresses.**

When drawing grandma, keep the preceding traits in mind and follow these steps:

1. **Sketch the main part of grandma's body as a large circle, sketch a smaller circle above it for the head, and then draw the center guidelines in both circles, like in Figure 8-13.**

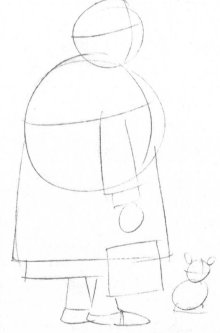

Figure 8-13: Grandma is soft, huggable, and rounded.

The center guidelines in both circles help you find the center point so you know where to center her face and big smile. Notice that the guidelines are closer to the right side of the circle. This is because grandma is almost in profile and is facing to the right. But the guidelines still go down the center of her face.

2. **Continue by sketching out grandma's arms and lower body.**

Begin by sketching her right arm. Because she's facing almost entirely to the left, you don't see her left arm. Then sketch the area around the body torso circle and make it squared at the bottom for her skirt. Squaring it off along the bottom establishes how long her skirt is and determines the area where her shoes are.

Next, draw her legs. In this pose both legs are pretty much hidden by her long dress, so you see only her mid calves.

3. **Draw grandma's facial features and the other details that give her that official grandma fashion sense (see Figure 8-14).**

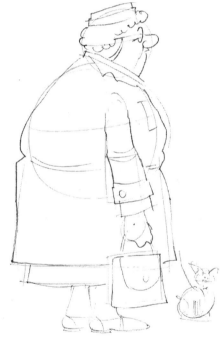

Figure 8-14: Cartoon grandma dresses traditionally and con-servatively — and she layers because she's always cold!

Grandma is facing all the way to the left, so you see the right side of her facial features. She has tiny eyes and round, wire-frame glasses. She has a large nose in the middle of her face, with a small mouth located right under her nose. Her hair is styled in a tight, short perm and is tinted a blue shade of gray.

Grandma dresses in multiple layers, including a long-sleeved shirt and sweater. She also wears a long dress. You can see a hint of her bosom — large and shapeless, for good, squishy hugs! — but it's covered up by all those clothes. She gave up wearing high heels in 1969 and prefers more comfortable shoes.

4. **Add a few details to complete her grandma look, as shown in Figure 8-15.**

 Using your own creativity and imagination, you may want to add a few details on your own. Perhaps grandma likes a big purse, and of course, don't forget her nervous little dog.

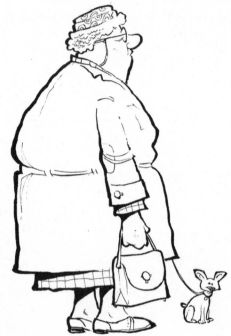

Figure 8-15: Grandma can be a kindly older woman or a real take-charge type.

The girl next door

Everyone loves the girl next door, and you can always tell who she is — she's pretty but not seductive, her makeup is understated, and she's kind to small children and animals, not to mention her parents. She's the all-American cheerleader type with a bubbly personality.

The following are a few traits or patterns that the girl next door possesses:

✔ **A cute, casual hairstyle.**

✔ **The looks of an active cheerleader type:** She's thin but looks athletic.

✔ **Very little makeup:** She doesn't need it!

When drawing the girl next door, keep the preceding traits in mind and follow these steps:

1. **Sketch the main part of the girl's body as a small circle for the torso, sketch a smaller circle above it for the head, draw another slightly larger circle for her midsection/hip area, and then draw the center guidelines in all the circles, as shown in Figure 8-16.**

Figure 8-16: The girl next door has a wholesome figure, with defined but not too sexy hips.

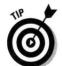

The key to drawing most young female bodies is a second body circle, used for the hip area, drawn right below the small torso circle. The girl next door has a small torso but slightly curvy hips to help define her body shape.

2. **Continue by sketching out the girl's arms and legs (see Figure 8-17).**

Her arms are thin and are part of her narrow shoulders. She's standing in a cheerleader-type pose that has her hands clasped and off to her left side. Next, draw her hips, which are the widest part of her body (but

they're shapelier and not as wide as other female body types). Then draw her legs, which are wider at the top and taper down as they reach her ankles.

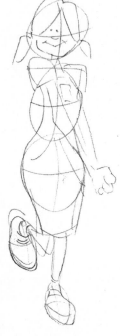

Figure 8-17: The girl next door is stylish and trendy, but in a tasteful way.

3. **Begin to draw the girl's facial features, including details that emphasize her wholesome, all-American look (see Figure 8-18).**

 She's facing you, so you see all her facial features. She has cute little eyes that give her a sweet, friendly appearance. She doesn't wear a lot of makeup, so her eyes look small but still give her that cute look. She has a small button nose that's straight and even in the middle of her face. She has a wide jaw and a big, wide smile that runs across her face. Her hair is pulled back into two ponytails.

 The girl next door wears age-appropriate clothes that are simple but trendy and stylish. She likes matching denim skirts and tastefully patterned shirts. Start by sketching her dress straps and long, pullover skirt. You can also see a hint of her bosom and the top of her cleavage is visible.

 She likes trendy, name brand sneakers with ankle socks that go well with her cheerleading outfit.

4. Finish by adding some details to complete her look.

Add details like her shoelaces and the pattern on her shirt. Don't forget the squiggly line in the middle of her skirt to indicate her leg movement and body language.

Figure 8-18: The girl next door is sweet, cute, and happy all the time!

Creating Those Crazy Kids

Kids are a cartoon staple; few cartoons don't have at least one rug rat running around creating havoc and confounding the adults. Your kid characters may be kids that act like kids, or they may be mini adults, talking infants, or even unborn babies! However you design your kid characters, you can be sure that anything can happen when kids are part of the cartoon action. This section gives you an idea of the types of kids you can include in your cartoons.

Talking babies

You often find babies in cartoons as main characters. Sometimes they grow up; other times they remain babies from the day they're born.

The following are a few traits or patterns that the baby possesses:

✔ **A very large head in proportion to body size.**

✔ **Very large eyes and a small nose:** He sometimes has no nose at all!

✔ **A body that's less defined than the head and face.**

When drawing the talking baby character, keep the preceding traits in mind and follow these steps:

1. **Sketch a large circle for the head and another medium circle below it for the body.**

 Babies' heads are disproportionate to their bodies, so the head circle should be approximately twice as large as the body circle.

2. **Draw the center guidelines in both circles, as shown in Figure 8-19.**

Figure 8-19: Start your baby with two circles; the head circle is about twice as large as the body circle.

The key to the baby is the large head. (In nature, babies of all species have big, fat heads and large eyes; that's why we find them so darn cute.)

3. **Sketch the baby's arms and legs.**

 Begin by sketching the arms, which are short and stubby and are part of the small round shoulders. The baby is sitting on his bottom, and you can see the bottom of his feet. Next, draw two small ovals in the bottom left and bottom right of the torso circle, directly over the torso area. These are for the baby's feet.

 In this pose, you don't see the legs fully because of the position of the feet. On the top of each small oval, draw five small circles on each foot for the toes.

4. Draw the baby's facial features, as shown in Figure 8-20.

The baby is facing you, so you see all his facial features. Babies have large, round eyes that are disproportionate to the rest of their head. This makes them appear cute. The baby has a small button nose centered between the eyes and located in the middle of the face, and it has big, chubby cheeks and a small, cute smile located under the nose.

Figure 8-20:
A baby's face is always his dominant feature.

The baby has a striped shirt and diapers on, so sketch out the horizontal stripes across the body.

5. Add some details to finalize the baby's overall look (see Figure 8-21).

This baby has confiscated mom's cell phone and has his bottle of milk handy; feel free to add toys or a cute teddy bear to your baby sketch.

Figure 8-21:
Cartoon babies have cute and cuddly accessories.

The little kid

Little kids are always fun characters to draw because they're so easy to caricature, and like babies, they're appealing and cute. Many of the longest-running comic strips have kids at their center.

The following are a few traits or patterns that the little kid possesses:

✔ **Large head:** Typically topped with hair that looks like a bird's nest.

✔ **Oversized sneakers, with all sorts of colors and fun designs on them.**

✔ **Always wears shorts:** Because he's always on the move.

When drawing the little kid character, keep the preceding traits in mind and follow these steps:

1. **Sketch a large circle for the head, which is the main part of the kid's body, sketch a smaller circle below it for the body, and then draw the center guidelines in both circles, as shown in Figure 8-22.**

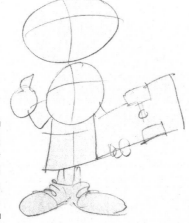

Figure 8-22:
Draw your kid's head larger than his body.

Kids' heads are disproportionate relative to their bodies, so the circle for the head should be bigger than the circle for the body. In this case the circle for the head appears almost twice as large. This doesn't have to be exact, so you can use your own judgment.

2. **Sketch the kid's arms and legs (refer to Figure 8-22).**

The arms are short and stubby and are part of the small, round shoulders. The kid is facing you, and you can see the entire body. Next, draw a small square below the smaller torso circle; this is the area you use for the kid's waist and pants. Beginning at the bottom of the small square, draw the little legs and shoes.

3. **Begin to draw the kid's facial features (see Figure 8-23).**

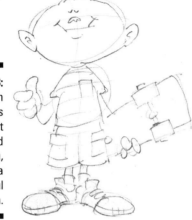

Figure 8-23: A cartoon kid is somewhat disheveled looking, with a cheerful grin.

The kid is facing you, so you see all his facial features. He has small eyes and a small button nose centered between the eyes and located in the middle of the face. He's got a big smile that runs across his face, and he has slightly chubby cheeks that are dotted with freckles.

4. **Dress the kid and add some details to finalize the kid's look (see Figure 8-24).**

The kid has a striped shirt and shorts on, so be sure to sketch out the horizontal stripes across the body and put pockets on the shorts. Then sketch out the details on the shoes. This kid likes to wear the latest name brand sneakers. Furthermore, his shoes tend to be bulky and have a lot of interesting things going on with them, like colors and stitch patterns. These details are unique to children's footwear. Sketch out a small oval shape and a few small circles for the skateboard, and he's ready to hit the streets.

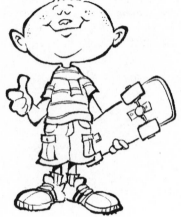

The bully

Bullies — they're generally nobody's favorite character, but sometimes they're necessary to create action for your other characters. They can also be fun to draw because you can make them menacing in a way that would never work for your main characters.

The following are a few traits or patterns that the bully possesses:

✔ **Large head and thick neck.**

✔ **Thick upper body, like a bulldog.**

✔ **A crew cut:** Because his dad likes military haircuts.

When drawing the bully character, keep the preceding traits in mind and follow these steps:

1. **Sketch a medium circle for the head, which is the main part of the bully's body, sketch a large circle below it for the body, and draw the center guidelines in both circles (see Figure 8-25).**

 Unlike other kid characters, the bully's head is large, but it's not out of proportion to his body. He has a thick neck and large upper body to give him a stocky appearance.

2. **Sketch the bully's arms and legs.**

 The arms are short and stocky but not muscular. The bully's shoulders are really part of his thick neck. Next, draw a small square below the smaller torso circle, which is the area you use for the waist and pants. The bully has short, stocky legs that are slightly bowlegged.

Figure 8-25:
The bully's body is larger in proportion to his head than the normal kid character.

3. **Draw the bully's facial features, as shown in Figure 8-26.**

 The bully has small, beady eyes and a menacing, squinty look on his face. He has a big nose that's located slightly higher on his face than other kid characters.

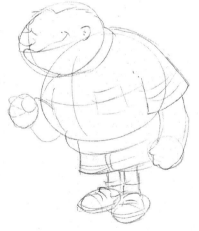

Figure 8-26:
Draw your bully with small, mean-looking eyes and a crew cut.

4. **Dress the bully and add some menacing details to finalize the bully's look (see Figure 8-27).**

 The bully has a striped shirt and shorts on, so don't forget to sketch out the horizontal stripes across his body and put pockets on the shorts. A few crosshatched lines on his shirt indicate that the shirt's

dirty and that he's been in more than one fight today. Then sketch out the details on the shoes. This bully likes to wear the latest name brand sneakers, but his parents don't buy them for him, so he takes them from the other kids.

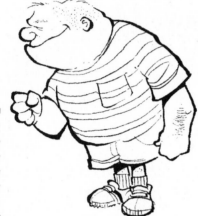

Figure 8-27:
A bully
looks dirty
and ready
for another
fight.

Chapter 9

Giving Inanimate Objects Personality

*W*hat better way to add depth and personality to your cartoons than to include inanimate objects as characters? Face it: A cartoon that contains nothing but people can be kind of dull. The world is so full of interesting objects — both man-made and natural — that leaving inanimate objects out of your cartoons would be a shame. In fact, inanimate cartoon objects are often the stars of the show, as in the movies *Cars* or *Beauty and the Beast,* where sports cars, teapots, and candlesticks are a big part of the action.

So if you want to give your cartoons an extra bit of life, try to find ways to include nonliving beings. This chapter shows you how to draw the objects that make up our world and instructs you in the art of animating those inanimate objects, should you decide that you want to make a toaster the hero of your cartoon universe. You may choose to make people into background characters rather than main characters, or, for a different twist, you may decide to eliminate people from your cartoons altogether! Even the most seemingly mundane inanimate object — like a dishwasher — can come to life if you give it the right details. This chapter explains how.

Cartooning Everything, Including the Kitchen Sink

In cartooning, as in life in general, the difference is in the details. Adding gadgets, contraptions, vehicles, appliances, and nature to your cartoons makes them more realistic and more entertaining to look at. Even if objects are just part of the background and not part of the action, drawing them realistically and a bit humorously puts life into your cartoons, as the next sections show.

Drawing the world around your characters

The environment that your cartoon character inhabits is part of the complete cartoon world you create. You want this environment to be recognizable to readers, accurate, and most of all, fun.

The *setting* that surrounds your cartoon characters is kind of like a movie set. If you pay attention to the backgrounds in movie scenes, you see everyday things like chairs, cars, trees, furniture, and so on. The backgrounds in a movie scene are probably no different than the everyday world that you live in. If you look around where you're sitting now, you'd see the same things. Depending on the setting, you may see a TV, fireplace, refrigerator, chair, or fish tank. Chapter 14 discusses more in-depth how to create the setting for your cartoon.

Adding small details to your cartoons adds interest to your art and gives the scenes a realistic and accurate setting. Depending on your subject, adding inanimate objects as characters also gives your cartoons a fresh voice and allows readers to look at the world from the viewpoint of something whose perspective is quite different than the norm — what would your refrigerator, for example, have to say about you?

Caricaturing just about anything

The art of caricature allows you to exaggerate whatever it is you're drawing. Although it's not required that you exaggerate your subject matter, I do highly recommend it, because exaggerating characteristics adds humor to your cartoons and gives them a whimsical look. The gentle stretching or distorting of even the most mundane household item can give it a bit more flair and charm.

When you're cartooning anything, think in terms of taking a regular picture and using Silly Putty on it. You may have done this as a kid. Take Silly Putty and press it down over a photograph in a newspaper or magazine. When you peel it off of the paper, the image appears on the bottom of the Silly Putty. You can stretch and distort the picture into all kinds of fun shapes. As you do this the image becomes exaggerated while still being recognizable. This principle is the key to the art of caricature.

Having Fun with Household Items

All cartoon characters need a place to live, so what better place to start your sketching than with their dwelling! You can find all sorts of great stuff to draw and caricature in a house. Depending on your cartoon, these items can be interesting background objects, or you can make them actual characters. For instance, just picture your cartoon with a toothbrush and toilet brush taking center stage! This section takes a look at how to draw a few common household items.

That comfy ol' sofa

If you're drawing a family cartoon, you'll probably be drawing your characters on the couch eventually. Some characters, like Dagwood in *Blondie,* seem to spend the better part of their day on one.

Many cartoon sofas incorporate the following characteristics:

- Their pattern is loud and plaid or crazy and clashing.
- They have springs coming out of the bottom of the cushions.
- They're overstuffed and comfortable looking.

When drawing a sofa, follow these steps:

1. **Sketch a long, three-dimensional rectangle box, as in Figure 9-1.**

 Drawing the basic box form helps you define the sofa and the space it takes up in the room or background. If you're drawing other objects in the room like a chair or an end table, this box will be large in relation to the other surrounding objects. (Chapter 12 can help you with putting everything into perspective.)

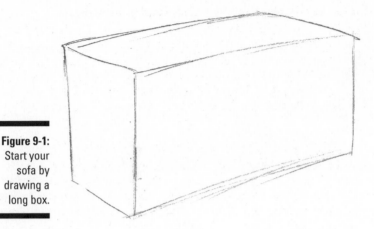

Figure 9-1:
Start your
sofa by
drawing a
long box.

2. **Sketch in the cushions and arms (see Figure 9-2) on both the left and right side of the box frame by drawing the sofa's arm that is closest to you (in my example, you draw the right arm first).**

 Start by sketching out a small shape about the size of a large loaf of bread in which the top and bottom lines are parallel to the top and bottom lines of the left side of the large box you draw as a guide.

 To draw the cushions, use the figure as a guide and draw two lines in the middle of the seating area to divide it up into three cushions. This sofa has three large bottom cushions, so the lines you draw dividing them up should be parallel to the lines for the arms so that they're all about the same length and going in the same direction.

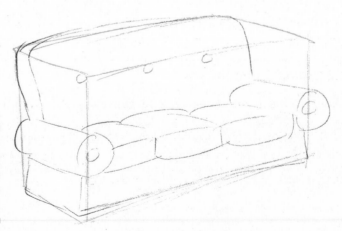

Figure 9-2:
Add
arms and
cushions to
your sofa.

3. Draw in the key details like the pattern on the entire sofa.

Adding items like patterns, buttons, skirts, or ruffles are ways to personalize your sofa. A more elegant room may have a striped sofa, while a country room may have a ruffled skirt and a flower pattern. In this drawing I add a plaid pattern, which is an easy way to decorate the sofa. Just make sure both your horizontal lines and vertical lines all follow the shape of the sofa. Don't forget the buttons on the cushions (see Figure 9-3).

4. Add extra details to express the type of room your sofa lives in.

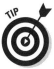

To give your couch your own personal look and feel, you can include a frilly lace along the bottom of the sofa, add a throw pillow or two, or add humorous touches like a spring or stuffing coming out of the cushions. And if this sofa belongs to a bunch of bachelors, don't forget the soda, pizza, and beer stains!

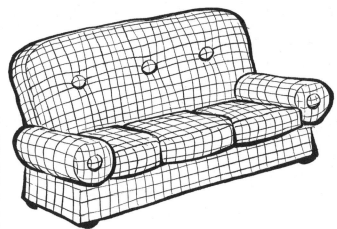

Figure 9-3:
Finish off
the sofa
with a wild
fabric
pattern.

The lounge chair

Every household has at least one chair, so look for opportunities to include a lounge chair in your cartoon. If dad's taking up the couch rather than leaning back in the easy chair, mom may be sitting there knitting, or it may be used as a jungle gym by three or four rug rats!

Incorporate these traits when drawing lounge chairs:

✔ Their pattern clashes with the other furniture.

✔ They recline back for maximum laziness.

✔ They're overstuffed and broken in.

When drawing a lounge chair, follow these steps:

1. **Sketch a square, three-dimensional box, as in Figure 9-4.**

 This basic form gives definition to the chair and the space surrounding it. For example, if you want a large lounge chair, you can draw the box in a slightly squatty shape that's wider than it is tall. If you want a smaller, more formal, upright chair, you may draw the box so that it's slightly taller and narrower. Use this box as a general guide to help you sketch out the details for the chair.

Figure 9-4:
Start your chair by drawing a square box.

2. **Sketch in the cushion and add the rounded arms on both the left and right side of the box frame.**

 To sketch the cushion, begin by drawing the chair's basic shape. Draw the back cushion so that it appears to be leaning back slightly. To add the arms, begin by drawing the arm that's closest to you. The chair in Figure 9-5 is positioned so that the right arm is closest to you. The arms are about the size of a large loaf of bread and should be parallel to the bottom of the chair. Stretching the shape so that the chair is slightly wider and a bit more squatty-looking than a real lounge chair gives it a cartoony appearance.

3. **Draw in the fabric pattern and other details, like in Figure 9-6.**

 Now's the time to add personal touches like a pillow, a patch on one of the cushions, some fancy chair legs, or perhaps a small cat taking a nap.

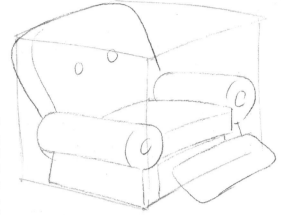

Figure 9-5:
Add
arms and
cushions to
your chair.

Figure 9-6:
Your chair is
now ready
for your
cartoon
character's
daily nap!

Animating appliances

You can make appliances amusing just to create a more interesting back-
ground, or you can give them a speaking part in your cartoon world (for
instructions on drawing talking appliances, see the "Making the toaster talk"
section later in the chapter).

Remember the following when cartooning household appliances:

✔ They have lots of buttons and switches.

✔ They're often retro-looking, because such appliances are easy to caricature.

✔ They should look like a specific appliance and not be generic-looking. If your goal is to draw a toaster, make sure it looks like a toaster and not just a box with a lever on it.

When drawing countertop household appliances, such as a blender and toaster, follow these steps:

1. **Sketch two square, three-dimensional boxes — one that's tall and another that's wide (see Figure 9-7).**

 The type of appliance you're drawing determines the overall shape. For example, if you draw a microwave, then the shape is more of a horizontal rectangle than the vertical rectangle you would draw for a blender.

 Drawing the basic box form helps you define the item and acts as a guide as you add details to the drawing, similar to drawing guidelines for the facial features when you draw a character. Your initial sketch acts as a general guide to help you place the other important elements and details necessary to whatever particular object it is you're drawing. The blender has the large cylinder top, and the basic guideline shape should reflect this.

Figure 9-7:
All appliances start off as a square box.

2. **Sketch in the details specific to the particular appliance.**

 Doing so includes drawing the top lid of the blender and the two openings on the top of the toaster. In Figure 9-8, you begin to see that the item on the right will be a toaster and that the item on the left will be a blender.

3. Draw in the key details like buttons and switches.

To sketch the buttons, switches, and other details, go into your kitchen and take a look at the appliances you're drawing. To draw switches and buttons, place them on the front of the blender with the adjustment knob on the right side and the control buttons on the left. Continue by drawing the pop-up lever on the front of the toaster centered in the middle of the panel and add knobs on the left and right below it.

Figure 9-8:
Specific
details help
identify
the kind of
appliance
you're
drawing.

4. Add any final details to finish off the look (check out Figure 9-9).

Adding a loaf of bread sitting next to a toaster is a nice touch. Using your own imagination and creativity, you can add other details to make this drawing your own.

Figure 9-9:
The
appliances
are ready
to use!

Calling All Cars

Drawing automobiles can seem complicated because of their large size and complex shapes and details. Drawing recognizable vehicles requires practice, but the results can add interest and fun to your cartoons. This section gets you started drawing a few types of cartoon cars.

The family car

Every family piles into the family cruiser eventually, and in some cartoons, the cars are the stars. A car can add dimension and reality to your cartoon, either as part of the background or as a character (see "The talking car" section later in the chapter).

Keep the following in mind when cartooning family cruisers:

✔ They often have squatty, exaggerated, funny-looking shapes.

✔ They're often some kind of SUV or station wagon.

✔ They're more accurately rendered if you study current car models to pick up on modern design details.

When drawing the family car, follow these steps:

1. **Sketch a large, rectangular, three-dimensional box and a smaller box on top to form the area for the roof and windows, as in Figure 9-10.**

 This basic form helps you define the car and acts as a guide as you add details to the drawing. This car is passing you going left, so you see most of the driver's side. Continue by sketching out the area for the front grill and headlights and then draw another horizontal line under the grill across the front for the top of the front bumper.

2. **Draw in the area for the wheels (see Figure 9-11).**

 Sketch the area for the wheels as ovals because of the angle they'll be viewed from. You can see the full view of the wheels on the driver's side but only the bottom of the wheels on the passenger side. Be sure and draw a slight, tall, thin oval shape to represent the inside of the wheel hubs on the driver's side.

3. **Sketch the car's main details, such as the headlights, bumper, antenna, and so on.**

 To draw the headlights, just fill in two small circles for the headlights in the rectangle shape you drew previously. To finish sketching the bumper, fill in the rectangle shape in the middle of the bumper for the license plate as well as the horizontal lines for the radiator grill.

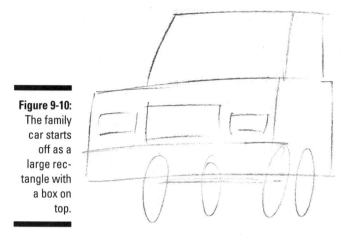

Figure 9-10:
The family
car starts
off as a
large rec-
tangle with
a box on
top.

4. Fill in the inside of the car by drawing the backs of the front seat as well as the small rectangle shape for the rear view mirror.

Draw two small square shapes on each side of the car for the rearview side mirrors. Keep them level with the top hood of the car and based at the bottom of the windshield.

Figure 9-11:
Add the
circles for
the wheels
and it
begins to
look like
a car.

5. Add the final details to finish off the look while adding motion to the moving car, as shown in Figure 9-12.

Cars have all sorts of small details, and it's important that you get them right so the car looks like a car. Adding door handles, mirrors, bumpers, and headlights sets the car apart. And don't forget to add the driver. To personalize your car, you can use your own imagination and creativity.

Perhaps some dice hanging from the rearview mirror? Also, when finalizing your car, you may want to darken or black out the interior so that the car itself stands out better. Adding a drop shadow below the car gives the impression that it's bouncing along down the cartoon highway.

Figure 9-12:
You're now ready to take a family trip across the country!

The sports car

Not every cartoon character drives a family road hog; some characters zip around in something sportier. If your main character is a middle-aged man going through a midlife crisis, or maybe a young, hip California woman, then a sports car is the perfect mode of transportation.

When drawing sports cars, keep the following characteristics in mind:

- ✔ Their shape is sleek and exaggerated, suggesting a fast car.
- ✔ They should be drawn with a slight forward slant, which gives them the appearance of speed.
- ✔ They're more accurately rendered if you study current car models to pick up on modern design details.

When drawing a sports car, follow these steps:

1. **Sketch a rectangular, three-dimensional box, and sketch another low-hung box on top to form the area for the windshield and driver (see Figure 9-13).**

This basic form helps you define the car and acts as a guide as you add details to the drawing. Make sure you place the top rectangle for the roof line. You want to also sketch in the area for the wheels. The driver's wheels are viewable here, but you see only the bottom half of the wheels on the passenger's side.

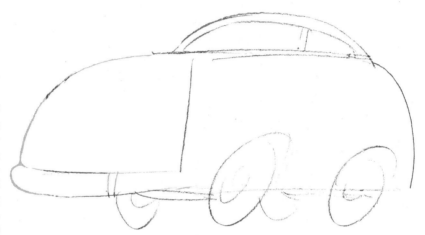

Figure 9-13:
A sports car begins with a rectangular box and a low-hung box on top.

2. **Draw in the details for the wheels, as shown in Figure 9-14.**

As you finish drawing the wheels, remember to draw smaller circles inside the larger ones you drew for the outside edges of the tires. The passenger side wheels will be darkened.

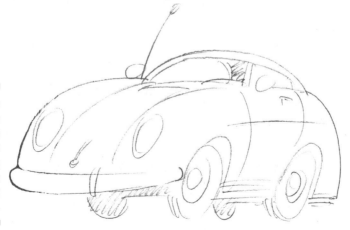

Figure 9-14:
Add the wheels to make the drawing begin to look like a sports car.

3. **Sketch in other details like the side mirrors, headlights, bumpers, and side trim.**

 Draw two small circles on each side of the car for the side mirrors. It's starting to look sporty! To draw headlights, begin by drawing two vertical oval shapes on the front of each front fender. Next draw two horizontal lines across the bottom front of the car for the front bumper. Fill in the small details like the door handle and side trim as well as the antenna, rear view mirror, and handle on the front hood. Drawing everything with a slight, forward slant gives the appearance that the sports car is really moving down the road.

4. **Include a few things that can add motion and movement to the sports car (see Figure 9-15).**

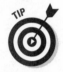

 To give the sports car your own personal look, add details like a funny license plate on the front or something hanging off the radio antenna. Adding a ground shadow below the car that doesn't touch the wheels gives the appearance that the car is moving quickly.

Figure 9-15: If you go too fast, you may get a ticket!

Truckin' down the road

Trucks are everywhere in real life, so they show up everywhere in the cartooning world, too.

Keep these hints in mind when cartooning all types of trucks:

✔ Their shapes are boxy and exaggerated for a humorous effect.

✔ They're more interesting to look at if they're older, retro-style trucks.

> ✔ They come in all shapes and sizes, so you should study them closely to capture what they actually look like.

When drawing a small truck, follow these steps:

1. **Sketch a large, rectangular, three-dimensional box and a smaller box on top to form the area for the roof and windows, as shown in Figure 9-16.**

2. **Fill in the basic sketch for the wheels with the driver's side wheels fully showing.** You can see the basic truck shape begin to take form. These shapes define the truck and act as a guide as you add details to the drawing.

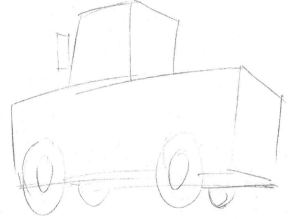

Figure 9-16:
All trucks
start off as
a series of
boxes.

3. **Draw in the inside details for the wheels (see Figure 9-17).**

 To draw the wheels, just continue by drawing the inside hub and the bottom rear tire tread. You can see the full wheels on the driver's side along with the inside details of the wheel hubs, but only the bottom of the wheels on the passenger side.

4. **Sketch in other details like the headlights, bumpers, and side trim.**

 To draw the taillights, draw two small vertical shapes at the rear on each side of the tailgate. Trucks have all sorts of great details like door handles, big side mirrors, big rear bumpers, and a gas cap.

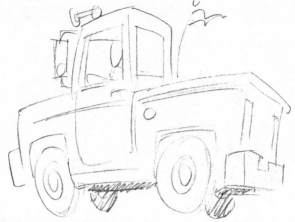

Figure 9-17:
Your truck
is almost
ready to
haul that
ugly sofa off
to the dump!

5. **Add any final details to finish off the look of this old truck, as shown in Figure 9-18.**

Don't hold back — you can really give your truck its unique look. Try adding an air horn on top or a flag attached to the radio antenna. Use your own imagination and creativity and see what you can come up with. Don't forget that adding a shadow below the truck shows that it's really bouncing down the road.

Figure 9-18:
Having the
wheels
appear off
the ground
adds the
illusion of
movement
to the
drawing.

Putting a Face on an Inanimate Object

The great thing about the world of cartooning is that you can give personality to anything. The key is to add human characteristics to objects, including the way the object moves and how you make the object express itself. You can humanize any object by giving it eyes, ears, and a big mouth. By humanizing inanimate objects, you can create offbeat and unique cartoon characters to give your comic a life of its own. The next sections look at a few examples of how to draw and humanize inanimate objects.

The talking car

In cartooning, you can take anything — such as a car — and make a talking character out of it. For example, Disney's very popular movie *Cars* took car models from all around the world and turned them into talking characters that acted and interacted just like people. The cars all had facial features and expressions created by incorporating the headlights and grill into a face.

Remember the following when cartooning talking cars:

- ✔ They have exaggerated movements that mirror human movements.
- ✔ Their facial expressions and features are incorporated into the existing car design.
- ✔ They have a friendly, cute look that gives them human appeal.

When drawing a talking car, follow these steps:

1. **Sketch a large, rectangular, three-dimensional box** (see Figure 9-19).

 This basic form helps define the talking car and acts as a guide as you add details and definition.

2. **Sketch in more details like the area for the roof and the driver's front wheel, as shown in Figure 9-20.**

 To draw the roof line, sketch a smaller square area on top so that it's centered between the two fenders. Next sketch the driver's wheel on the side of the driver's front fender by drawing a small circle on the character's right side. You can see the basic car shape begin to take form.

Figure 9-19:
A talking
car begins
with a large,
square box.

Figure 9-20:
With the
addition
of more
details, he
begins to
come to life.

The great thing about working in the world of cartoons is that you can create any kind of character you can imagine. The other great thing is that any kind of creature can walk, talk, and wear suits and Bermuda shorts! Here are a few examples of various cartoon creatures; see Chapter 9 for instructions on creating your own.

Cars and other gadgets are fun to draw because you get to create so many great details. These examples of various vehicles may inspire you when you want to create your own cars, trucks, and motorcycles. Check out Chapter 10 for more details.

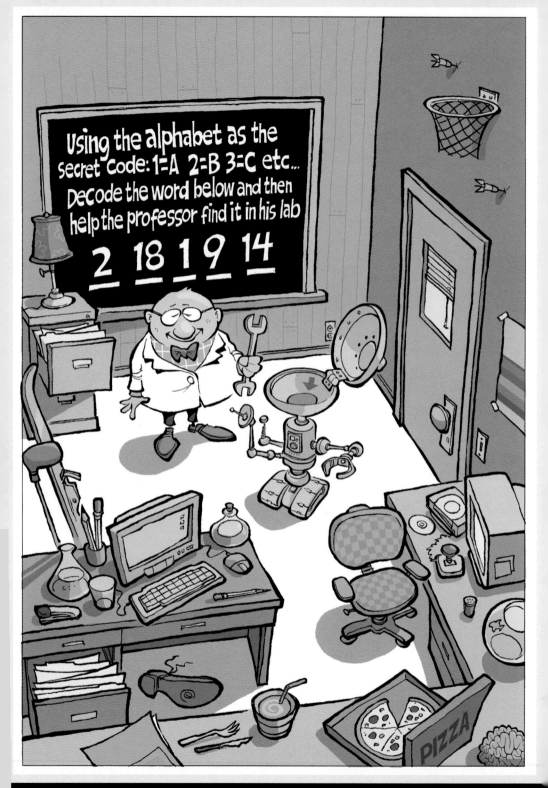

an example of a cartoon character and a full-page comic, complete with background and detailed surround
his for a kid's game magazine. Can you read the blackboard for the clue and find the answer somewhere in t
See Chapters 12 and 14 for more information about cartoon layout and drawing in perspective.

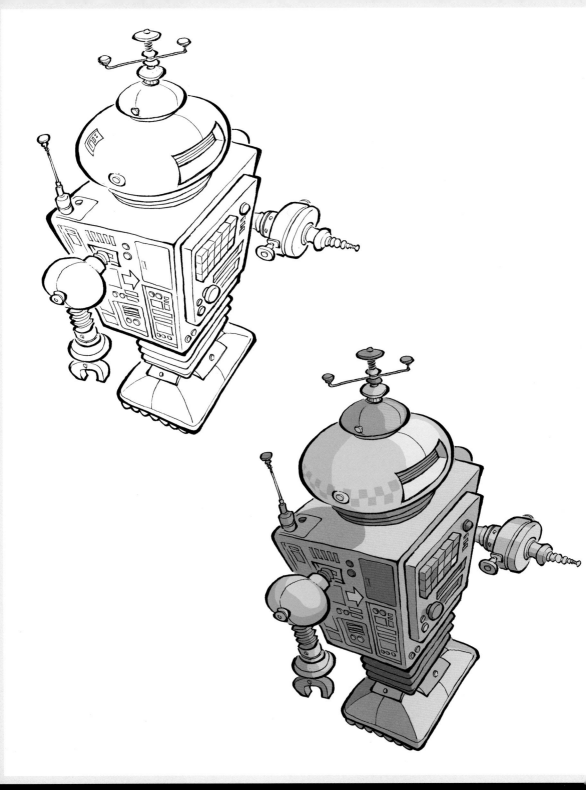

Using Photoshop to color your cartoons can make them come alive. In this example, the top panel is an inked cartoon image without color, and the bottom panel is what the image looks like after adding full color with Photoshop. Chapte

Photoshop has a number of tools to color and modify your cartoons. I used the gradient tool to add a color background to this example. Turn to Chapter 16 to read about more Photoshop tools and tricks.

3. Draw in the area for the wheels, as shown in Figure 9-21.

To do so, draw the three small half circles under the car. Don't worry about detail under the car; it will be blacked out. You can see that the driver's front wheel is in a more flexible position than a normal car wheel — more like an arm or leg you'd see on a human or animal character.

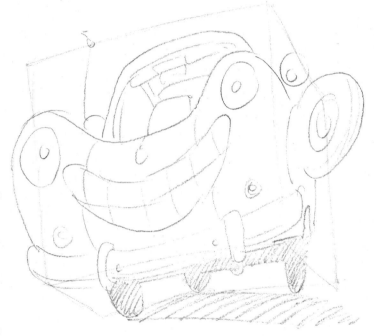

Figure 9-21:
The wheels are sub-stitutes for arms and legs for the talking car character.

4. Add the facial features that substitute for the headlights and radiator grill, as shown in Figure 9-22.

To do so, draw the front grill as a large smile and the headlights as eyes. This really gives this guy personality! You can see that the front of the car has big, wide, friendly facial features using the car's existing parts and design. Add side mirrors, the interior roof line, and seat outline that will be blacked out.

To make your talking auto your own creation, add details like a funny front license plate or a missing tooth in the car's smile.

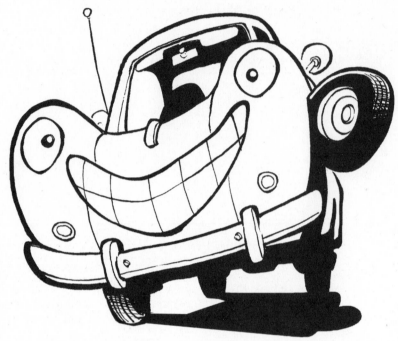

Making the toaster talk

Cars aren't the only inanimate object you can bring to talking life in the world of cartooning. You can give appliances a speaking part in your cartoon universe, too — like the toaster in this section.

Keep the following in mind when cartooning appliance characters:

- ✔ Their faces are made up of buttons and switches.
- ✔ They're more amusing if their shape is stretched or squished.
- ✔ They're more appealing if you give them human characteristics.

When drawing a talking toaster, follow these steps:

1. **Sketch a square, wide, three-dimensional box, as shown in Figure 9-23.**

 Drawing the box helps you define the item and acts as a guide as you add character details.

Figure 9-23:
Creating a
character
out of an
appliance
begins with
a square
box.

2. **Sketch in the facial details for the appliance character (see Figure 9-24).**

Draw in the front button details like the pop-up lever that will be his nose. Use the center pop-up lever as a guide and locate the eyes on each side of the lever. Draw a smile that's centered directly under the pop-up lever and curved up on the ends.

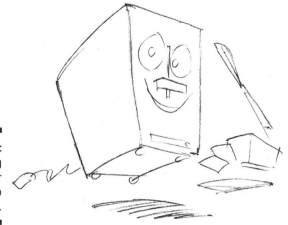

Figure 9-24:
The talking
toaster
begins to
come to life.

3. **Add any final details to finish off the talking toaster look, as in Figure 9-25.**

 Adding things like toast popping out the top and a dancing stick of butter next to the talking toaster makes for a delicious trio! Draw the accessories next to the toaster and have them moving outward to convey movement and action.

Figure 9-25:
Now you have someone to talk to every morning at breakfast!

You can choose to further personalize this guy by adding other items to the drawing like a talking loaf of bread or a blender buddy.

Smiling sunshine

One classic cartoon character that regularly pops up in children's cartoon shows, children's books, and animated movies is the big yellow sun with the smiling face. This is a prime example of a nonhuman object brought to life.

Incorporate the following when cartooning a big yellow sun:

- Big smiling face
- Round shape with lots of sun beams
- A wise personality

When drawing the big yellow sun, follow these steps:

1. **Sketch a nice, round circle, like in Figure 9-26.**

 By drawing the basic round circle, you define the area of the sun character. The circle acts as a guide when you add details. Draw the horizontal and vertical guidelines so that you can center the facial features.

2. **Sketch in the sunbeams (see Figure 9-27).**

 To do so, begin by drawing the U-shaped sunbeams around the sun so that they're evenly positioned around the sun but don't touch it. You can begin to see the circle look more like the sun.

Figure 9-26:
The warm, friendly sun begins with a nice, round circle.

3. **Draw in the key details for the big smiling face (see Figure 9-28).**

 Adding wide eyes and a toothy grin gives the sun a warm, appealing personality. He's wearing sunglasses because it's just so bright outside! Sketch in the glasses by centering them on each side of the center guidelines.

4. **Add a friend like a cute little star or cloud.**

 To draw additional celestial objects, start by drawing a star or two. Feel free to add as many clouds or stars as you want to keep the sun company. As you do, be sure and give them all happy faces to create a big, friendly universe!

Figure 9-27:
The
sunbeams
are making
this sun
come to life.

Figure 9-28:
The smiling
sun has
buddies to
keep him
company in
the sky.

Chapter 10

Exploring Anthropomorphism: Creating Animals and Other Creatures That Talk

In This Chapter

▶ Adding pets to your cartoon world

▶ Including other animals in your comic strips

▶ Putting out-of-this-world characters in your cartoons

Cartoons don't have to be realistic, so anyone and anything can be part of your cartoon world. Humans aren't the only characters you find in cartoons; animals are very popular cartoon characters. Although dogs and other household pets predominate in family cartoons, any type of animal can be a supporting character — or even the main character — in a comic strip. Some cartoon strips consist *only* of animals, with no human characters to be found.

You can also find unearthly creations — such as robots, spacemen, and droids — in some cartoon strips, and they can be as human in their behavior as the guy down the street. If you want to add talking animals, robots, and other nonhuman living beings to your cartoons, then you've come to the right place. In this chapter, I look at the wealth of characters found outside the human race, and I show you how to bring them to life.

Pets Are People, Too! Drawing Classic Cartoon Animals

Like their real-life counterparts, many cartoon families have at least one pet. The pet is often a dog, but it can just as easily be a cat, fish, or gerbil. You're limited only by your imagination when it comes to introducing animals into your cartoon families.

If you prefer, you can make animals the only characters in your cartoon, like the comic strip *Pogo* does. In such cartoons, your animals can conform to stereotypes — the mean rat, the kingly lion, the sneaky snake, and so forth — or you can cast them against type, like Disney did by making the rat the hero of the animated film *Ratatouille*. This section shows you how to create and draw some typical cartoon animals, including the details that help your characters come to life.

The family dog

The family dog character is a staple in the cartoon world, common to many popular comic strips throughout history. These cartoon canines usually come off as smarter than their human counterparts, often forgetting that they're dogs! Perhaps the most famous family dog is Snoopy, from the classic comic strip *Peanuts*. Snoopy is instantly recognizable and has been a favorite for many generations.

The following are a few traits of man's best friend, the family dog:

✔ Has a short cartoon body usually dressed only in a birthday suit

✔ Is smarter than his owner — but in a lovable way

✔ Displays human characteristics such as standing on two legs or eating with his hands

✔ Possesses the ability to speak — but his owner may not understand him!

When drawing the family dog, keep those traits in mind and follow these steps:

1. **Sketch the main part of the dog's body as a circle, draw a slightly smaller circle above it for the head, and then add center guidelines in both circles, as shown in Figure 10-1.**

 Drawing the center guidelines (for all your characters) helps you place the center point for your dog's facial features. The dog's body faces straight on, and his head is at about a three-quarter view.

2. **Sketch in the dog's arms and legs by placing the arms on the side and the legs under the large circle you draw for the body, as in Figure 10-1.**

 To do so, start the arms at the top of the shoulders. In this pose, the dog is facing straight on, so draw his arms and legs fully showing on the right and left side of his torso.

3. **Draw the dog's facial features, including a great canine smile and a black, diamond-shaped nose.**

To add these features, use the center guidelines so that the placement of the features is symmetrical. Place the eyes evenly on either side of the center guideline. Center the nose and mouth so they're balanced with each side of the face. This dog has a beaming smile and a slightly mischievous look (see Figure 10-2).

Figure 10-1: Start your cartoon dog by drawing two circles and a center guideline.

4. **Add finishing details that are specific to this canine creature.**

 Darken his ears and fill in the area for his nose so that they're both black. Add small little dots under the nose to give the impression that he has small whiskers.

5. **Personalize your drawing.**

 Get your dog ready for a day of loafing around the house. You can add extra details like his collar, bowl, newspaper, bone, and so on, as shown in Figure 10-3. Use your own imagination and creativity to see what you can come up with to make this character your own.

Figure 10-2:
Your dog's facial features give him character and personality.

Figure 10-3:
This family dog is a classic, lovable cartoon character.

That darn cat

Your cartoon family may have a cat in addition to or instead of a dog. Or perhaps the little old lady down the street has a couple of cats to keep her company. Because cats have more attitude than dogs, they can add spice and an edge to your cartoon world. Two examples are Garfield and Heathcliff.

Here are a few traits common to the family cat:

- ✔ Has a short, furry body
- ✔ Boasts a wisecracking attitude
- ✔ Displays human characteristics such as the ability to talk or use a can opener
- ✔ Is much smarter than his owner, although his owner often doesn't see it!

When drawing a cartoon cat, keep those traits in mind and follow these steps:

1. **Sketch the main part of the frisky feline's body as a large circle, sketch a smaller circle above it for the head, and then draw the center guidelines in both circles, as shown in Figure 10-4.**

 This cat has a nice, wide midsection, so don't be afraid to go big on the belly!

2. **Sketch the cat's arms on each side of the wide torso area, and sketch the legs.**

 To do so, begin by sketching out the arms so that they're in the position shown in Figure 10-4. The cat's left arm is holding something, so it's in the upright position. Draw the legs beginning at the bottom of the middle torso and straight down with the feet so that they point out in each direction, one to the left and one to the right.

 Like the dog, the cat wears only her own fur, so you won't put any clothes on her. In this pose, the cat is facing you straight-on. Her arms and legs are short and stocky compared to the large, round body area. This adds a sense of bulkiness and gives the impression that she has a pretty wide belly under all that fur.

3. **Begin to draw the cat's facial features, and give her a sly feline smirk (refer to Figure 10-5).**

 The cat's eyes are large and her nose is wide and shaped like an upside-down diamond. She has a wide smile, and you can see a few of her teeth through her sardonic expression. Her hair and whiskers protrude on each side of her face.

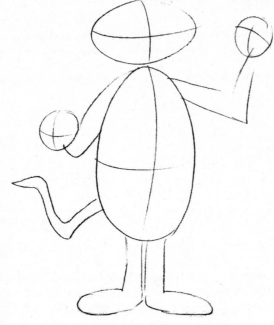

Figure 10-4:
Start your
cat sketch
with two
circles
and center
guidelines
and add
the arms
and legs.

Figure 10-5:
Cartoon
cats are
smart, so
give your
cat an
intelligent
expression.

4. Draw some toys for the cat to play with, as shown in Figure 10-6.

Cats get bored easily, so don't forget to give her a few toys. I like to add details like a ball of string or a mouse as her companion . . . or snack!

Figure 10-6:
The cat is a fun cartoon character that's full of attitude.

Pet goldfish

You may think a goldfish is a boring cartoon character, but think of all that can be seen through the glass of a fishbowl placed in the busiest room in the house! Goldfish can interact with other animal family members or can just observe through their distorted glass walls.

The following are a few traits of the pet goldfish:

- Has a round, wet-looking body
- Has a friendly look and smile
- Displays other human characteristics such as the ability to talk and strong powers of observation about his human keepers

When drawing the family goldfish, keep those traits in mind and follow these steps:

1. **Sketch the main part of the goldfish body as a large circle, and then draw the center guidelines, as shown in Figure 10-7.**

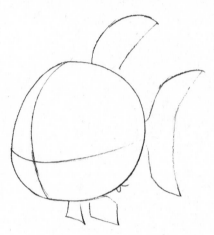

2. **Sketch the fish's fins along the bottom and on the tail, and square off the edges (refer to Figure 10-7).**

 To draw the fins, sketch two diamond shapes located directly under the torso area. In this stance, the fish is facing to the left, and you only see his right side fin with a hint of the left fin behind the belly. Next, from the top of the torso, draw a shape that looks like an orange slice standing on end. This is the top fin. For the back tail fin draw a half crescent shape and attach it to the body just above and just below the center guideline.

3. **Draw the fish's facial features, including a smile and a happy expression (see Figure 10-8).**

 The fish has a very large mouth, and the curve of the mouth goes all the way back until it runs into his gills, which are two vertical lines on the side of his head. Because he's facing to the left, you see his full left eye and about half of his right eye. His left eye is especially large and dominates his face and body.

4. **Add a few extra details (see Figure 10-9).**

 Using your own creativity and imagination, add details on your own. Perhaps you may add authenticity to his fishbowl, such as a fake castle and some glass chips. And don't forget the bubbles that indicate he's under water — he's ready for a day of swimming.

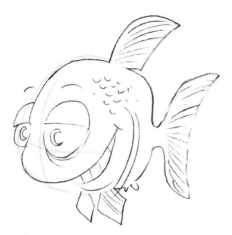

Figure 10-8:
Goldfish are happy creatures with a big mouth and eyes.

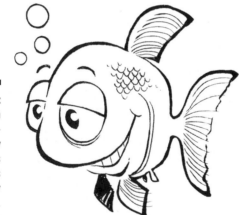

Figure 10-9:
The goldfish has a perfect view of his family's daily activities.

The World Is a Zoo

The cartoon animal world extends far beyond dogs, cats, and goldfish. Family pets aren't the only animals in comic strips — any animal, insect, or creature from your imagination can be the star of the show. If drawing common household pets isn't your thing, branch out into other animal cartoon characters.

Certain well-known stereotypes can be a big part of your cartoon humor, such as the elephant that never forgets anything. You can also play against that stereotype, though, with an elephant that forgets *everything!* Donkeys can represent liberal politicians or, well, themselves, like the donkey in the *Shrek* cartoons. In this section, I show you how to draw some of the animals populating the zoo.

Puts his neck out for others: The giraffe

Giraffes are often sketched as intelligent yet playful — think Geoffrey, the giraffe who personifies the Toys "R" Us chain. If you want to be creative, you can make your main character's best friend a giraffe — your story options will be endless.

Here are a few traits common to the cartoon giraffe:

- Has a long neck and lanky body that may be clothed in a stylish outfit
- May wear bifocals
- Possesses human characteristics such as the ability to talk or drive a car

When drawing the giraffe, keep those traits in mind and follow these steps:

1. **Sketch the main part of the giraffes's body as a large circle, sketch a long, narrow oval for the neck with a small circle on top for the head, and then draw the center guidelines, as shown in Figure 10-10.**

 This debonair giraffe is sitting in a chair reading the paper. Sketch out the square area in front of him for the newspaper. For the chair, start at the base of his long neck and draw an upside down "L" shape that slightly curves down following the torso area. Draw the armrest by drawing a shape about the size of a loaf of bread, and on the right end of that shape draw a line down and several across to finish off the bottom of the chair.

2. **Sketch the giraffe's long, lanky arms on each side, and draw the legs coming straight out from the bottom of the same area.**

 Start with the legs because they're the most visible in this scene. Follow the example in Figure 10-11 and draw a line from the bottom of the torso so that it moves upward to form the top of his leg and then down for his shin. The top should look like a small peak; this will be his knee. In this pose, the giraffe is sitting with his legs crossed and is facing slightly to the right. You can't see much of his arms because one is by his side and the other is behind the newspaper. You can see his fingers as they hold the top of the paper. Draw three small horizontal oval shapes for his fingers.

3. **Draw the giraffe's facial features.**

 He's wearing glasses that give him an intelligent look (refer to Figure 10-11). His glasses are small, and you get a glimpse of his squinty stare through the lenses. His snout is long, and his nose is way out on the end of it. He has two ears that point straight out, as well as two horn-type things (called *ossicones*) on the top of his head. Use the center guide-lines and center both eyes and the bridge of the nose so that they're symmetrical as you look at his face straight on.

4. **Personalize your character by adding a few extra details (see Figure 10-12).**

Figure 10-10:
Your giraffe
starts with
two circles
and a long
oval shape.

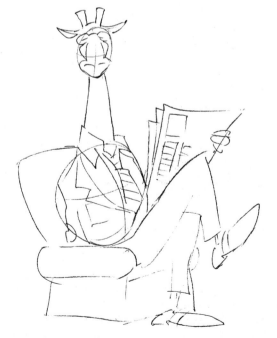

Figure 10-11:
Giraffes are
often seen
as intel-
ligent, so
glasses fit
his persona.

Include details like a pattern on the chair and some lines and boxes on the newspaper to help finish off your sketch. Don't forget to give him a nice jacket and tie (he's quite formal and dignified) and put a nice collar on his plaid shirt. Wing-tipped black-and-white shoes are a nice touch!

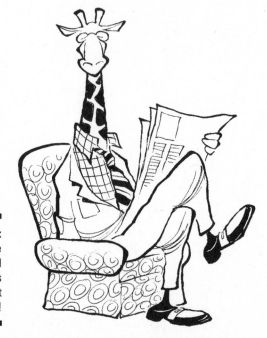

Figure 10-12:
The giraffe isn't afraid to stick his neck out for you!

Acts like the tough guy: Mr. Rhino

Rhinos aren't quite as humorous or funny as other animals, but they possess a certain charm, as well as the strength to be the leader of the animal pack! Your cartoon rhino may be a stern sidekick, or perhaps a mean coworker.

Here are a few traits common to the rhino:

- Has a big, bulky body
- Possesses a tough guy attitude
- Shows the fun side of his personality by wearing amusing ties

When drawing the rhino, keep those traits in mind and follow these steps:

1. **Sketch the main part of the rhino's body as a large circle, sketch another large circle above it for the head, and then draw the center guidelines in both circles (check out Figure 10-13).**

The rhino body is large and dominates the scene, so the center guide-lines also help the placement of the head as well as the legs placed on each side of the line. His left arm will be holding a dumbbell and is in a curled position.

Figure 10-13:
A rhino can be an offbeat character to add to your repertoire.

2. **Sketch the rhino's arms on each side of his body, and draw the legs coming straight down into his shoes (see Figure 10-14).**

 Add laces on the shoes as well as the top line for his socks, which come up above his ankles. In this pose, the rhino is facing left, so you see his right side but only a hint of his left side. His arms and legs are broad and burly and ready to burst out of his shirt.

3. **Draw the rhino's head and face (refer to Figure 10-14).**

 The head and face are large and top-heavy. This rhino has glasses, small eyes, and a huge snout with large nostrils and a big horn pointing straight up. He's got a relatively small mouth compared to the rest of his head.

4. **Add some personality to the rhino by drawing accessories and details (see Figure 10-15).**

 The rhino's a tough guy of the animal kingdom, but he still likes to express his personality with his outfits. Add details like a shirt and funny shorts. Put something in his hand like a dumbbell, hammer, or ax.

Figure 10-14:
He's work-
ing out and
ready to
rumble!

Figure 10-15:
The rhino
is one of
the animal
kingdom's
tough guys
even if he
does wear
patterned
underwear!

They Came from Outer Space

One of the great things about being a cartoonist is the ability to take liberties with reality and create your own interpretation of the world around you. This is especially true when creating unique and out-of-this-world characters — literally and figuratively — so you may want to include aliens, robots, and other creatures in your cartoons. Because nobody has ever seen an alien (unless you believe the UFO conspiracists), your aliens can have any look you want them to have — one eye and antennae aren't required! This section walks you through the different steps on drawing these extraterrestrials.

Beaming down aliens

Not all aliens are little green men, but they can be if you want them to be. Designing a totally new life form can be fun as well as challenging. Aliens are associated with certain stereotypes, but you're free to experiment and give your alien whatever appearance and personality quirks you desire.

The following are a few common traits of the cartoon alien:

✔ Has spindly arms and legs covered with a one-piece, futuristic outfit

✔ Has a large head with big eyes

✔ May "speak" telepathically

When drawing an alien, keep those traits in mind and follow these steps:

1. **Sketch the main part of the alien's head as a large circle, and then draw the center guidelines, as shown in Figure 10-16.**

2. **Sketch the alien's tentacle body coming out from the bottom of the space helmet (see Figure 10-17).**

 In this pose, the alien is facing you. It has a long body that looks like one single tentacle from an octopus. Using Figure 10-17 as a reference, begin by drawing two lines starting from the top of the head area and going down parallel to each other. Curve both lines in an up and down fashion and have the ends meet at a point. The finished shape should look like it's squirming.

3. **Draw the alien's face, which is large and round like a balloon and is enclosed in the big round helmet.**

 The alien is facing you so you see its one large eyeball.

Figure 10-16:
Whatever
it is, it's not
human!

4. **Sketch some extra details (see Figure 10-18).**

 Add other details like the spots on the alien's head and the bottom scale lines on its tentacle. Use your own imagination and creativity and add other details like a spaceship in the background.

Figure 10-17:
The alien
must prac-
tice mind
control,
because
it has no
arms to halt
you in your
tracks.

Cyborgs and droids

If you're a fan of science fiction, you know that cyborgs are a cross between a human and a machine, and the result is always one twisted looking life-form! You can include some cyborgs and other droids in your cartoons for a unique mix. Imagine a human falling in love with a cyborg and all the fun you can have with that story line.

The following are a few traits of the cartoon cyborg:

✔ Is a mixture of human and machine; mix up the parts any way you like

✔ Can perform inhuman feats because of its part-robot makeup

✔ Is usually one of the villains in the universe set on conquering the world, so a mean look is essential

When drawing a cyborg, keep those traits in mind and follow these steps:

1. **Sketch the main part of the cyborg's body as a circle, sketch a larger circle above it for the head, and then draw the center guidelines in both circles (see Figure 10-19).**

2. **Sketch the cyborg's arms and legs coming out from its torso (see Figure 10-20).**

 In this pose, the cyborg is walking to the left and the arms and legs are moving in a stride manner. The left leg is in a full stride outwards while the left arm is holding a ray gun.

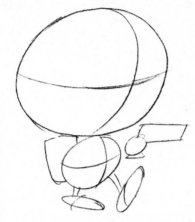

3. **Draw the cyborg's head and facial features (refer to Figure 10-20).**

 The cyborg is a mixture of human and machine, so you want to draw it
 with a variety of fun gadgets and machinery. Its helmet is covering its
 entire head, and it has mechanical vision goggles. To draw the goggles,
 begin by placing them in the center of the helmet along the horizontal
 guideline. Finish by drawing the end ear cap devices on each end. Because
 it's facing left, you only see the right ear device. On top of the helmet draw
 an antenna on each side of the vertical guideline.

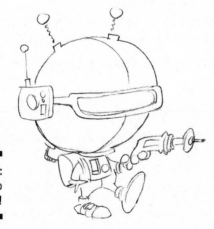

4. **Finish the cyborg by adding tubes and wires all over its body (see Figure 10-21).**

 Add other details like body armor and a jet pack. Personalize your cyborg as you choose and make it your own creation.

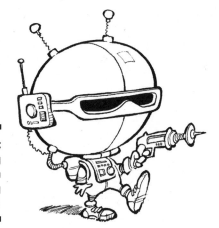

Figure 10-21:
The cyborg is one mean looking dude!

Classic robots

From the classic science fiction of the 1950s on through to the last *Star Wars* movies, robots have been an integral part of popular culture. Just like aliens, you can draw and include robots in your cartoons in a hundred different ways, and they're always a blast to create!

Here are a few traits common to the cartoon robot:

- Has a boxy body and head
- Always senses danger before humans do
- Sports a lot of flashing lights and gadgets on its chest

When drawing a robot, keep those traits in mind and follow these steps:

1. **Sketch the main part of the robot's torso as a square box and sketch a circle on top for its head, and then draw the center guidelines (see Figure 10-22).**

Figure 10-22:
The robot
begins to
take shape.

2. **Sketch the robot's arms and legs coming out from the sides of its body (see Figure 10-23).**

 In this pose, the robot is standing facing to the left, and the arms and legs are flexible like an accordion. You see only the right arm completely; the left arm is protruding out from its side.

3. **Draw the robot's facial gadgetry (see Figure 10-23).**

 Sketch out the robot so you see all its face plate buttons and gadgets and flashing lights on its breast plate. It has a rotating laser for an eye and a slit for a mouth.

4. **Finish the robot with a few extra accessories like clamps for hands and a satellite dish on top (see Figure 10-24).**

 Add other details like the bolts and screws to hold the robot together.

Figure 10-23:
Does it do
windows?

Figure 10-24:
The robot is
a must have
for the 24th
century!

Pogo: Politics in a swamp

Pogo followed the misadventures of a group of creatures living in the Okefenokee Swamp. Pogo himself was a possum, and his best friend Albert was an alligator. A mainstay of *Pogo* was the lampooning of political figures as fellow swamp creatures. Contemporary figures of the day like Richard Nixon, Spiro Agnew, J. Edgar Hoover, and George Wallace all made their appearances. As a result of the strip's political undertones Walt Kelly, creator of the *Pogo* comic strip, was often censured. He took considerable heat for lampooning Senator Joseph McCarthy, as well as for depicting Russian leader Nikita Khrushchev as a pig and Cuban leader Fidel Castro as a cigar-chomping goat uttering pro-Marxist rhetoric.

Walt Kelly was born in Philadelphia, Pennsylvania, in 1913. As a young man, he worked for Walt Disney as a storyboard artist on animated shorts.

Later, he graduated to such full-length feature films as *Dumbo* and *Fantasia*. While illustrating army manuals during World War II, Kelly developed his most famous character, Pogo, who first saw print in 1943 in a comic book. *Pogo* didn't debut in newspapers until 1948.

After Kelly's death in 1973, his widow continued the strip with the help of various assistants until the summer of 1975. Another attempt to revive the strip was launched in 1989 but failed shortly thereafter. But *Pogo* lives on in book collections and retrospectives of the original strips.

The strip had an unrivaled influence on so many cartoonists, including Garry Trudeau (*Doonesbury*), Berkeley Breathed (*Bloom County*), Jeff MacNelly (*Shoe*), and Bill Watterson (*Calvin and Hobbes*).

Chapter 11

Drafting Editorial Cartoon Characters

*E*ditorial cartoons (also known as *political cartoons*) exist to make a point, and often a very barbed point at that. Although editorial cartoons may also amuse or entertain, their primary purpose is to create social or political commentary that simplifies the subtle and often complex underlying issues of a news story.

Editorial cartoons dissect the issue and break it down into its simplest form using visual metaphors to represent the cartoonist's opinion. So you don't think anyone will listen to your political views? Express them in cartoon form and more people will take a look because of the visual appeal of cartoons.

In this chapter, I discuss all the aspects of political cartooning, from caricaturing public figures to dealing with public criticism.

Defining Editorial Cartoons

An editorial cartoon can address any issue, be it political or social. But it must make a statement or take a stand on an issue or it's not an editorial cartoon. Editorial cartoons can be any of the following:

✔ **Funny:** Humor can give an editorial cartoon an extra punch, but only if the humor still allows the real issue to be understood.

✔ **Poignant:** Cartoons that use powerful images that evoke emotion. The memorial cartoons that followed the tragic events of September 11th are good examples.

✔ **Critical:** Editorial cartoons can seem mean-spirited or even vicious if you're the subject of the cartoon or a supporter of the subject. However, if you agree with the cartoonist's portrayal, you see his work as right on target. It simply depends on what side of the issue you happen to fall.

Thomas Nast: The father of American caricature

Historians refer to Thomas Nast as the "Father of American caricature." He's also regarded as the first American political cartoonist who started a rich, colorful trend that continues today. Nast laid the groundwork for not only editorial cartooning but also criticism and satire in all its current modern forms. His legacy continues in cartoons, late-night monologues, comedy sketches, TV opinion programs, and any other form of social critique.

Nast's drawing talents were apparent from very early on. In 1855, at the age of 15, he started working as a draftsman for a newspaper, and within three years he landed at *Harper's Weekly*.

Nast quickly became famous for his work and subsequently became a national celebrity. Perhaps the series of cartoons Nast is most famous for is the work he did depicting Boss Tweed, a powerful New York politician who used corruption as a method of operation. Nast's drawings were instrumental in the downfall of Tweed and his corrupt operation. Tweed was so concerned about Nast's drawings that he even attempted to bribe Nast with over a half million dollars — a vast fortune in the late 19th century.

Nast rejected Tweed's offer and instead continued the attack with his pen. Tweed was arrested in 1873 and convicted of fraud, among other charges. Tweed escaped in 1875 and eventually fled to Spain. Ironically, Spanish officials were able to identify Tweed the fugitive by using one of Nast's cartoons.

Additionally, Nast is credited with creating the symbols for both major American political parties. After President Andrew Jackson used the term "jackass" to criticize the Democratic Party, Nast began using a donkey in his cartoons as the symbol for Democrats. Nast was also responsible for creating the Republican Party elephant. In an early cartoon, he drew a donkey clothed in lion's skin, scaring away all the animals at the zoo. One of those animals, the elephant, was labeled "The Republican Vote." That's all it took for the elephant to become associated with the Republican Party.

He also popularized the image of Uncle Sam and created the modern image of Santa Claus — the one often seen in classic ads for the soft drink Coca-Cola.

Editorial cartoons can be diverse, but most follow certain traditional styles. In modern political cartooning, two styles have emerged:

- ✔ **The traditional style:** This style involves the use of visual metaphors and stereotypes. Many cartoonists use visual metaphors and caricatures to explain complicated political situations, and thus sum up current events with a humorous or emotional picture. These cartoonists generally were influenced stylistically by *Mad* magazine. Their purpose is to bring across a message to people and try to make them think a certain way.

- ✔ **The alternative style:** Also referred to as the *altie style,* this style provides more of a linear read than usually seen in comic strip format. Altie style is typically more text-heavy and less reliant on visual gags than the traditional style.

Refer to the "Setting the Scene for What You Have to Say" section later in this chapter for more on these two styles.

Both are legitimate ways to convey a message; the traditional forms of editorial cartooning rely more on the art to tell the story and convey the message than the wordier, text-heavy, alternative formats do.

If you don't want to end up being caricatured in an editorial cartoon, don't run for office!

Understanding the Pen's Strength: What an Editorial Cartoonist Does

"The pen is mightier than the sword" is a phrase from a play coined by 19th-century British playwright Edwards Bulwer-Lytton. This quote sums up the nature and power of editorial cartoons better than just about anything ever said, except for the well-known phrase, "A picture is worth a thousand words." Editorial cartoons exemplify both these statements; together they define the long tradition of biting satire and social commentary that makes up the blood and guts of editorial cartooning.

To be an editorial cartoonist, you have to be able to express your opinion, which means that you have to *have* opinions and be willing to expose them to a sometimes less than adoring public.

To be an editorial cartoonist and express your opinion, you follow this daily routine to come up with your cartoon:

1. **Search for newsworthy hot topics.**

 People don't read cartoons that discuss things they have no interest in. In today's 24-hour news environment, a new story is always being reported. As a result, there are many stories and topics from which to obtain subject matter. Check out the next section for more hands-on advice about finding ideas.

2. **Form an opinion about an issue.**

 It helps if you actually have opinions before becoming a political cartoonist, because people will look to your cartoons for a particular slant.

3. **Draw a cartoon that illustrates how you feel about that issue.**

 Every issue or news story has a story behind the story. A good editorial cartoonist will try and say something about what's really going on under the surface of an issue, to make the reader think or look differently at an issue or situation, like peeling back the layers of an onion.

One thing that an editorial doesn't do is *report* the news. That task is left up to the reporters and news gathering organizations. The cartoonist's job, by comparison, is to comment about the story. A cartoonist is a political and social commentator.

The rest of this chapter breaks down how you can discover ideas, create opinions, and then draw a cartoon to show that opinion.

Finding Ideas and Forming an Opinion

The first step to creating an editorial cartoon is coming up with an idea. Being a news junkie is almost a prerequisite to being a good editorial cartoonist. To form your ideas, you have to regularly read and listen to the news. Finding ideas isn't overly difficult because of the influx of news sources on TV, in print, and online. Just keep these simple steps in mind as you formulate your ideas and come up with your opinion:

1. **Tune into a wide variety of news outlets and look for an interesting news story.**

 Doing so gives you the most comprehensive and thorough amount of information about a story. When searching for ideas, you can look at a wide assortment of sources, including the following:

- **TV:** You can look at the network news outlets like ABC, NBC, CBS, and FOX. In addition, you have local news affiliates as well as cable news networks, such as CNN and MSNBC.

- **Radio:** Listen to the plethora of radio news, including National Public Radio.

- **Web sites:** Countless sites are available, including Slate and the Drudge Report. You can also check out different blogs for ideas. Newspapers' Web sites are also great sources.

- **Newspapers and news magazines:** If you like to have the actual newsprint in your hands, several newspapers and news magazines are great sources, including the *New York Times, Washington Post, Newsweek,* and *Time.*

2. **After you have a good handle on the facts of the story, digest that information and create your opinion for a possible cartoon angle.**

 Opinions are usually the result of a gut reaction to an issue. However, it's important that you become as well-informed as possible on an issue so that your opinion is based on all the available information and not just what you may hear on a TV news sound bite. After you feel you have all the information about the issue, ask yourself how you feel about it.

 This sounds a lot more complicated than it actually is. Everybody in the course of going about their daily lives hears bits and pieces of news throughout the day. Chances are you hear these stories and form some kind of opinion in your head. Then you meet your fellow coworkers at the water cooler as they're talking about the very same story. By this time you have some idea about how you feel about the issue and express it to them. Editorial cartoonists do the same thing, except they express their feelings through their drawings (and, hopefully, get paid for them!).

3. **Jot down the ideas on paper as quickly as possible.** The most common and perhaps the best way to do this is to always have a notebook handy so that you can jot down ideas and rough sketches. You may discover over time that coming up with ideas is easy if you stay tuned into what's going on in the news.

Setting the Scene for What You Have to Say

Editorial cartoons are powerful forms of communication, but they're not without their methods and formulas. You need to familiarize yourself with some common elements of these cartoons in order to get your point across effectively. This section gives you a leg up on the more traditional methods as well as the alternative route.

Grasping the art of visual metaphors

One of the primary functions of an editorial cartoon is to make a strong point to the reader. One of the best ways to accomplish this is known as *visual shorthand* or the use of metaphors to get the point across. *Metaphors* are comparisons that show how two things that aren't alike in most ways are similar in one important way. Editorial cartoonists use metaphors to make their cartoons more interesting and entertaining. To use a metaphor, you need to find one visual scenario and apply it to another in an effort to make a broader point.

Figure 11-1 shows a classic example of how you can use a visual metaphor to convey the message. The economic crisis of 2009 has President Obama promising to enact another round of stimulus to help the economy. Great news, right? Well, the downside (and it's a biggie) is that the U.S. will have to borrow the money to fund the stimulus, which Obama says will be in the form of tax cuts. Basically, that's feeding the growing national debt. Bingo. That last line is all a good editorial cartoonist needs to cultivate an idea. So you have to find some visual metaphor to express the idea of feeding the national debt.

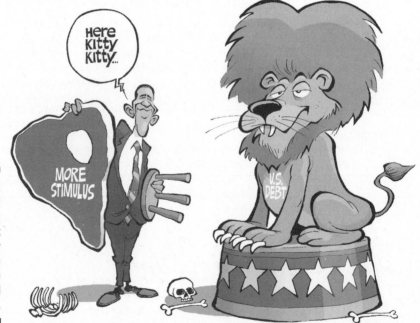

Figure 11-1: Depicting the growing U.S. debt as a hungry lion is an example of a visual metaphor.

In this figure you have Obama feeding the debt, literally. The debt could have been drawn using a variety of animals or creatures to convey a hungry beast (a hungry lion in my interpretation). Drawing the stimulus as a big cut of meat naturally made sense from a visual metaphor viewpoint.

Using stereotypes to convey your message

Just like visual metaphors, stereotypes are another commonly used artistic tool often employed in editorial cartoons. A *stereotype* is a conventional and oversimplified conception, opinion, or image based on the assumption that members of a certain group have attributes in common. Stereotypes are forms of social consensus rather than individual judgments.

People usually view stereotypes in a negative light, so make sure you avoid certain stereotypes, such as those that target sensitive historical topics like race. You also want to avoid stereotypes about topics that instigate prejudice and false assumptions about entire groups of people, including members of different ethnic groups, religious orders, or sexual orientation.

Editorial cartoons do try to invoke generally nonoffensive stereotypes to make a greater, broader point about an issue. You may want to draw all your politicians and representatives as big fat guys who gorge on taxpayer money. The reality is that the politicians don't really do that, at least not literally. However, readers can relate to that characterization and stereotype because that's the way the politicians are sometimes perceived. Some additional stereotypes commonly used in recent editorial cartoons are:

- Drawing oil companies as fat cats
- Drawing lawyers as sharks
- Drawing terrorists as rats

One distinction that must be made is how and when to use a stereotype in a cartoon. For example, it's okay to stereotype terrorists as rats. It's a pretty safe generalization that all terrorists hate the U.S. and want to kill everybody who lives here. However, a bad stereotype would be to portray all Muslims negatively just because some terrorists are Muslims. The cartoonist should always use discretion when employing stereotypes so as not to distract or overshadow the point he's trying to make.

Letting the art make your point

The advantage to letting the art tell the story is that there's something powerful about a single, stand-alone image that conveys to the reader what you're trying to say. You want the art to deliver the message and act as the visual punch line. This simply follows the idea that "a picture is worth a thousand words." As a cartoonist you want to take advantage of a medium that allows the art to do the talking.

One of the most famous examples of art making a point followed the assassination of President John F. Kennedy on November 22, 1963. The next day, a cartoon appeared in newspapers across the country by legendary cartoonist Bill Mauldin showing the statue of Lincoln at the Lincoln Memorial with his face in his hands, mourning in anguish at the news of JFK's tragic death.

The image was powerful and contained no text. People who saw it instantly knew what it was saying as it so accurately conveyed the somber feelings and sentiment of the American people.

Going the altie route

Alternative cartoons typically are more text-heavy and rely less on the art to convey a message. This format utilizes more dialogue that tends to be more cerebral in nature. The practitioners of this modern interpretation of editorial cartooning seem to be more influenced by literature than the traditional cartoonists who derive their style from a long line of succession that dates back to *Mad* magazine.

Alternative cartoons usually follow a multipanel format with lots of dialogue, and the art in some cases is no more than talking heads. This format can be extremely effective if it contains dialogue that's well-written and makes a strong point.

Drafting Believable Caricatures

One of the most powerful tools an editorial cartoonist has at her disposal is the art of caricature. A *caricature* is a drawing that exaggerates the fundamental nature and essence of a person to create an easily recognizable likeness. Caricatures in editorial cartoons are usually viewed as less than flattering but generally serve a greater purpose in the larger context of the cartoon.

Politicians are great targets of caricatures. You can exploit and integrate the politician's weaknesses into your caricature. For example, even though former President George W. Bush was over 6 feet tall, many editorial cartoonists drew him as a small figure, with diminished height (as in Figure 11-2). This reflected his diminished popularity toward the end of his second term in office.

In order to draft believable caricatures, you need to study the facial characteristics and body language of the politician in question. This section examines several current politicians and leaders and teaches you how to caricature them using not only their facial features but also their body language and personality traits.

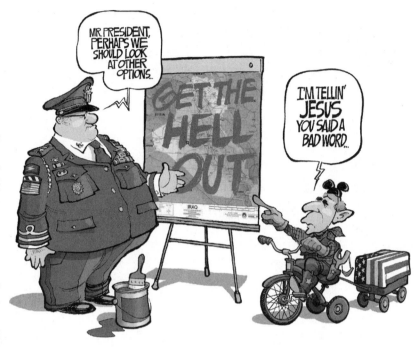

Figure 11-2:
The size of President Bush in this cartoon reflects his diminished popularity in the polls as a result of the war in Iraq.

Knowing how to capture a likeness

To capture the likeness of someone famous while caricaturing him is to pick up on key elements of his face and exaggerate them. When caricaturing someone's likeness, you want to study the following:

- **Natural characteristics of the subject:** Focus on features like eyes, ears, nose, and so on, because these are areas that are most recognizable to the reader. George W. Bush has a thin upper lip, and the space between his upper lip and nose is longer than most. Cartoonists exaggerated this in his caricatures while still allowing him to be recognizable.

- **Acquired characteristics:** Identify things like moles, scars, facial lines, and so on, because these unique features can help establish who the person is right away.

- **The person's vanities:** Focus on features like hairstyle, glasses, clothing, and facial expressions. When you have to draw the entire person and not just the face, playing up the mannerisms and body language add another important aspect and dimension to the caricature.

- **Other key elements:** You want to pick up anything else to emphasize and exaggerate in the caricature drawing.

You can see an example of characterization by taking former President George W. Bush as an example. If you study his face, you see that he has a slightly larger space between the bottom of his nose and his top lip. Notice also that his eyes are small and slightly close together. Next, notice his hairstyle. You can see these things reflected in his caricature (see Figure 11-3).

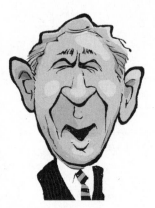

Figure 11-3: President Bush's caricature reflects basic key elements in his actual face.

Drawing a president: The how-to

Ushering in a new administration and newly elected president means editorial cartoonists must forget the guy who occupied the office for the last four years and move on to the new guy. The new guy today is Barack Obama, and he's got an interesting face. I take a look and break it down to show how you can successfully caricature it.

You can easily identify the following unique to Obama's face:

✔ Long and narrow facial structure

✔ High cheekbones

✔ Wide smile that shows lots of teeth

✔ Prominent laugh lines on each side of his face and around his mouth

✔ Large, round ears

✔ Short, cropped haircut

When drawing President Obama's face, keep those traits in mind and follow these steps:

1. **Sketch a long, large oval and draw the center guidelines in a vertical and horizontal direction, as in Figure 11-4.**

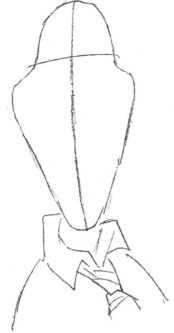

Figure 11-4:
President
Obama's
face is long
and narrow.

Obama has a long lean face; the guidelines help you properly center and position his facial features.

2. **Sketch in the area for his eyes, ears, nose, and mouth.**

 To draw his mouth and nose, draw a line under the center horizontal guideline for the nose. Next draw another line under that one that spans the width of his face and that slightly curve downwards at the ends. President Obama has a great big smile that shows lots of teeth. Obama also has deep, prominent laugh lines that almost touch the sides of his face when he smiles. To draw his eyes, draw two small lines on each side of the vertical guideline. His eyes are squinting, so draw another smaller line under the lines for the eyes that meets towards his nose and moves towards the sides of his face in a slightly downward fashion. Don't forget his ears, which are round and protrude out from the sides of his head. Draw two large oval half circles that begin at eye level and move around and down and end at the middle of his mouth level (see Figure 11-5).

3. **Add a shirt and tie to the leader of the free world, like in Figure 11-6.**

 His tie is slightly loosened and his collar is open just a bit. It was very common for Obama to appear this way, especially during the long days on the campaign trail.

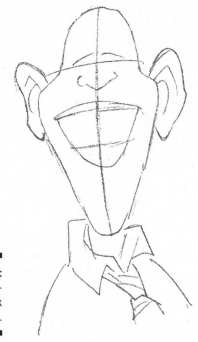

Figure 11-5:
He's begin-
ning to look
presidential.

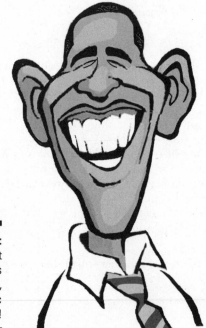

Figure 11-6:
President
Obama has
a great,
optimistic
smile!

Creating Classic Editorial Cartoon Characters

Editorial cartooning has classic and genre-specific characters that editorial cartoonists regularly use as metaphors and symbols. These classic characters are easily recognizable and have become American icons. They include the symbols for the Republican and Democratic parties, along with Uncle Sam, just to name a few. This section looks at some of these characters in more detail and the step-by-step process to creating them.

The Republican Party elephant

The elephant was officially adopted as the mascot of the Republican Party several years after Thomas Nast (see the sidebar "Thomas Nast: The father of American caricature") drew the first editorial cartoon portraying the Democrats and Republicans in their now familiar animal skins in the mid 1880s.

When drawing your Republican elephant, remember these common traits:

- Large body and accurate elephant features
- Usually dressed in dark, pin-striped suit
- Usually portrayed as pro-military and conservative on social issues.

When drawing the elephant, keep these traits in mind and follow these steps:

1. **Sketch a large circle for the body, sketch a smaller circle for the head above it, and draw the center guidelines in both circles, as in Figure 11-7.**

 The elephant is going to have a nice, wide midsection, so don't be afraid to go big on the belly!

2. **Sketch the elephant's arms and legs on each side of the large wide torso area (refer to Figure 11-7).**

 To draw the arms, use the figure as reference and draw the right arm so that it falls by his side and the left arm and hand in a position that shows he's holding something. To add legs, draw them going straight down from the bottom of the torso area with his shoes pointing to the left. In this pose, the elephant is facing slightly to his left. His arms and legs are

short and stocky compared to the large round torso. This adds a sense of bulkiness that often represents big corporate interests or big money when portrayed in cartoons.

3. **Draw the elephant's facial features, large massive ears, and long iconic trunk (see Figure 11-8).**

 The trunk and tusks are long and dominate the center of his facial features. The other dominant features are his ears, which are large and slightly squared-shaped. Elephants have small eyes by comparison, and he can also look good in small wire glasses. His mouth is located beneath his trunk and therefore isn't visible.

4. **Complete the details on his suit and tie, like Figure 11-9 shows.**

 You can personalize your own elephant drawing by coming up with any details that appeal to you and mesh with your character's personality. In my figure, he's wearing a power pin-striped suit and tie. Adding suspenders and cuff links is also a nice touch. Finish off by completing his foot wear, which are slip-on loafers, of course!

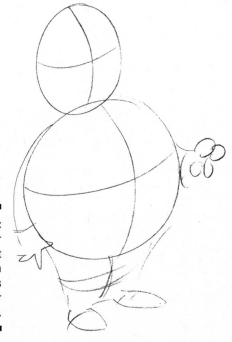

Figure 11-7:
Start your
elephant
sketch with
two circles
and center
guidelines.

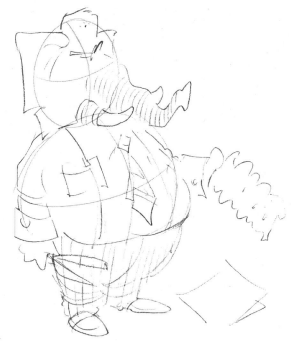

Figure 11-8:
This
elephant
looks like
he'll never
forget!

Figure 11-9:
This
elephant
looks ready
to run for
office.

The Democratic Party donkey

On the left side of the aisle, you find the other major party in the U.S. — the Democrats. The recognized symbol for this party is the donkey. When you draw this symbol, keep the following few traits in mind:

✔ Long donkey ears and accurate donkey features

✔ Wears a suit, but often shown without a jacket, for a more casual, blue-collar attitude

✔ Usually portrayed as pro-big government and liberal on social issues

When drawing the Democratic donkey, keep those traits in mind and follow these steps:

1. **Sketch the main part of the donkey's body as a medium-sized vertical oval shape, sketch a smaller horizontal oval above it for the head, and then draw the center guidelines in both, like in Figure 11-10.**

2. **Sketch the donkey's arms and legs on each side of his narrow torso.**

Figure 11-10:
Start your donkey sketch with two oval shapes and center guidelines.

To do so, use Figure 11-10 as a reference and draw his arms so that they appear in an upward lifting motion. His right arm is totally visible while his left arm is partially hidden by his body and his right arm. To draw his right leg, make two lines slightly bent at the knee and draw the foot/shoe so that it faces to the right. His left leg is in a bent and raised position, so his knee is high and comes up past the elbow on his right arm. In this pose, the donkey is facing to his left and appears to be juggling some balls.

3. **Draw the donkey's long face and ears and that great jackass smile (see Figure 11-11).**

To do so, draw his nose snout so that is comes out past his stomach. His ears are long and point straight up and are turned to the right. The donkey's head is slightly turned to his left, so you see all his facial features from the right. His eyes are small and his snout is long, and he's got a wide smile.

4. **Add his shirt and tie (see Figure 11-12).**

Adding the final details is a great way to personalize your own donkey. To do so, add any details that strike you as amusing. In my drawing, he's ditched his jacket and his shirtsleeves are rolled up, giving him that "can do anything" look. Including juggling!

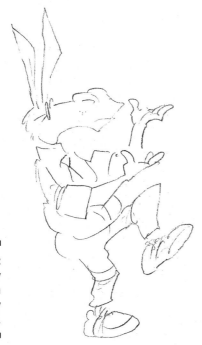

Figure 11-11:
The donkey
will soon
be ready
to lead.

Figure 11-12:
This guy
is truly a
donkey of
the people!

Uncle Sam

Uncle Sam is the alter ego and iconic representative of the United States, with the first images of Uncle Sam dating all the way back to the War of 1812. He's often depicted as a tall, lanky man with white hair, dressed in clothing that resembles the U.S. flag. Most of the time he wears a blue coat, red-and-white-striped trousers, and a top hat with red and white stripes and white stars on a blue band.

The following are a few traits common to Uncle Sam:

✔ Long, lanky body

✔ Strong, resilient attitude

✔ Recognizable costume, almost like a superhero

When drawing Uncle Sam, keep those traits in mind and follow these steps:

1. **Sketch the long, lanky body as a long vertical oval, sketch a smaller circle above it for the head, and then draw the center guidelines in both, as shown in Figure 11-13.**

Figure 11-13:
Begin
Uncle Sam
with a long
vertical oval
and center
guidelines.

2. **Sketch Uncle Sam's long lanky arms and legs on each side of the torso area.**

 In this pose, he's facing to his right and looking downwards. His arms and legs are long and lanky, like that of Abraham Lincoln's. Draw his left arm so that it falls down by his side while his right arm is bouncing the ball. His legs are really close together so draw them so that they come straight down from his torso and his shoes point to the left (see Figure 11-14).

3. **Draw his facial features (refer to Figure 11-14).**

 He's facing to his right so you see only the facial features on his left side. His eyes are small and he has high, narrow cheekbones. His hair is slightly long in the back, and the tall top hat sits atop his head.

4. **Fill in the final details, like in Figure 11-15.**

 You can add features like the stripes on his pants and the stars on his tie, hat, and jacket lapels. His clothing can be worn in many different ways depending on his situation and the task he's doing. Without his jacket and his sleeves rolled up he looks like he's ready to get down to the business of defending the nation.

Figure 11-14:
This Uncle
Sam has
a strong
American
resolve.

Figure 11-15:
Uncle Sam
is ready
to defend
America.

Roll with the punches:
Dealing with readers' responses

One of the most interesting things about being in a profession that specializes in forming opinions is the strong response, both positive and negative, you generate from individuals who read your editorial cartoons. Sometimes people like what you have to say. Other times people are vocal in their dislike of your opinions, and they usually don't hesitate in expressing their own opinion.

If you pursue editorial cartoons as a career, have some published, and then get some reader responses, I suggest you do what I do. Most of the time, regardless of what the readers say, I simply respond with a single sentence that says, "Thank you for your interest in my work." I've learned over the past decade not to take what readers say personally. Take the comments with a grain of salt and as further evidence of the power and importance of editorial cartoons in our political and social discourse. Besides, it's fun to ruffle people's feathers!

E-mail has changed the way editorial cartoonists get feedback from the public. You may get complimentary e-mails and comments from readers who like how you expressed an idea or drew something. On the flip side, you can get some negative e-mail, so be prepared. An unsettling trend in e-mailing is that people are much more vicious and mean-spirited when they e-mail than they would be if they wrote a letter or confronted you in person. Perhaps this is because e-mailing is a much more instantaneous thing, and when they stumble upon a cartoon on a Web site they find disagreeable, bullets start flying and hit their target (that's *you*) quickly.

Some of the more memorable comments I see regarding my editorial cartoons are things like:

"Just read your cartoon . . . you suck!"

"You're nothing but a conservative Nazi."

"You're nothing but a liberal scumbag."

The last two depend strictly on how the reader perceives the point of the cartoon. In their eyes, if you criticize a conservative politician or cause you're liberal, and if you criticize a liberal politician or cause you're a conservative. You may be amused that readers can make assumptions about your political affiliations based on one cartoon, but they do!

The Obama cartoon controversy

In July of 2008, *The New Yorker* gained national attention and attracted a firestorm of controversy over its cartoon cover. The cover was entitled "The Politics of Fear," by Barry Blitt and depicted Democratic nominee Barack Obama in a turban, dressed in a long Middle Eastern style robe, fist bumping with his wife, Michelle Obama. Michelle Obama was portrayed with a large Afro hairstyle while wearing camouflage pants and holding an AK-47 assault rifle. Both were standing in the Oval Office with a portrait of Osama bin Laden hanging on the wall while an American flag burned in the fireplace.

According to the magazine's editors, the intent of the cover was to satirize the rumors and misconceptions about Obama. Vicious rumors about the Obamas had been floating around and were beginning to be reflected in public opinion polls. The magazine set out to throw all the images together in an attempt to shine a harsh light on the rumors in an effort to satirize them.

However, on the heels of the controversy that followed, the editors acknowledged the misunderstanding, particularly by those unfamiliar with the subtle humor the magazine is famous for.

Part III
Cartoon Designs 101: Assembling the Parts

The 5th Wave By Rich Tennant

"Have you figured out what the powers of that new superhero will be? How about the power to meet deadlines? That would be a good power."

In this part . . .

You may have good ideas, and you may be able to draw well, but how do you put the two together to create viable cartoons? In this part, I tell you how to bring it all together, from assembling the cartoon background to using the right type of lettering. I also discuss how to maintain the proper perspective and how to lay out a scene that adds depth and detail to your cartoon world.

Chapter 12

Putting Everything in Your Comics in Perspective

Cartoon characters are, by nature, one-dimensional, unless you're putting your characters into a pop-up book. But they don't have to look one-dimensional. Drawing your cartoons with the illusion that they exist in more than one plane is part of the art of cartooning. In this chapter, I give you the tools to take your characters and cartoons from flat images to two- or three-dimensional drawings, adding depth, realism, and interest to your artwork.

Grasping What Perspective Is

As you look around the real world, everything you see is from a three-dimensional viewpoint. So for your cartoon world to look like the real world, you must draw objects in proper perspective. When you're drawing cartoons, the term *perspective* refers to the technique of drawing that creates the illusion of space and depth in a flat panel.

Perspective basically means that an object appears to get smaller as the distance between the object and the viewer gets bigger. For example, as a car drives away from you, it gets smaller in perspective. Perspective doesn't just apply to moving objects, though; it also applies to objects that are just sitting in place, like buildings. If you look at a building, the sides that are visible to you appear to get smaller the farther away they are from where you're standing.

Your first attempts as an artist are probably to draw things in a flat and simple manner. However, with a basic understanding of the principles of perspective, you can increase the depth of your art and have a lot of fun doing it. This section gives you an overview of what perspective is and isn't and the different types of perspective you can use when drawing your cartoons.

You can quickly see the difference in perspective by simply drawing a box as a flat square or drawing it so that it looks like a cube (see Figure 12-1). The cube is much more interesting to look at — and much more fun to draw!

Figure 12-1: Drawing cartoons with some perspective looks better than drawing them without.

Starting with the vanishing point and horizon line

The element that gives objects in a drawing perspective is called the vanishing point. The *vanishing point* is the point on the horizon where parallel lines appear to meet. For example, if you look down a set of railway tracks as they go off into the distance, you know the two track edges are parallel to each other and remain the same distance apart. However, the farther away they get, the closer they appear to get to each other.

The other important element in understanding perspective is the *horizon line*. The horizon line (HL) in perspective drawing is a virtual line drawn at the viewer's eye level; it gives a point of reference for the vanishing points as to whether objects are going to be seen straight on, from above, or from below in your cartoon. Figure 12-2 shows the vanishing point and horizon line.

As the tracks fade away in the distance, the edges seem to convene and end up at a single point on the horizon. This is the vanishing point (VP). Any object you draw in perspective that includes parallel lines has one or more vanishing points.

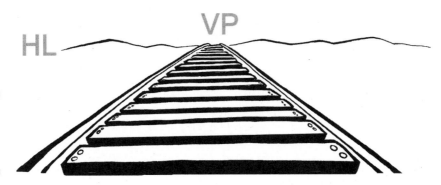

HL VP

Figure 12-2:
Hey, where
did the
train go?

To create a proper perspective, start with the vanishing point as the point of reference for the drawing. You don't have to mark a big *X* in your drawing to designate where the vanishing point or points are, but you should be aware of the general location so that all the appropriate angles line up accordingly.

Introducing 1-2-3 point perspective

When drawing your cartoons, you want to make sure everything looks in balance and in place. Drawing objects in the correct scale and from the correct perspective gives your cartoon a richer, more realistic and natural appearance that isn't jarring to the eye.

When introducing perspective in your artwork, you have three main choices. This section explains how to draw from one-, two-, or three-point perspectives. The number of *points* refers to the number of vanishing points in each drawing. Check out the section "Putting Perspective to Practical Use," later in this chapter, for ways you can implement these perspective points into your drawings.

Drawing one-point perspective

A *one-point perspective* drawing is a drawing with a single vanishing point on the horizon line. This is the standard "receding railroad tracks" phenomenon demonstrated in Figure 12-2.

You typically use one-point perspective for objects that have lines either directly parallel with the viewer's line of sight or directly perpendicular (such as railroad slats). So you can use one-point perspective for roads, railroad tracks, or buildings with the front directly facing the viewer. Figure 12-3 shows an example of a drawing in one-point perspective.

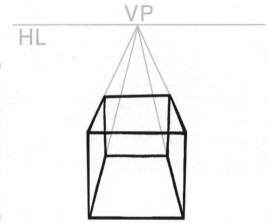

Figure 12-3:
The lines in a one-point perspective drawing appear to meet at one place on the horizon.

Utilizing two-point perspective

With *two-point perspective,* your drawing has lines parallel to two different angles. You can have any number of vanishing points in a drawing, one for each separate set of parallel lines that are at an angle relative to the plane of the drawing.

If you have more than one vanishing point in two-point perspective, all the vanishing points have to exist on the same horizon line — in other words, at the same eye level perspective.

You can use two-point perspective to draw the same objects that you draw with one-point perspective, only from a rotated view. For example, if you were standing directly in front of a house and moved to a position looking at the house's corner, you'd see another dimension. One wall would recede toward one vanishing point, and the other wall would recede toward the opposite vanishing point. Check out Figure 12-4 for an example of a drawing with two-point perspective.

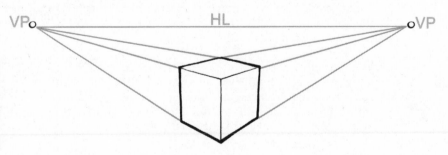

Figure 12-4:
You can see both sides in a two-point perspective drawing.

Drawing three-point perspective

Another option you have for adding perspective to your cartoons is to use the three-point perspective. You can use *three-point perspective* for things like buildings seen from above. In addition to the two vanishing points from the two-point perspective — one for each wall — a three-point perspective drawing has another vanishing point where those walls recede into the ground (the third vanishing point is actually below the ground). Another common use of three-point perspective is a drawing that looks up at a tall building. In this case, the third vanishing point is high up out of view, somewhere in outer space. Figure 12-5 shows an example of a drawing in three-point perspective.

Figure 12-5: Drawing things in three-point perspective can help add height and drama to the composition.

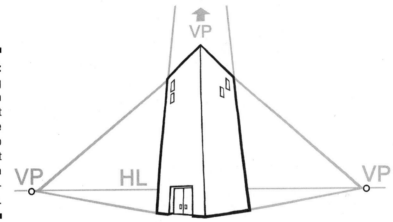

Recognizing the wrong perspective

You don't have to be the world's greatest art critic or an expert in geometry to know that something drawn from the wrong perspective just doesn't look right. It's natural for your brain to have an intuitive negative reaction to a drawing in which something is incorrect. (Modern art may be the exception to this!) When drawing your cartoons, make sure the perspective corresponds to the real world around you. Otherwise, the overall composition will fail. Figure 12-6 shows an example in which the perspective is off.

Do you see the problem? It's the picture on the wall behind the chair. It just sort of jumps out at you, doesn't it? Your eye probably went right to the object in the drawing that's not in the correct perspective because your brain was telling you that something just wasn't right.

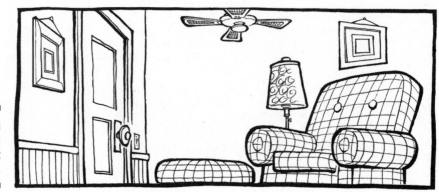

Putting Perspective to Practical Use

Putting everything into perspective isn't difficult. You just need some basic, how-to knowledge and the ability to apply those concepts to the elements and objects you frequently draw. This section shows you how.

Sketching common, everyday objects in perspective

Most cartoon worlds contain everyday elements — cars, appliances, furniture, and so on. Drawing them with the proper perspective is important so that they don't jump out at readers and create a jarring, annoying distraction. You can draw these household items from various angles in two- and three-point perspective.

Drawing a chair

A chair is a common object that you'll probably put in your cartoons in some form or another when creating a story line with characters and their surroundings. Chapter 9 shows you how to draw a chair. To draw a chair from two-point perspective, which is probably the way you'll most frequently draw it, just line up each angle to the respective vanishing points on the horizon line. In two point perspective, vanishing points need to exist on the same horizon line. Figure 12-7 shows a chair from two-point perspective. You can see the parallel lines that indicate the two different angles as they go off in the direction of two separate vanishing points on the same horizon line.

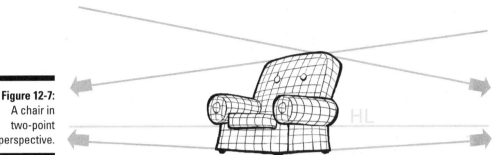

Figure 12-7:
A chair in
two-point
perspective.

If you want to draw the chair as if you were looking down at it from a balcony, you can draw it in three-point perspective. To do so, you need to draw the chair so that is has three different angles pointing in the direction of three different vanishing points.

These vanishing points can and should usually be far out of the parameters of the composition. As long as the angles are lined up and eventually will reach a vanishing point, the object will retain the right perspective and look natural. If you try to have the vanishing points meet in the drawing, the object will probably look distorted rather than natural. Figure 12-8 shows an example of a chair in three-point perspective. You can see the parallel lines that indicate the three different angles. Objects drawn in three-point perspective tend to look more dramatic.

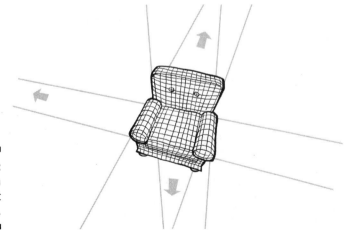

Figure 12-8:
The chair in
three-point
perspective.

Sitting at your desk

A desk is another common object that you'll probably draw many times in some form or another when creating a story line with characters and their surroundings. Figure 12-9 shows the desk from a two-point perspective. You can see the parallel lines that indicate the two different angles.

Figure 12-9:
A desk in
two-point
perspective.

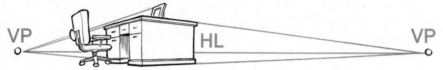

Figure 12-10 shows the desk from a three-point perspective. This is probably the way you would draw the desk if one of your characters was looking down at it. You can see the parallel lines that indicate the three different angles.

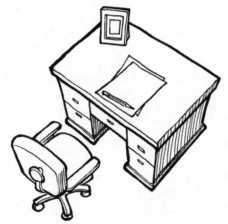

Figure 12-10:
A desk in
three-point
perspective.

Focusing on the fridge

The refrigerator's nice rectangular shape is similar to the boxy or square shape of many other household items, such as TVs, beds, radios, microwave ovens, toasters, and so on. Chapter 9 shows you how to draw different house-hold appliances. To draw your fridge in two-point perspective, you need to line up two different angles so that they meet two different vanishing points on the same horizon line, if you were to draw a ruler out as far as the line goes. However, most of the time, the vanishing point goes out past the drawing and

would end up off the paper you're drawing on. Figure 12-11 shows an example of a fridge in two-point perspective. You can see the parallel lines that indicate the two different angles meeting on the same horizon line.

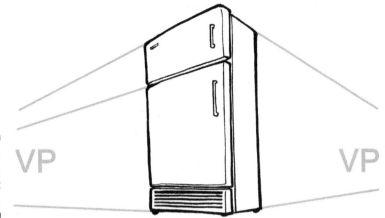

Figure 12-11: A fridge in two-point perspective.

If you want to draw the fridge as if one of your characters were looking down at it as she stood on a ladder changing a light bulb, you can draw the fridge from a three-point perspective. To do so, you need to have three different angles lined up with three different vanishing points. This differs from two-point perspective because not all the vanishing points end up on the same horizon point in three-point perspective. Figure 12-12 shows an example of a fridge in three-point perspective. You can see the dramatic angles of each fridge and how they indicate the three different angles and vanishing points.

Figure 12-12: The fridge in three-point perspective.

Juggling multiple elements in perspective

Most of the time, you won't be drawing cartoons with just a single element; chances are you'll be drawing objects in relation to other objects around them. Consequently, it's important to demonstrate how multiple objects work in connection to one another in two- and three-point perspectives.

For example, if you draw a chair, you'll probably draw the objects that sit near the chair, such as a table and a lamp. To make sure these items are in two-point perspective, the lines of all the objects should be generally moving toward the same vanishing points on the same horizon line. This doesn't mean everything has to line up perfectly, as if it were on a big grid. Objects are moved slightly as they're used throughout a room. The side table may have been bumped or the lamp may have been moved around when it was turned off or on. However, the lamp and table are in the correct scale and perspective in relation to the chair. Figure 12-13 shows the parallel lines that indicate two different angles in the chair, side table, and lamp.

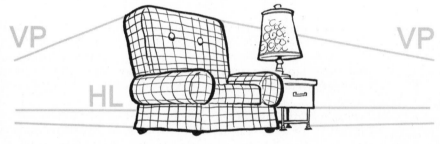

Figure 12-13: A chair, table, and lamp in two-point perspective.

If you want to create more of a dramatic background, you can use three-point perspective with this grouping of furniture. To do so, you want to line up all the objects so they meet one of three different vanishing points. Two of those vanishing points meet on the horizon line, and the other meets somewhere either below ground level or in outer space, depending on what you're drawing. Figure 12-14 shows an example; you can see the parallel lines that indicate the three different angles.

Looking down: A bird's-eye view

Understanding perspective is very important if you want to create height or depth in your drawing. The term used to describe a scene viewed from above is called a *bird's-eye view*. The term comes from the fact that the viewer's angle and perspective is the same as a bird's if it were flying high up in the air

over the object. That doesn't mean you have to draw the scene as if you're a half mile up in the sky; it just means that you're looking down at the objects you're drawing.

Figure 12-14:
The chair, table, and lamp in three-point perspective.

Things drawn in a bird's-eye view fall into the three-point perspective category and, if done correctly, can look extreme and very dramatic. The bird's-eye view differs from this chapter's previous examples of three-point perspective simply because the object is viewed from directly (or nearly directly) above.

To draw things from this perspective, make sure that the top of the object is the area that's most visible. Because the angle is so dramatic, the vanishing point moving toward the third horizon line disappears below the object, and that vanishing point isn't visible from this angle. For an example, look at Figure 12-15. The bird's-eye view of the refrigerator is much more dramatic than a straight-on view. The area most visible is the top, and you can barely see the sides. Notice how you can see the milk and other food items on the shelves and on the inside of the open door.

You can also draw other elements from a bird's-eye view. Figure 12-16 shows an example of a utility truck. Chapter 9 explains how to draw a basic truck. Drawing it from a bird's-eye view creates a drawing that's more visually interesting than other angles or views. The truck on the right is more of a box shape, and the roof, hood, and truck bed are the areas that are most visible.

When you're attempting to draw from a bird-eye view, it may be helpful to use a prop, like a toy truck, so that you can see how the vehicle looks from this viewpoint. Notice that the top of the truck's roof is most visible, along with the bed of the truck. The right door is barely visible, and you can see just a sliver of the back window on the cab of the truck and the tailgate. If you didn't make these areas just slightly visible, the perspective wouldn't look

correct. The key is to study the object you're drawing from the correct perspective to be sure what you're drawing is correct, from a perspective point of view. This angle is dramatic; it adds interest to the object and allows you more ways to tell a story.

Figure 12-15: The refrigerator from a bird's-eye view.

Figure 12-16: A truck from the front and from a bird's-eye view.

Putting Your Characters in Perspective

Inanimate objects aren't the only things you need to draw in perspective; your characters need to have the proper perspective as well. Unlike square and linear objects such as refrigerators, TVs, cars, trucks, and buildings, your characters' shapes are less boxy and therefore may be more of a

challenge for you to draw. No need to worry — putting things in perspective is all about lining up an element's parallel lines with the respective vanishing points. Check out Chapters 6 and 7 for step-by-step details on creating basic cartoon characters. This section explains how to ensure your characters are in perspective.

Lining up body shapes

You need to not only draw your characters in proper perspective with the things around them but also draw their body parts in proper perspective to each other. Because body shapes are rounded and generally nonlinear, this skill can be difficult to master at first. The next sections explain how, starting with a body type that's more linear than most, because angular types are easiest to line up to a vanishing point.

Linear body shape

Drawing a linear body shape, or one that's boxy and has sharp angles, is easier to line up to a vanishing point than a nonlinear body shape, simply because the nonlinear shape has no defined or obvious angles to line up to the vanishing point. To draw a linear body shape, you first need to break down the character into three main body parts:

- The head and neck area (the top)
- The torso and arms area (the middle)
- The legs and feet area (the bottom)

Break these areas down to three box shapes:

- The head and neck area is box A
- The torso and arms area is box B
- The legs and feet area is box C

If you draw your characters in a normal, straight-on view, you stack the three boxes on top of each other, as Figure 12-17 demonstrates.

If you want to draw the three boxes in three-point perspective, line up three different angles so that they lead off in the direction of three different vanishing points. Figure 12-18 shows an example where the box on the top is the first you see, followed by the box in the middle, and then the box on the bottom. You can see how the square edges of the boxes line up nicely with the parallel lines leading to the same vantage point that moves down and meets below ground level.

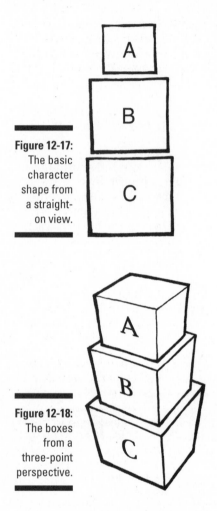

Figure 12-17:
The basic
character
shape from
a straight-
on view.

Figure 12-18:
The boxes
from a
three-point
perspective.

Nonlinear body shape

Most characters you draw will probably be nonlinear (unless you're drawing robots), which means they lack the hard, sharp angles and edges you find on more linear objects like a TV or refrigerator. Your characters probably won't have the perfectly square shapes that the three stacked boxes have in the previous section. They'll have more curves and be more rounded, and lining up something without clear lines to a vanishing point may prove to be frustrating to you. However, if you know how to line up the basic body shapes of your characters (circles and ovals), then drawing them in perspective may prove easier than you think.

TIP

If you draw your characters in a normal, straight-on view, the shapes need to line up so that A, B, and C are lined up. Figure 12-19 shows an example with three circles stacked on top of each other. Each circle has a label — A, B, or C. The head and neck area is circle A, the torso and arms area is circle B, and the legs and feet area is circle C.

Figure 12-19:
The basic character shape from a straight-on view.

How would you draw that same character in three-point perspective? If you think in terms of three balls stacked on top of one another, what would you see first? The answer is the top ball, or A circle. You'd then see the second ball, or B circle, and then the third ball, or C circle. So to draw the balls in three-point perspective, draw horizontal and vertical center guidelines to help determine the middle line and give the shapes some dimension. Figure 12-20 shows an example.

Figure 12-20:
The ball frames in three-point perspective.

By erasing the lines from inside the balls in Figure 12-20, you can create a solid body look. You can see the top of the A ball and see balls B and C as they stick out from under the top ball (see Figure 12-21), which gives you a snowman look.

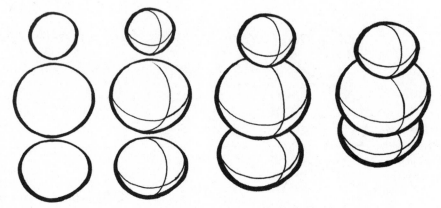

Figure 12-21:
Three balls form a snowman.

Drawing from the top of the head down

Using the three stacked balls sample from the previous section as a guide, you can draw a character in the same fashion. You see that the character in Figure 12-22 is very much like the three stacked balls in the degree to which each body area is visible to the viewer. The first thing you see is the top of the head, then the torso, then the legs and feet. These areas follow the three stacked balls A, B, and C.

As you move the balls in line with one another so that the top ball is more visible than the balls below it, the perspective becomes more of a bird's-eye view. Secondly, the distance between the A and B areas becomes shorter, and area C begins to disappear altogether. If you were standing directly above someone, you probably wouldn't be able to see his legs or much of his shoes.

Figure 12-22:
A character from three-point perspective.

As you develop your story line and comic layout, you draw your characters with objects surrounding them. The objects surrounding the character may have a linear or boxy shape. Despite this, the character's nonlinear shape fits well and looks natural by comparison. That's because both the linear and nonlinear shapes are drawn in the correct scale and perspective.

Drawing characters in the correct scale

You want to make sure your characters are drawn to the same scale as their environment, or they won't look realistic. Although you may occasionally want a character to be out of proportion with his surroundings, usually to exaggerate a point, most of the time, you want the environment and the characters to look as if they're living in a cohesive, balanced world.

The scale you draw your characters to depends on whether they're in the foreground or background of your cartoon. The decision to place your characters in the background or foreground depends on your story line or a decision to add visual drama and interest to the composition. The following looks at a few options you have.

Small scale; characters in the background

Characters in the background of a drawing appear smaller and smaller the closer they are to the vanishing point on the horizon line. For example, the character sitting in the chair on the left in Figure 12-23 has no background or foreground objects to indicate any type of scale. The same character on the right is shown sitting on a chair in the background of the drawing. Taking the same character and placing him in a setting demonstrates the importance of proper perspective and scale. The objects in the foreground are larger in scale compared to the character in the background.

Figure 12-23:
From this perspective the character on the right appears to be in the background.

Figure 12-24 shows the vantage if you were sitting on the floor looking from one cubicle to another. The dramatic perspective of the layout allows the reader to see all the way up to the lights on the ceiling as they become smaller in scale and move farther away behind the other cubicles in the office. The ends of the lights are in alignment with the vanishing point for this composition, as are the ends of the cubicle walls and the computer equipment in the foreground.

Figure 12-24:
The character appears smaller in scale in relation to the surrounding objects.

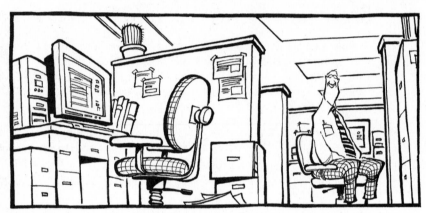

Large scale; characters in the foreground

Objects in the foreground of a drawing appear larger compared to surrounding objects as they get closer to the viewer and farther away from the vanishing point. The character sitting in the chair on the left in Figure 12-25 exists in a void; he has no point of reference around him to indicate scale. The same character on the right is in the foreground of a drawing and appears larger compared to the objects in the background.

Figure 12-25:
From this perspective, the character on the right appears to be in the foreground.

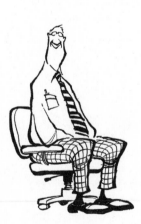

Putting the character in the foreground (see Figure 12-26) gives the character an entirely different look compared to everything around him.

Figure 12-26: The character appears larger in scale in relation to the surrounding objects.

Looking up: The worm's-eye view

You can also view three-point perspective from the ground up. The worm's-eye view looks upwards at your cartoon world. This can be a humorous or dramatic point of view, and one not usually seen after you leave toddlerhood behind. Here's what the three stacked balls would look like at that angle.

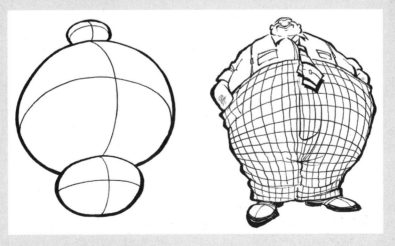

Chapter 13

The Art of Lettering

*W*hen you first start cartooning, you may be concentrating on the drawing aspect, getting all your characters to look just right. However, the best cartoons in the world are pointless unless they *say* something. Generally, your characters need to speak, and because they can't speak out loud, they have to speak with printed words.

To give your cartoon characters a voice, you want to use the appropriate cartoon lettering. The look and feel of the lettering can convey just as much as the words themselves. To create just the right lettering for your cartoons, you can either draw it by hand or use computer-generated lettering. In this chapter, I talk about the different types of lettering found in cartoons and how to choose the letters that best bring your characters to life.

Preparing to Letter

Most cartoon characters "speak" using printed words that are often (but not always) surrounded by a frame. You can draw the best cartoons in the world, but they can fall flat when combined with lettering that's substandard, illegible, or sloppy. Lettering is crucial to the art as a whole in several ways:

 ✔ It affects the cartoon's visual appearance.

 ✔ It allows your characters to communicate.

 ✔ It contributes to the story or gag line by making it comprehensible; obviously, if people can't read your writing, you have a big problem on your hands!

In addition to serving a communication function, great lettering should also complement the art and be part of a larger creative narrative. In other words, great lettering should be art, too. To make your lettering help your cartoons stand out, check out the following sections for some basic ideas to help you get started.

Appreciating the role lettering plays

Lettering plays a crucial role in the success of your cartoons and comics. The lettering you choose to use should reflect and enhance the tone of your cartoon. The wrong type of lettering can create an incongruous or jarring effect, so lettering is one thing you want to get right.

You can create lettering styles in a variety of line widths ranging from very fine to heavy (see Figure 13-1 for some examples). However, you want to create your lettering with a line width that's consistent with and complementary to the line width that you draw the rest of the art in. Typically, the line width for the lettering is smaller than that of the line art. And unlike the varied line width of the line art, you want to keep the line width for the lettering the same so that the reader can view it easily.

Figure 13-1:
Line quality for your lettering can vary from regular to bold.

You may want to choose a pen tip that's fine or medium for the basic lettering and a thicker pen tip for lettering you use for emphasis or action, much as you would use normal typeface in a printed word document and bold typeface occasionally to make something stand out.

Spending time perfecting your skills

The art of lettering doesn't always come easily to cartoonists. The ability to letter clearly and legibly, and to make the lettering appealing and not stiff or forced, takes time and practice. Lettering is a separate skill from drawing, and you shouldn't neglect or overlook it. As your skills progress, you'll become more comfortable lettering and more confident at it.

Begin by sitting down with a pad of paper and practice drawing out your lettering. As you practice, you may want to use a ruler and create a horizontal baseline to use as a guide so that the bottom of all the letters sit on this line and create consistent spacing from the words below it. Draw a series of horizontal lines and place them on top of each other, spaced evenly apart so that they can accommodate regular-sized handwriting written out on each line.

You may choose to experiment with your own lettering style or mimic well-established lettering like a Serif style. Thousands of font styles are available. Buying a font style book or downloading a font guide from the Internet can help you create and draw your own lettering style.

Selecting the right pens

Every professional cartoonist gets asked two questions more than any other: "Where do you get your ideas?" and "What kind of pens do you use?" When creating your cartoon's lettering, choosing the right pens is a crucial decision. Most cartoonists use a specific pen to letter with, one that differs from the pen they draw with. When selecting your pens, base your choice both on personal preference and the type of results you're looking for.

The best place to start when selecting a pen is the local art supply store. Most stores carry a wide assortment of pens and even allow you to try them out before you buy them. Take advantage of this — scribble and doodle to get the feel for the right pen for you.

Look for pens that don't smear and dry quickly. Also look for pens that have a solid line quality and adhere well to the paper on the first application. You don't want to buy a pen that requires you to go over your lines many times to achieve a solid line.

The pen most cartoonists choose for lettering is capable of achieving the small detail work required for lettering. One of the most popular series of pens to come along in recent years is the Pigma Micron pens. The unmatched quality of Pigma Micron pens makes them the preferred choice of professional cartoonists and illustrators looking for precision. See Chapter 3 for more about the different types of pens used for cartooning in general.

Making Lettering Part of the Art

Lettering communicates directly to readers by conveying the story or punch line, just as text from a book does. However, cartoon lettering differs from the text of a book or newspaper because it's actually part of the art.

Lettering is a crucial part of the overall composition. Good cartoonists make sure that their lettering complements their style and doesn't fight against it. Lettering should be easy to read but also organic; it should flow with the rest of the art. Certain types of lettering flow naturally with certain cartoon types; others clash because they "say" different things.

Cartoonists have numerous options when incorporating the lettering with the art. The following sections explain this in more detail.

Knowing the differences between handwritten and computer fonts

Cartoonists need to have a good eye for design, and lettering is a part of the design. You can choose to letter any way you want. The only real requirement is that your lettering is legible to the reader. When actually creating the lettering, remember that the letters should always be large enough for the reader to see without dominating the composition or overshadowing the line art itself.

You basically have two options when creating lettering: handwritten or computer-generated fonts. Each has its pros and cons.

Handwritten lettering (Figure 13-2a) has the following going for it:

- It looks more natural.
- It better complements the surrounding cartoon.

Handwritten lettering has the following negatives:

- It takes more time to create.
- It takes more effort to ensure that the text is consistent.

Meanwhile, computer type font (Figure 13-2b) has a couple of advantages:

- It's easy to create.
- It's easy to read.

Using computer type font does have its drawbacks, including the following:

- ✔ It looks stiff.
- ✔ It doesn't make your cartoon distinctive.

Many amateurs use fonts because they're impatient or because they lack the skill to hand letter correctly. But lettering that's sloppy, badly spaced, too stiff, or illegible gives the impression to the reader that you may not know what you're doing. The best remedy for this is to practice. If you're a cartooning newbie and want an easy solution, go with the computer font and check out the "Going the Simple Route: Picking a Type Font" section later in the chapter. If you want to try your hand at crafting your own lettering, check out the "Going the Hand Lettering Route" section.

Figure 13-2:
Handwritten
lettering (a)
and com-
puter font
lettering (b)
both have
pros and
cons.

Placing your lettering

Where to place your lettering is an important and sometimes difficult decision that may force you to modify the cartoon's composition. You have a couple of basic options when it comes to placing the lettering:

- ✔ Incorporate the text *inside* the cartoon's composition.
- ✔ Place the text *outside* the cartoon's composition.

Often, the option you choose depends on spacing and the type of format you use to draw your cartoons. In a multiple panel layout, you have the luxury of more space, and incorporating the lettering inside the composition may be a better option, as in Figure 13-3.

However, if you're drawing a single panel cartoon like *The Far Side* or *Family Circus* and you need all the available space in the panel for art, then placing the lettering outside the cartoon is a better option, as in Figure 13-4.

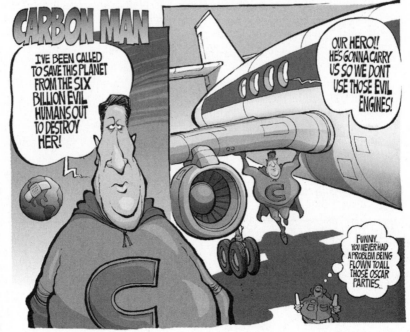

Figure 13-3: Lettering incorporated inside the art can help the story line flow.

Figure 13-4: Lettering placed outside the cartoon's composition allows for more space to draw in.

Fitting in your lettering

Finding the right spot to place your lettering depends on how busy or complicated the art is. The more text you have, the less available space remains for the art. However, sometimes you can't avoid using a lot of text; in this case, just be sure to leave plenty of space when you're sketching so you don't have to erase any art later.

When you write down an idea for a cartoon strip, comic panel, or editorial cartoon, the idea comes without regard for spacing or the layout challenges you face when it comes time to put pen to paper. You may have a great idea or story line that requires a lot of dialogue. This results in your having to incorporate the lettering somewhere in the composition without it obstructing the art and impeding the art's ability to tell the story.

To get your lettering to fit, I suggest you experiment. Try placing the text in different locations in the panel, and play around with different text sizes. Try different options to see how your lettering fits with the art until you find one that looks best for your cartoon, as in Figure 13-5.

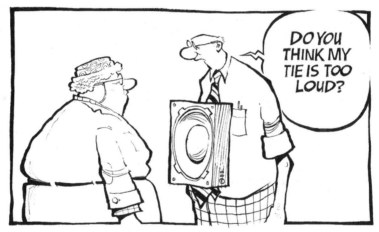

Figure 13-5: You have many options when choosing where to place your lettering.

Utilizing word balloons

Word balloons are unique to cartoons. The *word balloon* is that round bubble with a squiggly tail that floats around inside most cartoons and contains dialogue or a character's thoughts. When you draw word balloons, you have a couple of basic options:

- Round and symmetric, as in Figure 13-6a
- Unstructured or organic and blended into the surrounding art, as in Figure 13-6b

Deciding what kind of word balloons to use really depends on the overall style and feel of your line art. If your style is loose and spontaneous, then a hand-drawn word balloon is more suitable to the overall design. However, if your style is cleaner and more linear, then the more symmetrical word balloons may better complement the surrounding layout. Of course, none of this is absolute, and you're free to use your own imagination and creativity to experiment to find out what works best for you.

The origins of word balloons

The word balloon was invented more than 150 years ago when cartoons became popular in newspapers. The invention of the word balloon stemmed from the need to separate the text from the rest of the art and to have a buffer of white space around the text, allowing it to stand out and be easily read.

Word balloons have evolved over the years, just as styles have evolved. You can clearly see this evolution if you study many of the classic cartoons over the past century to see how different cartoonists have experimented with various word balloon techniques. Around the turn of the century, word balloons were small

and drawn closely around the text. Word balloons became bigger and incorporated more white space among the wording as cartoonists' styles became more simplified and cartoony. However, no fast or hard rule exists as to how you have to draw a word balloon. Like the style in which you draw the line art, the word balloon is a matter of preference and what looks and feels right to you.

In any case, the original purpose of the word balloon still stands — to create a designated place for the dialogue text to appear that's separate from the rest of the line art.

Figure 13-6:
Word
balloons
can be
symmetrical
and even (a)
or loose
and hand-
drawn (b).

Going the Simple Route: Picking a Type Font

Lettering can be a tedious task, because creating legible, consistent lettering takes time. After a while you may dread lettering your cartoons. You're not alone if lettering makes you nervous, or if the thought of hand lettering a text-heavy story line makes you cringe. Many cartoonists find lettering a boring task that takes away from the actual joy of drawing.

If lettering your cartoons is causing your blood pressure to rise, one solution is to type out the text after you scan the cartoon into your computer in Photoshop. (See Chapter 15 for all the tricks available through Photoshop.) The drawback to this method is that your cartoon contains a standard type font, and, more often than not, it doesn't look original.

If you do choose to go the type font route, many fonts are available. If you're using Photoshop, the fonts you typically have in your computer's font manager are available for you to use. You may also purchase a font suite package that comes bundled with hundreds of different styles for you to choose from, if you want something a little different.

Going the Hand Lettering Route

Perhaps you want to be a tad more adventurous and want the lettering in your cartoons to have more of an original look and feel. If so, you may want to consider hand lettering your cartoons rather than using computer type fonts. Hand lettering is more than just writing out dialogue in your normal handwriting. As you begin to letter, you discover that you really are drawing each character letter instead of writing it.

Doing your own lettering takes time, patience, and practice. I suggest you work on your lettering and come up with a style that best fits the overall style of your art and the cartoon itself. This section helps you take your handwriting and turn it into cartoon lettering.

Creating your own unique fonts

You basically have three options when creating your own fonts. You can use a computer program, which is one of the easier ways; you can attempt to manipulate your handwritten font on-screen in each cartoon; or you can experiment and create your own handwritten font. This section looks at these three options.

Using a computer program to make a handwritten font

One alternative to using preexisting type fonts is to create your own font. You can use your own handwriting or use a computer font program to help you produce your lettering. You can purchase one at any computer software retailer or order a copy on the Internet. Several software programs can help you accomplish this goal; two well-known programs are Fontifier and YourFonts. These programs provide you with easy, step-by-step instructions on what you need to do to take your own handwriting or hand lettering and make a font out of it.

In order to create your own font using one of these programs, follow these general steps:

1. **Write out the alphabet in a style of your choice.**

 You can use your own daily handwriting or actually draw out the individual letters in a bolder, more stylized fashion. You may also want to write out the letters in rows of four letters each.

2. **After you finish writing out the lettering to your satisfaction, scan the letters into the computer.**

 You may want to scan this in at 600 dpi or better so that the letters are crisp and clean.

3. **Open up the font creation program and import the newly scanned alphabet images.**

4. **Follow the specific instructions on formatting.**

 When completing this process, the end result will be a new font file with the letters you created in it.

5. **Upload the new font file to your computer's font manager, and the font will be available for you to use in a variety of programs, depending on what you have installed on your hard drive.**

One thing you can't escape when using a type font is that the letters and lines of text appear uniform. This is especially noticeable with a regular text font, but it's also obvious in your own handwritten font. This uniformity creates an artificial and rigid appearance, which is caused by what's known as a *baseline,* or the line on which the letters sit. The baseline is there to make sure the typeface is straight and level and creates a uniform structure. The baseline is part of the font type program and is created automatically.

Manipulating after you type

One way to make the font look more handwritten is to manipulate it after you type it out in the computer font you create. You may want to go back and move random individual letters or words just slightly so that they no longer line up rigidly on the baseline. Doing so allows you to create text that has a more organic appearance, similar to if you had written it out by hand (see Figure 13-7).

If you decide to go this route, know that it's very time-consuming; it may take as much time as it would to letter by hand in the first place! However, if you feel your hand-lettering skills aren't up to par yet, this may be a viable alternative.

Figure 13-7:
The font in the top balloon appears normal, while the same font in the bottom balloon has been manip-ulated.

Experimenting with your handwriting

When you write your lettering by hand, you can also experiment with differ-ent scripts, varying them with different cartoons or to change the mood or feel of a cartoon. Your options are endless, so take a notepad and try differ-ent ones. However, when you decide to go down this road, you need to make sure your lettering is consistent from cartoon to cartoon so that readers can easily identify your work. For example, you may create a standard-looking cartoon lettering in capital letters, like in Figure 13-8a. If you want to get a little more whimsical and fancy, you may try something that looks more handwritten, such as Figure 13-8b. Peruse the comics to get ideas for differ-ent types of scripts.

Figure 13-8:
Lettering styles can be diverse. Feel free to come up with your own hand-writing font.

EXPERIMENT WITH LETTERS TO TRY AND

a

come up with a style that works for you.

b

Creating drama with action words

You can add as much show and fervor to your comics as you like, and doing so with a handwritten font is easy. Everybody is familiar with the classic comic book action-style words like BOOM!, POW!, and WHAM! These words and the way they're drawn create a sense of action and add drama to the visual story line. They can also serve as an important artistic element to the overall cartoon.

You can see how this type of bold lettering can convey action and is dynamic in its visual impact and expression, as in Figure 13-9.

Figure 13-9:
Action words can help visually convey important story line elements.

Such words not only tell part of the story line but also add interest and action visually, as in Figure 13-10.

Figure 13-10:
Action words can add visual interest and convey excitement to the cartoon.

Keeping Track of Your Spacing

The spacing between your words and letters is important, whether you choose to use a type font or letter by hand. Keep the following in mind to keep your spacing looking good:

- ✔ **If you hand letter:** The tendency is to run the letters or words too close together. The end result is sloppy lettering that may not be easy to read. The best solution for this is to draw out guidelines so that each letter and word has a baseline. As you write out the text, you simply line up the bottom of each letter along the line, which creates a consistent space between the top line and the line below it.

- ✔ **If you use a type font:** The opposite of sloppy is often true. The end result is text that appears too perfectly spaced and stiff and doesn't look quite right against the backdrop of the rest of the hand-drawn art. To counter this, choose a font that appears to have more movement; this makes rigid spacing far less noticeable.

Chapter 14

Directing the Scene

● ●

● ●

*T*he way you draw the background, the details you include that make up the environment, and the manner in which you place figures all contribute to the story that your cartoon tells. Even the simplest sketch benefits from a proper layout and details that make the cartoon background come alive.

You want your cartoons to be more than just characters walking around in blank space. The characters need a home — a background that lets the reader know where they are. In this chapter, I take apart cartoon layouts to explain what components make for a great layout. I also show you how to add the background details that make your cartoons fun and visually interesting.

Eyeing the Importance of Layout

When moviemakers begin production on their new picture, one of the most important things they need to consider is the layout. How will things look through the camera lens? One of the ways filmmakers do this is by story-boarding the movie. A *storyboard* is essentially a large comic strip of the film produced beforehand to help filmmakers see how things will play out.

Layout and design are crucial to the storyboarding process, and you should view comic strips in the same light. When designing your comic strip, think about layout as if you were making a movie. *Layout* is basically the collective relationship among the characters, backgrounds, how you decide to show each individual panel, and how these components all work together to tell a story.

Your cartoon, like a movie, cuts from shot to shot; some shots are close-ups and some are long shots. You may show some shots from a certain perspec-tive to create drama, or you may show the characters in silhouette to break up a monotonous visual story line.

Your cartoon story will be more interesting and appealing to the reader if the art and layout changes from panel to panel and you avoid showing just a bunch of talking heads (although that's fine in some cases, if the story warrants it). Character placement, the perspective you choose, and the angles you use in each panel are all important aspects of a good layout that also add to your cartoon's appeal.

This section gives you the lowdown on putting together your cartoon's layout, knowing the differences between background and foreground, using shadows effectively, and adding important details.

Planning your layout

Layout is such an important facet of drawing cartoons. You don't want a flat and boring cartoon, so make sure your cartoon world is as graphically interesting as the real world. Experimenting with different perspectives, angles, and background details can help improve your story line and increase your cartoon's visual impact.

The basic layout of the art and the placement of the characters and scenes are dependent on the story line. After you write the *script* (what the characters say in the word balloons; check out Chapter 13 for more info), you must plan the layout and the individual comic panels. You may go through several different layout roughs before achieving the desired flow.

Your layout varies depending on whether you're doing a daily comic strip layout (see Figure 14-1) or a Sunday comic strip layout (see Figure 14-2). Each format has certain size restrictions and limitations:

✔ **A daily comic strip layout is limited in space.** The most common strip size that cartoonists use to draw is a horizontal strip that's about 4 x 13 inches. Then the strip is sent to the syndicate, which formats it and reduces it down to run in the newspapers. This size is challenging for cartoonists to work with because they simply don't have a lot of room to draw and tell a story. Being creative in this format requires the cartoonist to use the individual panels efficiently.

✔ **Sunday comic strip layout sizes are typically bigger than the dailies.** The Sunday features are also horizontal and reduced down to fit on a newspaper or magazine page, but they're not reduced as much as daily strips. They're usually drawn at around 10 x 14 inches and then scaled down to fit the size that runs in the newspaper. This size isn't as challenging for the artist as the daily size and permits the cartoonist to be more creative in the use of the individual panels.

Although webcomics have no standard size, many Web cartoonists design their comics similar in size to a Sunday multipanel layout format.

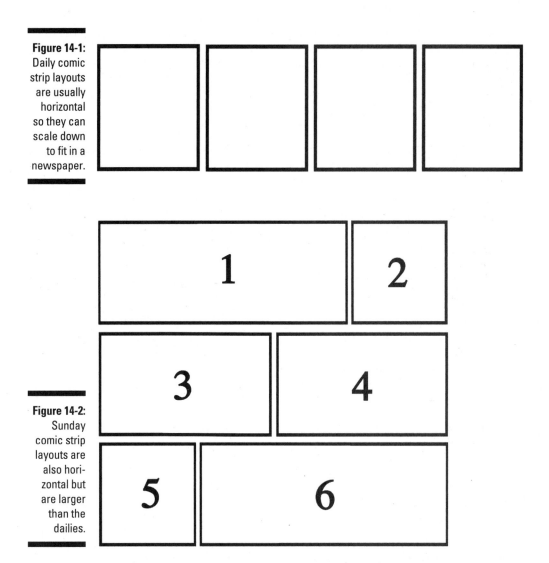

Figure 14-1: Daily comic strip layouts are usually horizontal so they can scale down to fit in a newspaper.

Figure 14-2: Sunday comic strip layouts are also horizontal but are larger than the dailies.

Comparing foreground and background

Deciding whether to place characters or objects in the foreground or background of your cartoon is an important decision that affects your story line. The *foreground* is generally where the main action takes place; objects in the foreground often appear more dramatic because of their larger scale. In contrast, being in the *background* allows readers to view an object more completely, depending on how far back the object is placed. Images in the foreground can add drama to your cartoons, and images in the background can add detail and texture.

Figure 14-3 is an example of an image in the immediate foreground. As you can see, the door is positioned so that you see only a close-up of the middle section and door knob. The clothes hanging in the closet are also in the foreground. The combination of these two views gives the impression that the viewer is in the closet looking outward. The choice of placement adds drama and scale to the layout and composition.

Figure 14-3:
Images in the immediate foreground create drama and scale in the layout.

Figure 14-4 shows an example of an image in the distant background. The choice of placement adds perspective and depth to the layout and composition.

Figure 14-4:
Images in the distant background make the drawings more dimensional.

Telling the story in shadow

A four-panel comic layout can be boring and repetitive if each panel looks the same. One way to add a little variety is to have the images or characters in one of the panels appear in shadow or silhouette. Using shadows and silhouettes in the course of comic storytelling can be a powerful way to communicate mood or tone.

For example, if the first two panels of your cartoon are action-oriented and then you pull back to show the characters in shadow or silhouette in panel three, the art and punch line in panel four may have a stronger impact on the reader. The visual joke delivers more punch because of the delay in panel three. This is similar to a comedian pausing for just a moment right before he delivers a joke's punch line.

Figure 14-5 shows how drawing characters or other objects in a panel using a shadow or silhouette can play out visually.

Figure 14-5:
Having characters in shadow can create visual drama and break up the art.

Creating visual drama

You can also experiment with your cartoon's layout and create visual drama in a comic panel. Some of the ways to add visual drama to your cartoons include

✔ **Drawing things from a dramatic perspective.** Drawing buildings or cityscapes from dramatic angles helps create scale and can have a dramatic impact. For more information about drawing things in perspective, thumb through Chapter 12.

✔ **Showing foreground objects in extreme close-up.** Not everything in your layout has to be the same size and scale. Drawing objects in large scale and placing them in the foreground helps create dramatic weight

and can be an excellent layout strategy. For example, say you squat down next to a car's bumper while looking past it down the street. If you sketch that scene, you have both a prominent object in the foreground (the bumper) and other, smaller objects off in the distance.

Setting the Scene

The sets you design in a comic strip setting serve the same purpose as in movies. In a movie, the set designer creates and builds the sets in which the actors interact with one another. With a cartoon strip, you don't construct actual sets, of course, but the background is just as important. You want to capture the appropriate details and objects to make the set look realistic while also making the art interesting for the reader to look at. This section covers how you can create amazing scenes for your cartoons.

Details make the difference in a scene

You want your cartoon's setting to be accurate and believable but also to have personality. You want the setting to reflect the style in which you draw the characters so the art has a synergy and is appealing to the reader.

You can really create an interesting scene by all the little details you add. Just open your eyes and look at the hundreds of details around you. Details add a sense of authenticity to what you're drawing and give readers more interesting things to look at. It doesn't matter whether the scene is inside or outside — bedrooms, kitchens, offices, bathrooms, closets, garages, buildings, signs, roads, bridges, and fields are filled with all sorts of surfaces, textures, and shapes. For instance, if your characters live in middle-class suburbia, the details you add to the drawing tell readers a lot about the characters.

As an example, take a look at Figure 14-6. This room is plain and kind of stark. Perhaps the characters that live here are blue-collar, or maybe your comic is about a bunch of college students living in a small apartment who don't have much.

By comparison, look at the same room in Figure 14-7, which has many more details. This room is more interesting to look at because of the details like texture, depth, patterns, furniture, knickknacks, and so on. Not everything you create has to look like this fancy room, but at least you can see how the details make the drawing a better overall setting for your characters — and the more detailed version is a lot more fun to draw!

Much of the impact of this image relies on *overlapping,* which is key to understanding scale, object relationships, and depth. The chairs, table, lamp, and other objects are all positioned in the room so as to allow the viewer to see only portions of them as they sit behind larger objects in the foreground.

Figure 14-6:
This room is boring and lacks visual interest.

Figure 14-7:
This room seems like a much more enjoyable place to lounge around in than that other room!

Creating your scene

Much if not most of the time, the setting you choose is predetermined by your story line. If your story involves a new bride cooking Thanksgiving dinner for the first time, you're not going to use a national forest for the setting. Or if, for example, you have two characters walking and talking throughout the entire story line, you may want to set the scene outdoors so they can walk and talk for as long as you need them to, as showing the characters walking around and around the house would get repetitious and artificial. So let your story line naturally determine what kind of setting you choose.

A room with a view — setting the scene indoors

Creating a room for your characters is like being a set designer. You have to know all the elements that go into the setting, what looks good, and what works best for the story line.

To get a good feel for what goes into designing the indoor sets for your cartoon, take some time and walk around your own house and take some notes. How does your kitchen look and how is it laid out? What about the bathrooms and bedrooms? And the den? Making sure you include the right furniture, wall hangings, wallpaper patterns, and other particulars — right down to the door handles — helps you create an interesting, believable setting. As you create an indoor setting, don't forget to add elements that indicate an indoor setting, such as doorways, stairs, or pictures on the walls.

Figure 14-8 shows a bedroom. Details like the basketball on top of the dresser indicate that a teenager may live here — although the closet looks a little too neat to belong to a teenage boy!

Figure 14-8: This bedroom looks like a great place to catch some zzz's!

Figure 14-9 shows an example of a bathroom. Notice that such details as the shower curtain, lighting fixtures, and tiles add realistic and visually stimulating patterns to the composition.

Figure 14-10 shows an example of a kitchen. Details like the appliances, pots and pans, kitchen throw rug, and cabinets all add texture to the setting.

Figure 14-9:
This bathroom has a throne fit for a king!

Figure 14-10:
This kitchen is ready to cook in!

Urban planning — setting the scene outdoors

Setting a scene outdoors requires you to understand the urban landscape and all the trappings of a modern society. Take a stroll outside and take a good look around. What do you notice? In addition to trees, parks, grass, bushes, and so on, you may notice sidewalks, roads, power lines, billboards, signs, shopping malls, and all the other evidence of a commercialized, urban environment. This phenomenon has another name — urban sprawl.

Although this sprawl may inspire you to put on a pair of sandals and protest urbanization, drawing all this stuff can make for some interesting settings and backgrounds for your characters. Drawing outside details isn't difficult. Adding a bit of sky, clouds, street vendors, and vehicles gives the setting away and makes your background more interesting to look at, but don't stop there. Add elements that make your setting instantly identifiable.

Figure 14-11 shows an example of a rural outdoor setting. Notice big details like the truck and the trailer parked up on blocks, and smaller details like the broken blinds, wooden steps, and ugly front door — this ain't Park Avenue!

Figure 14-11: You can almost hear the hound dogs barking in the background of this sketch.

By contrast, Figure 14-12 shows a typical suburban street found in Anywhere, USA. Notice the details like the car parked on the street and the power lines off in the distant background. This is a generic, two-kids-one-dog family setting, perfect for the American Dream family.

Figure 14-12: This may look like the street you live on, if you're out in the 'burbs.

Part IV
Cartooning 2.0: Taking Your Cartoons to the Next Level

The 5th Wave By Rich Tennant

©RICHTENNANT

"This is how I grew up reading comic books, so this is how I'm gonna draw them."

In this part . . .

You have the basics of cartooning down, and you want to ramp up your efforts. In this part, I look at the incredible tools available to today's cartoonists, including computers, the image editing software Photoshop, and computer animation. All professional cartoonists today use computers as part of their art, and if you want to discover how to play with the big boys, this part can show you how.

Chapter 15

Cartooning in the Digital Age

Cartooning has changed in the last few decades, thanks to the power and creative ability of computers. Computers can make just about every aspect of cartooning easier, from creating and editing your art right on the computer to sending files to clients or newspapers almost instantaneously.

Computers can make you a better artist. Granted, the computer doesn't actually draw for you any more than a pencil draws for you, but computers can and do improve your skills as an artist by providing you with digital technology that's become essential in this competitive era. They make the production of your work much more efficient by allowing you to digitally color your art, easily correct mistakes, and format and e-mail your work to interested parties.

In this chapter, I look at the ways cartoonists work with computers on a daily basis and the ways you can use a computer to improve your work.

Digitally Formatting Your Drawings

Getting your artwork from paper to computer is known as *digitally formatting* your art. To get artwork from paper to computer, you need a basic piece of equipment known as a *scanner*. Scanners, or more specifically, *flatbed scanners,* are absolutely essential to cartooning today, because without one, you can't digitize your artwork.

With a scanner, you place your drawing face down on the surface like you would a copy machine. From your computer you operate the scanner controls, and within a few minutes your art is transferred digitally and appears on your computer screen, ready for you to color, e-mail, or post on your Web site!

Fortunately, scanners, compared to other computer devices, are relatively inexpensive. This section walks you through what you need to know about digitizing your art, including getting the right scanner, scanning in your work, and saving it in the proper format so you can work with it.

Choosing a scanner

To be able to digitize your artwork, you need to scan your cartoons into your computer. The scanner you select can make a significant impact on the quality of your digital work. When choosing a scanner, you have three basic options:

- **A relatively inexpensive flatbed scanner:** This type of machine can scan in black-and-white line art and text documents.

- **A full-color flatbed scanner:** This type can be quite costly, but it allows you to scan high resolution photos or other completed art.

- **An inexpensive three-in-one unit:** This option consists of a scanner, copier, and printer.

So which should you choose? I actually prefer options one and three; here's why:

- **You're probably going to be drawing your art on paper using black-and-white ink, pens, or pencils, and then using the computer to color it.** In this case, you need only a scanner with the ability to scan in your work at a relatively high optical resolution.

- **Most flatbed scanners do a great job scanning in basic black-and-white or grayscale images.** Thus you can take the less expensive route without compromising the quality of the finished product. The scanner I have cost about $150, and all I ever do with it is scan in black-and-white originals.

- **The more expensive, full-color scanners can cost thousands of dollars.** However, because I use Photoshop to color my cartoons instead of watercolors, markers, or paints, I never scan in anything but black-and-white line art, so I really have no need for a color scanner, and you probably won't either.

However, if you actually color all your artwork by hand with markers, colored pencils, or watercolors, you may opt for a full-color scanner, which can get expensive. Some of the three-in-one units allow for some colored scanning, although they usually don't produce high quality results.

Scanning your work into the computer

After you purchase a scanner, you're ready to start scanning in your artwork. Before you do so, you need to connect it to your computer, which is a simple process. All you do in most cases is this:

1. **Use a USB port or other connection method and follow the manufacturer's instructions to connect to the computer.**

2. **Install a scanner driver by inserting the CD that comes with the scanner into your computer's disc drive and follow the manufacturer's instructions on the software disc.**

3. **From the scanner monitor on your desktop, you're now ready to scan something in!**

The scanner is a relatively simple device to use; in many ways it works like a photocopier. A flatbed scanner is usually composed of a glass pane, under which is a bright lighting source that illuminates the pane, and a moving optical array. Just like a copy machine, you place the art or document face down on the glass and close the lid. When you press the start button (this is located either on the scanner itself or operated from the scanner driver installed on your computer's desktop), the sensor array and light source move across the pane, capturing the image you placed face down on the glass.

The main difference between a copier and a scanner is that with a scanner, the image appears on the computer screen instead of being printed out on a piece of paper. However, you can still print the image by using the print command on your computer after you save, change, color, or further enhance it on the computer.

Setting the correct resolution

Before scanning your work into the computer, you need to set the resolution on your scanner. *Resolution* affects the clarity of your image; the higher the resolution, the sharper the image will appear. Resolution is expressed as the physical dot density of an image or number of *dots per inch* (DPI) when the image is physically reproduced by being printed onto paper or displayed on a monitor. The higher the DPI, the clearer the image and the better you can see small details. Most scanners have settings that range between 25–9600 DPI.

Most black-and-white line art cartoons can be scanned in at between 300–600 DPI. This level of resolution ensures a nice, clean line reproduction and works well for newsprint. I don't recommend going below the 300 DPI level if your art will eventually be printed. However, you can go substantially lower, to 72 DPI,

if the image will be used only for Web reproduction. Computer monitors can display only 72 pixels per inch, so setting the DPI of your Web images higher than 72 only wastes file space.

However, scanning in your art at a high DPI level is always a good idea so that you have a high resolution original that you can copy and reformat later. Keep in mind that if you scan in the art at a higher resolution, the file size will be bigger, and this may make it harder to work with the file, depending on how much memory your computer has. If you stay in the 300–600 DPI range the file size should be manageable. You can always go down in resolution but you can never go up, as this will cause distortion.

To set the correct DPI, do the following. Figure 15-1 shows you a screenshot.

1. **Open up the scanner monitor on your computer desktop.**

2. **A box appears that allows you to configure the items you're about to scan.**

3. **Find the box in the scanner monitor that controls DPI and either move the setting up to increase the DPI or down to reduce it. Most scanner monitors also allow you to manually type in the DPI number setting you require.**

Figure 15-1: Choosing the correct DPI settings makes a difference in the clarity of your finished product.

Selecting a Photoshop mode: Bitmap, grayscale, RGB, and CMYK

When you scan in your artwork, you need to make one more decision. When using the most common software, Photoshop, you have to choose the correct mode because this helps format the item being scanned in for

optimum reproduction. Photoshop offers several different settings to choose from: bitmap, grayscale, RGB, and CMYK, each one appropriate for different purposes. If you're not using Photoshop, then the program you're using will have its own mode setting. However, it will also have bitmap, grayscale, RGB, and CMYK, as these are all universal. The next sections look at the pros and cons of each in more detail, so you can choose the right setting at the right time for your work.

Using bitmap

In my experience, scanning in your black-and-white cartoons as a bitmap is almost always best. You can always convert it to grayscale or CMYK later. Bitmap images are pixel-based. To understand what a pixel is, imagine an image of a beach ball drawn on a grid of 800 columns by 600 rows. Each cell of the grid represents a *pixel* of the larger bitmap image.

Scanning in line art as a bitmap ensures that the lines are crisp and the detail is clear as long as you don't increase the size of the art. When you scan in your artwork using bitmap, make sure you use a high resolution DPI level so that you have a high resolution original you can copy and reduce in size later if necessary.

The quality of a bitmap image depends mainly on its resolution, which is the number of dots or pixels per inch of space. Therefore, resizing bitmap images results in poorer image quality. Decreasing bitmap image size means decreasing pixels per inch, so some pixels are removed. This results in less sharp images. This only works if the art stays the same size as it was originally scanned or is reduced during the final printing/reproduction in a newspaper or magazine.

Increasing bit map image size means that new pixels have to be created. These new pixels can be only approximations and not accurate replications of the original pixels. This results in splotchy images with lots of pixel noise.

A bitmap image is resolution-dependent, because it uses a fixed number of pixels to represent its image data. Zooming the bitmap image of the beach ball causes it to lose quality and detail as the image data contained in each pixel isn't scalable.

Choosing grayscale

Sometimes you may want to scan in your original line art as a grayscale image. *Grayscale* means exactly what it sounds like, an image absent of color done in a range of gray shades. Most of the time this is best suited for photographs and not line art. However, in some situations you may choose to first scan in

your work in grayscale. For example, if you draw your cartoons using an old-fashioned shading material like Zip-a-tone or Duoshade, you want to scan in your art as a grayscale. If you were to scan in these products using the bitmap setting, the art would appear as dark line art and would fail to pick up on any of the gray or shading elements.

However, if your line art is a simple black-and-white drawing with no shading or color, your best choice is to scan in your artwork as a bitmap and convert into grayscale afterwards. If you scan in your black-and-white line art as grayscale, the blacks may appear as dark gray and the line work may appear a little fuzzy.

The main reason you scan in line art as a bitmap is so it picks up the black lines in a nice crisp fashion. However, you can't do things to the drawing while it's in bitmap mode. You must then convert it to another mode format.

Moving into color: Comparing RGB and CMYK

Before you can begin to color your artwork, you must convert it from bitmap to grayscale and then to a color mode. You may wonder why you can't save it directly into a color mode. In order to ensure that your line art is crisp and true black, you must scan it in first as a bitmap. If you scanned it in directly as a color file, the line art would appear dark gray and the file would probably be too big to work on without using up too much of your computer's memory.

Also, Photoshop doesn't allow you to color your files or create layers until your file is changed from a bitmap to a color mode.

You have two basic color modes to choose from:

- ✔ **RGB:** RGB is an abbreviation for Red, Green, and Blue. Display devices generally use this color model. One of the most difficult aspects of desktop publishing in color is color matching — properly converting the RGB colors into CMYK colors so that what gets printed looks the same as what appears on the monitor.

- ✔ **CMYK:** CMYK is an abbreviation for Cyan, Magenta, Yellow, and Black. CMYK is a color model in which all colors are a mixture of these four process colors. CMYK is the standard color model used in offset printing for full-color images. Because such printing uses inks of these four basic colors, it's often called four-color printing.

If the image you create in Photoshop will ultimately be printed, it's best to create it in CMYK. To do so, look at Figure 15-2 for direction. CMYK is best for art that needs to be color separated, like a T-shirt design, for example. RGB is good for files that will be viewed only on the Web.

Figure 15-2:
Choosing
the correct
mode is an
important
decision.

Getting a Grasp on Photoshop Basics

Drawing your cartoon is the first step; scanning it into the computer is the second. Step three is using a computer program, such as Photoshop, to transform your cartoon by cropping, editing, enhancing, lightening, darkening, shading, adding color, or just about any other editing graphic you can think of. Because Photoshop is by far the best program for working with digitalized art, I focus the rest of this chapter on using Photoshop.

Photoshop is a graphics editing program produced by Adobe that you download to your computer. (For a book full of information, check out the latest version of *Photoshop CS4 For Dummies* by Peter Bauer, published by Wiley.) This section gives you an overview of the important features of Photoshop and how to turn your black-and-white sketched drawing into a full-color digitalized masterpiece.

Becoming acquainted with your toolbar

Figuring out how to use Photoshop starts with a thorough understanding of all the features it contains. After you open your cartoon in Photoshop, several control panels appear on your desktop, one of which is long and narrow.

This toolbar (see Figure 15-3) is full of features that are helpful for cartoonists. To be able to fully utilize Photoshop and all its bells and whistles and to get the most out of the program, you need to familiarize yourself with this toolbar. Here are the main tools and what they do:

1. **Burn tool:** Darkens an image. To use this tool, just drag it over the image.

2. **Cropping tool:** This tool changes the size of the image. To use, select the area you want to crop and then press enter.

3. **Dodge tool:** The Dodge tool lightens an image. To use, drag the icon over the image you want to lighten.

4. **Eraser tool:** This can erase part of the photo in a certain layer. To erase everything in a certain area to make it white, flatten the image or go through every layer to delete that part.

5. **Eyedropper tool:** Samples a color from the picture, color swatches, or the color picker. To use, click on the color on the image you want to take and right-click.

6. **Hand tool:** Moves around an image within an object. Use with the Zoom tool when you want to adjust the section of picture you want to look at.

7. **Lasso tool:** The Lasso tool can select areas within a layer that can't be reached with the Marquee tool.

8. **Magic Wand tool:** The Magic Wand is an automatic selection tool. It selects everything in the layer.

9. **Marquee tool:** This is a group of tools that allows you to select rectangles, ellipses, and 1-pixel rows and columns.

10. **Move tool:** This tool moves around all objects within a layer. To move an entire image, flatten the layers by selecting Layer, then scroll to Flatten Image.

11. **Paint Bucket tool:** Makes an area one color. To edit all layers at one time, click on All Layers at the top of the window.

12. **Pen tool:** The Pen tool makes lines and can be used with shape tools to create different shapes. To create lines, use the Pen tool to create anchors (the little boxes on a line) and change the shape of the line by moving around the anchors.

13. **Pencil tool and Brush tool:** Draws or paints a line. Same as the Pencil or Brush tool in Paint. Change the color of the paintbrush by clicking on the color picker.

14. **Sponge tool:** The Sponge tool soaks color out of the image. Drag the tool over the section of the image you want to change to use.

15. **Type tool:** Puts text in a picture. Click on the picture with the Type tool and select a box the size of the area you want to add text. Type in the box, then adjust the size of the text box.

16. **Zoom tool:** Zooms in on part of the picture for closer editing.

17. **Gradient tool:** Use this to highlight a color and make it fade from dark to light.

18. **Airbrush tool:** Use this tool to create a soft spray and clouding technique.

19. **Blur tool:** Use this tool to soften sharp edges.

20. **Measure tool:** Use this tool like you would a ruler.

21. **Rubber Stamp tool:** Use this to replicate the same pattern or image.

Figure 15-3: Learning to use the toolbar is essential to becoming an efficient cartoonist.

Cleaning up your artwork

Before you can color your cartoons, you need to whip them into shape. This may involve cleaning up pencil lines that show up after you scan in your line art, or perhaps moving elements of the cartoon around to make a better composition. These things are easy to do when you know what tools work best to accomplish this.

The tools on the toolbar can save you time and create a better looking cartoon in a number of ways. The toolbar has many helpful tools. I focus on a few of the primary and most helpful basic tools in this section.

The Eraser tool: Cleaning up your art digitally

One of the great things about working with art in the digital age is that you can modify your art using the computer in ways you never could before. The ability to modify your artwork on the computer helps produce clean, crisp art. The Eraser tool in Photoshop is one of these great tools that make your job a lot easier.

After you scan in your artwork you may find smudges, smeared lines, or other imperfections in your line art. These types of imperfections have a way of becoming even more noticeable when the art is reprinted, at which point it's too late to clean it up.

The old way of cleaning up your art required you to erase all your pencil lines after the ink dried so that these small lines wouldn't show up when your cartoon was reprinted. Typically, a cartoonist would sketch out the drawing with light pencil lines and then move to the final phase of the drawing known as *inking*. Using the light pencil sketch as a guide, the artist would either take a pen, nib, or brush and go over the pencil lines, creating a nice crisp final drawing.

After the ink dried, the cartoonist would erase the light pencil lines. Artists have done this for several hundred years of newsprint production, and it generally works pretty well, except for the following problems:

- It can be messy with all the little shavings that are produced as a result of the erasing.
- You may get some ink smearing.
- You risk lightening up the art by causing your inked lines to fade.
- It can take some time to get rid of all the pencil lines depending on the complexity of your drawing.

Using the Eraser tool effectively can streamline the process of cleaning up your art. One thing that I suggest is to use a nonphoto blue pencil for sketching instead of using a dark pencil. Anything drawn with nonphoto blue pencil isn't picked up by the scanner, and you won't have to waste time erasing anything.

To use the Eraser tool, follow these steps:

1. **Click on the toolbar icon that looks like an eraser, as in Figure 15-4.**

 Doing so changes your cursor into an eraser.

2. **Adjust the size or diameter of the tool to very large or very small.**

If you have a lot of erasing to do, you may need to enlarge your Eraser tool so that it covers more area. To do this, choose the diameter setting from the brush palette. You can either choose one of the sizes listed or create your own size by manually adjusting the diameter size by moving the size adjusting arrow up or down.

3. **Erase any unwanted lines, spots, or other imperfections that aren't supposed to be part of the original art.**

Figure 15-4:
Editing and
erasing
in the
computer
is easy and
efficient.

The Lasso tool: Moving or scaling an image

One great thing about Photoshop is that it allows you to edit and change your art in ways that would have proved nearly impossible before. The Lasso tool is an example. This tool icon looks like a rope lasso, and it allows you to literally lasso part of the art and move it around (see Figure 15-5).

Before this tool was available, cartoonists had to white out the area they wanted changed and redraw it, or physically cut it out and glue or tape it in the new area. With the Lasso tool you never have to do that again.

Figure 15-5:
The Lasso tool can help you adjust the composition for a better cartoon.

Say you hand-draw and scan in your line art. You then decide you want to move one of the characters or objects over to the right of the composition a little more. To do so, just follow these steps:

1. **Select the Lasso tool and use it to draw a line around whatever it is that you want to move.**

 After you complete a circle around the area you want moved, the lasso is formed, and it flickers as if to appear highlighted.

2. **Drag your lasso to any other area in the drawing.**

3. **Click the mouse.**

 The lasso disappears and the object stays in its new location.

You can also adjust the size or scale of part of the drawing using the Lasso tool.

1. **Draw your lasso around the area you want to manipulate.**

2. **Go to the menu bar under Edit and scroll down to Transform.**

3. **Under Transform, select Scale**; a box appears around the area that you previously lassoed.

4. **Move your cursor so that it touches one of the corners of the box.**

5. **Scale the art bigger by moving the corner out or smaller by moving the corner in (see Figure 15-6).**

Figure 15-6:
The scaling feature offers you many options on the size of your art.

Coloring and Shading in Photoshop

One of the great benefits of using Photoshop is that it allows you to color and shade your artwork right on screen. After you clean and size your artwork, you're ready to color it. You won't believe how your cartoons come to life when you add color to them! This section walks you through how to color and shade your cartoons in Photoshop.

Converting your bitmap file

Before you can jump in and start coloring your artwork, you first need to take a few steps after you scan in your cartoon. As I mention in the "Selecting a Photoshop mode: Bitmap, grayscale, RGB, and CMYK" section earlier in this chapter, you need convert the bitmap file to grayscale if you haven't already done so. To convert the file, follow these easy steps:

1. **Select Image on menu bar.**

2. **Scroll down to Mode.**

3. **Select Grayscale.** Grayscale mode allows you to work in layers, so you can color and edit different parts of your cartoon independently of each other. You must convert the mode from bitmap to grayscale because the layers features don't work in bitmap mode.

Working in layers

One of the unique things about Photoshop is the ability to work in layers. Each *layer* in a Photoshop document is a separate image that you can edit apart from any other layer (think of a *layer* as an image on a sheet of clear material). Together, all the layers form a stack of images. Layers allow you to break up each color step so you can work on it individually. With layers you can separate your cartoon into as many layers as you want. When you need to make small changes to the cartoon, you don't have to disturb any of the other sections.

When you scan in a black-and-white cartoon, it's scanned in as a single image, comprised of the black line art as well as the white background. To prepare your cartoon to work in color and to use layers, follow these steps:

1. **Use the Lasso tool and draw around the entire cartoon.**

2. **Select Edit from the menu bar.**

3. **Scroll down to Cut, then Paste.**

4. **The cartoon reappears as a new layer.**

5. **Select the Magic Wand tool from the toolbar.**

6. **Click on any white area on the cartoon.**

7. **White areas become highlighted.**

8. **Hit the delete button on the keyboard.**

9. **White areas disappear, and only the black-and-white line art "frame" remains.**

10. **Make sure you've converted the mode from grayscale to CMYK by selecting Image on the menu bar, then scrolling down to CMYK.**

11. **Select Layer from the menu bar and scroll down to New.** A new layer appears and now you can begin to color your cartoon.

You can create additional layers underneath the image so that everything is created from behind the black-and-white frame. To add new layers select Layer from the menu bar and scroll down to New. New layers appear, and now you can begin to color your cartoon (see Figure 15-7).

Another way to look at the layering process is to compare it to the way that traditional, classically-animated movies were created. The traditional animation process follows these steps:

1. The lead cartoonist creates the basic character design.

2. He passes it on to another artist who tightens the image.

3. The next guy inks over the sketch onto clear acetate.

4. The final artist flips the image in reverse so that he can color the image from behind to preserve the inked lines on top.

Figure 15-7:
Layers allow you to work on different aspects of your drawing separately.

Line art layer

Highlight layer

Shading layer

Color layer

Each of these processes is a layer, including the process by which they color each cel. A *cel* is an individual frame in an animated movie. Each cel is hand-painted and separate from the other cels.

When you scan your black-and-white cartoons into Photoshop, you can color the art in very much the same way as the animators do when working on a movie. You can actually separate your coloring process into as many layers as you want, so that you can get as detailed and specific as you want.

You can create additional layers underneath the image so that everything is created from behind the black-and-white frame.

You manage layers with the Layers palette feature. The Layers palette displays a thumbnail view of each layer to help identify it. The appearance of a Photoshop document is a view of the layer stack from the top down. When you want to change something, you can go to that specific layer and change it without affecting the other areas, as in Figure 15-8.

The Layers palette (see Figure 15-9) displays a thumbnail view of each layer to help identify it. The appearance of a Photoshop document is a view of the layer stack from the top down. When you want to change something, you go to that specific layer and change it without affecting the other areas.

For example, if you have a character whose shirt is colored brown, you may designate an individual layer just for the shirt and name it "shirt." If you decide to change the shirt color, simply go to the Layers palette, select the "shirt" layer, and make the change you want. No erasing or Wite-Out necessary!

Figure 15-8:
You can
change
each layer
without
affecting
any of the
other layers.

Add or delete layers

Figure 15-9:
The Layers
palette
helps you
manage and
view each
layer you
create.

Coloring with Photoshop tools

Photoshop has several tools that make coloring your cartoon a breeze. The
following are the three primary coloring tools. I recommend you begin with
the Brush tool, because after you start coloring your cartoons, this is the tool
you'll probably use the most.

✔ **The Brush tool:** This tool applies color to your document, similar to the
way a traditional paintbrush would apply paint on paper or canvas. You
choose different brush options by selecting a brush size and shape from
the brush palette. The edges of the lines created when using the brush
tend to be slightly softer that that of other tools, mimicking a real brush.

✔ **The Pencil tool:** The Pencil tool behaves much like the brush except that it has hard edges. The Pencil tool options are basically the same as the Brush tool.

✔ **The Airbrush tool:** The Airbrush tool works more like a traditional airbrush or spray paint. The Airbrush tool puts paint on a bit lighter than the Brush tool, but when you hold your mouse button down without moving the cursor, the paint builds up, just like it would if you were to hold the nozzle down on a can of spray paint (see Figure 15-10).

Figure 15-10: The Brush, Pencil, and Airbrush tools are essential to the coloring process.

Shading and highlighting with the Burn and Dodge tools

Other features you can use in the Photoshop toolbar allow you to add elements of lighting and shadow into flat art images. The Burn tool and the Dodge tool are both designed to help you accomplish this in a realistic and believable way.

Burning an image with the Burn tool darkens an area, while *dodging* an image with the Dodge tool lightens the area. You can see how these two tools can add shading and highlighting and give a 2-D image a 3-D effect by noticing the difference between the original image on the left and the one on the right (in Figure 15-11). These tools are great for adding highlights and shading to your art that give the impression of definition of shape as well as depth and dimension to your art.

Saving Your Work

After you clean your artwork and size it just the way you want, you need to save the file. Make sure you always have a master original. This master needs to be a file that's *unflattened,* meaning all the layers are still open and you can go back and easily change elements of the cartoon. Save your master as a .psd file (the abbreviation for a Photoshop file).

Remember: It's a good idea to be saving and backing up your work as you go. This will prevent your losing hours and hours of work if something happens like your hard drive freezing up or your losing power. This way when you restore the computer your file is ready for you right where you left off.

In addition to your master file, which can be changed at any time, you also need to save a finished, *flattened* copy. You do this in the following way:

1. **Select Layers on the Photoshop toolbar.**

2. **Scroll down to and select Flatten to flatten the file.**

3. **Save the flattened file in another format such as .tif, JPEG, or PDF.**

Several files types are commonly used to save artwork. Here are some advantages and disadvantages of each:

- ✔ **TIFF:** TIFF is an abbreviation for Tagged Image File Format and it's the best choice for saving your cartoons. You can save black-and-white, grayscale, or RGB and CMYK color files using TIFF. TIFF image files optionally use LZW *lossless* compression. Lossless means there is no quality loss due to file compression. Lossless guarantees nothing will be lost or altered when your files are compressed. Although TIFF files can be large compared to other formats, TIFF files generally offer the best print reproduction for your line art or color files.

- ✔ **JPEG:** There's a lot of confusion over JPEG files. You should use JPEGS for photographs and not line art, because unlike TIFFs, JPEGs use lossy

compression, which means that some visual quality is lost in the process and can't be restored. I'm often asked to send my art to someone as a JPEG for one of usually two reasons:

- The person is on a PC and can't open a TIFF file. Most PCs aren't graphic-friendly compared to Apple computers.

- It's also possible that they don't know anything about printing graphics reproduction, because if they did, they would know JPEGs are meant for photographs.

Nevertheless, for people who want to simply view the art on their PC, I send them a JPEG file to review. However, if your art is going to be printed, line art or color cartoons should never be JPEGs; they should be TIFF or PDF files.

- **PDF:** PDF is an abbreviation for Portable Document Format. A PDF is a file that allows electronic information to be transferred between various types of computers. The software which allows this transfer is called Acrobat. To view and print a PDF file you first need to download and install a copy of the Adobe Acrobat Reader.

- **GIF:** GIF stands for Graphics Interchange Format. The overwhelming majority of images on the Web are now in GIF format, and virtually all Web browsers that support graphics can display GIF files. GIF files incorporate a compression scheme to keep file sizes to a minimum, and they're limited to 8-bit (256 or fewer colors) color palettes, which translates to the lowest color option and isn't optimal for full-color printing. As a result, files that are meant for print should never be GIF files. Only files that are for Web display only should be GIF files.

- **EPS:** EPS, which stands for Encapsulated PostScript, is a standard file format for importing and exporting PostScript files. Because an EPS file can contain any combination of text, graphics, and images, it's a very versatile file format. You can visualize the content of EPS files easily because they contain a small preview image. This is done so that applications don't need a PostScript interpreter to display the content of the EPS file. Even office applications such as Microsoft Word can display the preview image.

E-Mailing Your Art Files

Formatting your files correctly for e-mailing is just as important as saving them in the right format. If you're working in Photoshop or another art program, your finished file may be quite large, especially if you use lots of layers or filters, even after you flatten the file.

If your file is large, you can attempt to e-mail it as is, but many e-mail providers have limits as to how big a file can be. (Think of it as having created a beautiful piece of furniture, only to discover that it won't fit through your

door!) Furthermore, it may take a long time to upload a file if it's too big. The best remedy for this is to reduce the size of your file before you e-mail it by using one of the following programs:

- **STUFFIT:** Files that use this program are compressed and have a .sit or .sitx file extension. The StuffIt format is a modern archive format, designed to be extendable, support Mac OS X, Windows, and UNIX/Linux file platforms. Optimized compressors give it the edge for getting files as small as possible. Double-click on the attachment and the StuffIt program automatically opens the file.

- **ZIP:** Zip is a compression program common on both Windows and Mac OS X and is good for compressing files so that you can easily transfer them via e-mail. Double-click on the attachment and the Zip program automatically opens the file.

- **FTP:** Another popular method for transferring large, high-resolution art files is through FTP, or File Transfer Protocol. This is a direct transfer of files from your computer to another computer over the Internet. The advantage of FTP is that you can transfer very large files quickly.

The evolution of Photoshop

One of the first computer painting or drawing programs offered on Apple Macintosh computers was called MacPaint. This full-featured program went back to around 1984 and came bundled with other software on every Mac computer. MacPaint's bitmap-based PICT file format was used for printing the screen.

MacPaint was significant because its ease of use — and often entertaining results — showed a novice audience what a GUI-based system could do. (*GUI* means *Graphic User Interface,* which is the graphics you look at on your computer screen.) However, to draw with Mac Paint you had to use the mouse, and the results were very childlike at best. Early programs like MacPaint also had no practical application that would allow the artist to paint, color, or manipulate an existing drawing.

What left MacPaint in the dust was the introduction of a program called Photoshop, created by the graphics software company Adobe. Photoshop is, hands down, the best program for creating and modifying images for the Web, and this includes cartoons. Photoshop is available for both Mac and Windows; its plusses include intuitiveness, a huge number of reference guides, and the most complete set of tools. The basic premise of Photoshop started as a thesis on the processing of digital images and evolved into a program named Display. In 1989, Adobe took interest in the program and released the first ever version of Photoshop to professionals in 1990.

After initially marketing Photoshop as a professional tool, Adobe created a consumer version which cost much less than its professional counterpart and was often bundled with other products like digital cameras and scanners.

Who uses Photoshop today? Everyone — just check out all the Photoshopped images on the Internet. Just about anyone can use Photoshop today, and many do, achieving imaging results once available only to professionals with high-end advanced equipment.

Chapter 16

Making Cartooning Your Livelihood

I have some good news for you: You can make a living with cartooning. However, before you quit your day job, run out and buy supplies, and start sketching, realize that cartooning as a career isn't for just anyone. You have to be really good, very persistent, in the right place at the right time, and good at marketing your cartoons. If you're a beginning cartoonist, I suggest you hold off on this pursuit for a while. Take the time to perfect your craft, get lots of feedback from friends, family, and online, and start slow.

However, if you've been drawing for quite some time and are confident in your cartoons and your ability, then you may want to see whether this hobby can become a vocation. Before you jump into anything, first take a deep breath and read this chapter. Here I look at what you have to do to make it into the big time, from preparing your work for submission to getting syndicated, and I tell you how to keep the IRS satisfied if you start making money as a cartoonist. I also suggest you check out Chapter 18 for some other quick tips if you plan to pursue cartooning as a career.

Deciding to Go Full Time

Drawing cartoons can be a fun hobby, one you can enjoy for years. When you think about turning pro, however, just being good isn't good enough. Becoming a professional cartoonist is like becoming a professional writer,

actor, athlete, or musician. Cartooning is a nontraditional profession that can be a dream job for many, so the competition is tremendous. Getting even a foot in the door requires a lot of hard work, talent, and just the right timing.

You may notice I didn't include "luck" on the list. I don't put much stock in blind luck, and you shouldn't, either. In reality, the kind of luck that most people find is the kind of luck where *preparation meets opportunity*. This simply means that you have to be well prepared for the right opportunity to come along and then take it. Opportunities rarely come knocking on your door; you need to go out and find them.

Preparing for those opportunities requires a lot of hard work and planning. No one becomes an overnight success overnight, but knowing where and how to start is half the battle. The next sections show you how.

Evaluating whether you can handle the career

If you're contemplating becoming a professional cartoonist, you have many factors to consider. Most important, you need to look at yourself in the mirror and really ask yourself whether you can handle the pressures involved with a career in cartooning. Pressures, you say? How can drawing a three-panel cartoon be that difficult? Well, take it from me. Cartooning isn't as easy as it looks. When you evaluate yourself, ask yourself the following questions:

✔ **Can you draw this cartoon or comic strip for an extended period of time?** Typically, a syndicate offers a new cartoonist a ten-year contract. That's seven cartoons a week for ten years' — ten years' worth of daily deadlines that you can't miss . . . yikes!

Some people don't want to plan ahead for what they're doing next week, let alone ten years; are you sure you have ten years' worth of ideas for your strip? No, you don't have to have them all plotted out ten years in advance, but you have to be certain that your character will keep you interested enough to keep drawing it for the next ten years.

✔ **Can you handle the pressure of a daily deadline?** A deadline is like a bottomless pit; you have to keep feeding it new material and you can't ever say enough is enough. Coming up with fresh new material is a vital part of being a good cartoonist and is often considered the hardest part of cartooning. If you feel confident that you have the passion and endurance to go the distance, then the next step is to take a hard look at the quality of your work.

If these questions scare you, cartooning as a career may not be right for you. That's okay. Cartooning can still be a great hobby, one you can enjoy and share with others. And a few years down the road, with a few thousand

cartoons under your belt, you may want to take another look at the possibility. Being a professional cartoonist isn't a "one time offer" opportunity; you can try your hand at it at any time.

Looking for honest feedback

If your mom was like most, you probably grew up hearing how wonderful you are. Mom was probably your biggest cheerleader, telling everyone who would listen that her kid was going to be the next Charles Schulz. From a Parenting 101 standpoint, encouraging your kids in their artistic pursuits is one of the best things a parent can do. However, the downside of buying into mom's beliefs is that you may have never done an honest evaluation of your work. Friends' opinions don't count, either. Because no one else is going to say it, you must say it to yourself: "Am I *really* good enough?"

Honestly evaluating your work is something you must do before you go any further with your desire to become a professional cartoonist. Take a long hard look at your drawing skills while asking yourself the following questions:

- ✔ Does your art look like it would be at home next to the other long-running strips that have been published in the newspapers over the last ten years?
- ✔ Can you draw in perspective?
- ✔ Can you letter well?
- ✔ Do the characters you create look professional?
- ✔ Does the tree you drew in panel #3 look like a tree?

Answering these questions honestly is important, because you need an accurate assessment of your abilities. Not being honest sets you up for big disappointment, not to mention some snickering if your work is amateurish. Just remember: Editors or syndicates are more than happy to tell you how bad you are! However, if you're satisfied that you do have what it takes, getting an unbiased third party to evaluate your work is the next logical step and always a good idea.

Checking with the professionals

Before you take the plunge and try to make a full-time career out of cartooning, I also suggest you show your work to other professionals to get their feedback. A professional cartoonist will probably have nice things to say about whatever you show them just to be polite, as well as to be encouraging to a fellow cartoonist. However, professional cartoonists will probably also want to be honest with you, because they were once just starting out and can appreciate that honest, straightforward feedback is the best thing for you in the long run.

If you don't know any professional cartoonists, look up contact information for your favorite cartoonist and call him up. Some have Web sites or blogs that make it easier to contact them. Cartoonists are often willing to talk to beginners and to chat about the cartooning field.

After you make contact, you can ask if it's okay to put together samples of your work and mail it to him. Mailing is preferable to e-mailing because the files may be too big for his inbox, or may get caught in a spam filter. Mailing your work also makes it more likely that the professional cartoonist will real-ize that you took the time to mail the big envelope, especially if you've made contact ahead of time. Additionally, your fellow cartoonist will have hard copies of your comics, which are always easier to read than trying to look at your work on a small computer screen.

Include a nice cover letter indicating you're a *huge* fan of the cartoonist's work and would love his opinion on yours. It's also a good idea to include your contact info, because he may be motivated to get in touch with you, or to check out your Web site, if he sees something promising in your work.

Another way to get in contact with cartooning professionals is to join a pro-fessional association. By joining as a student or associate member, the aspir-ing cartoonist can network and make contacts with real live professionals. Chapter 18 has more details on professional organizations for cartoonists and how to join them.

Knowing the Market

Another important step to take when you're considering being a professional cartoonist is to know how to market your work. When you're starting your cartooning career, think of your work as a product, just like any other busi-ness would. When car companies introduce a new automobile they first do extensive research, testing, and marketing. You need to do the same before introducing your work to the public.

You have two avenues to pursue when marketing your work: starting with your area papers or sending your work to a national syndicate, which, despite the somewhat negative connotation of the word, is a company that agrees to distribute and sell your work to national and local newspapers and magazines. This section helps you determine what initial research you need to do when marketing your work and then discusses these two avenues.

Doing your initial research

In order to market your work, you need to know what you're getting into and who you're competing against. Make sure you carefully research the following:

✔ **The market you're aiming for:** Where you want your cartoon to be picked up can help you decide what type of product to pitch. Certain types of cartoons only appear in certain media. Comic strips are marketed to newspapers and Web sites, editorial cartoons to newspapers for their editorial pages, and gag panel cartoons can be marketed to magazines like *The New Yorker*.

✔ **Your competition:** Remember that your local newspaper probably doesn't carry all the strips available on the market, so you may have to search the Internet to get a good idea of all the comic strips out there to see who you're going up against.

Looking at what's in the market currently also gives you an idea of what's *not* out there. If you've got a great idea for a comic strip and you see that nothing is out there to compete against, then the syndicates may be interested in filling a hole in the market with your feature. However, if your cartoon is about a lazy, sarcastic cat that eats spaghetti and has a dimwitted sidekick dog, by doing the research you can see there may not be a market for your work because a similar cartoon already exists.

On the flip side however, syndicates tend to do the same thing that TV programmers do; they market "new" products that are very similar to programs with a proven track record. How many comic strips feature a family and a dog or a cat? How many comic strips have you seen over the years that have kids as the main characters? How about talking animals? Syndicates may reject your idea if it's *too* cutting edge because they're looking for something more conventional. The bottom line is to try and create something that appeals to you that's also marketable, and if that sounds easy, rest assured that it's not.

Starting locally

One way to sell your work and at the same time test-market it is to sell it locally. Contact your local newspaper features editor by putting together a professional sample package and mailing it to her with a cover letter. Emphasize the fact that you're a local resident in your cover letter; local newspapers love to showcase local talent and know that a locally drawn comic strip appeals to readers.

Successfully getting your comic strip into a local newspaper helps you in three important ways:

✔ It teaches you what it's like to have a daily or weekly deadline that you must meet.

✔ It helps you build a portfolio of work that you can use when you decide to try for a syndicate contract.

✔ It gives your work credibility, because it proves you're publishable.

Another great way to get started if you happen to be a college student is to join your college newspaper. Many, many cartoonists begin their careers by becoming part of their college paper; it's a great way to gain experience with deadlines and get published — and to get used to having your work criticized!

Selling to the syndicates

You may decide to skip the small town papers and go right for the national market, or you may approach the national market after you've built up your portfolio locally. To get your work widely published, you need to be syndicated. *Syndication* is the distribution of your work to paying customers throughout the country. A syndicate company agrees to distribute and sell your work in return for a share in the money.

The United States has about a dozen major syndicates, and most of them handle comic strips, along with columns and other specialty features. Some of the major syndicates are United Media, Universal Press, Creators, Scripps Howard News Service, King Features, Tribune Media, and the Washington Post Writers Group. You can do a quick Internet search to locate each company's Web site, which contains more information about them, as well as the current comics that each is currently promoting.

Because syndicates are in the business of selling comics to subscribing publications, they're always willing to look at new comic features for possible syndication. It's the ultimate dream of many cartoonists to get syndicated throughout the world and get paid truckloads of cash, not to mention becoming famous. But it's also very difficult to achieve, particularly these days, as circulation numbers drop and newspapers and magazines cut back on the amount of outside material they purchase.

Many syndicates face difficulties finding clients for cartoonists they already represent, never mind taking on new clients. However, you never know if your product is the right thing at the right time unless you try over and over again. Getting through the syndicate maze requires a bit of know-how, which I provide in the next sections.

For more information on how to contact a syndicate, check out Chapter 18.

Grasping How Syndication Works

Everyone — well, your mom at least — tells you you're ready for the big time, but how do you even begin to market cartoons or comics? Before you get ready to send your art out the door, you need to understand syndication and the ways that syndicates rule the modern cartooning world.

Syndication works like this:

1. **You, the aspiring cartoonist, draw a month's worth of comic strips and submit them to the dozen or so major syndicates in the country.**

2. **The submission arrives at the syndicate's office in New York, where it goes into a pile with the rest of the ten to fifteen thousand other submissions the syndicate receives each year.**

3. **Submissions editors go through the stacks and review each submission, looking for the next great marketable comic strip.**

4. **After they spot a promising submission, they pass it up the chain to the other editors who also review it.**

 During their review, they look for several things in order of importance:

 - Is it well written?

 - Is it well drawn?

 - Is it similar to another feature already in syndication?

 - Can we market this feature effectively?

5. **The big kahuna editors choose their final picks.**

6. **After many months you may receive a letter (or phone call, if you're really lucky) from an editor. This letter could say several things:**

 - **Thanks but no thanks.** Otherwise known as a rejection letter, this means they either didn't like your work or don't have a place for it on their list.

 - **No thanks, but keep trying.** If they see something that needs work, they may express that in the rejection letter, encouraging you to try and improve these things and resubmit at a later date. Any personal comment or note is a positive sign that your work has promise, so really up your effort if you get any type of personal response.

 - **Let's work on it.** They could also agree to a development deal where they offer you a contract to help you improve areas in the comic strip, in the hope that after the end of the development period the strip is ready to market. If during the development period you show no improvement, then they'll pass on the strip at the end of this period.

 - **You've got a deal!** Congratulations, you've broken into one of the toughest businesses around!

If the syndicate picks up your cartoon, the development process begins. You'll work with an editor to help ready your strip for publication. This process may include suggestions on writing or small changes to the art. Some cartoons are perfect and require no changes at all — don't count on it, though! Editors live to change things.

When the strip is ready for publication, the syndicate offers you a contract and sets a launch date. It's the syndicate's job at this point to begin marketing and selling the strip to the newspapers. The syndicate usually wants around 50 sales before launching the strip, although this number is different for each individual syndicate. For more info about a syndicate giving you the thumbs-up, check out the "Welcome to success (but don't expect millions)" section later in this chapter.

Creating a Winning Submission Package

Standing out from the competition starts with your first submission package. A syndicate may get ten to fifteen thousand submissions a year; they wade through looking for the gem in the rock pile, the comic strip they feel is marketable and potentially profitable, for you *and* them. Out of all the submissions each syndicate may receive a year, only about a half dozen are selected for syndication, not great odds. Your chances of winning the lottery are a little lower, but not much. In order to make your submission rise to the top, I offer some suggestions in this section.

When you mail your submission package, resist the urge to get cute; dancing delivery girls, balloons, and twenty dollar bills won't increase your odds of having your submission accepted! Send in a professional looking, typed (not handwritten) cover letter, and make sure to cover the postage — a postage due submission is sure to end up in the post office's dead letter section.

Attaching a straightforward cover letter

One of the most important pieces to include in your submission package is a clear, straightforward cover letter. A simple, businesslike, professional resume and cover letter do more to impress a syndicate editor than a coconut that needs to be hammered open and contains your 400 original samples of a comic strip about a group of island castaways. I would venture to guess there's a 100 percent chance that that coconut will go right into the trash, with your submission still in it.

The cover letter is where you can concisely tell the recipient about you and your intentions for writing for them. When writing your cover letter, don't try to be overly clever. Briefly introduce yourself and tell a little bit about your feature. Keep it simple and professional; let your work sell itself.

Choosing samples of your work

In addition to a professional cover letter and resume, you need to send good clean samples showcasing the best examples of your work. Think of your submission as a long distance job interview; you want to impress them with your professionalism and show them you're qualified. Obviously, choose samples that represent your very best work. This may be a one-time shot, so you have to put your best foot forward. You may want to show your samples around to friends and family to get their feedback, especially if you have friends and family who work in the cartooning business! If not, send only samples that get a universally positive response — a halfhearted chuckle or "huh" isn't a positive response!

When putting together your sample portfolio, keep the following two points in mind:

- ✔ **The number of submissions:** Most syndicates want to see a month's worth of daily strips, which equates to 24 black-and-white samples. This number breaks down to six days a week for four weeks to be 24 black-and-white dailies. Additionally, you need to send two Sunday color samples as well.

- ✔ **The size of submissions:** Each sample needs to be proportional so that when it's reduced it will be the correct size. Most comic strip cartoonists draw their daily comic strips 13 inches wide by 4 inches tall. Most single-panel cartoonists draw their daily panel 7 inches wide by 7 inches tall, not counting the extra space for the caption placed underneath the drawing. You can draw larger or smaller than that, as long as your cartoons are in proportion to those sizes. The reproduction of your work is very important to the syndicates so don't overlook this.

 Make sure the copies you send are clear and that the word balloons are easy to read without squinting. If they have to squint to read your work, then it goes in the garbage. Reduce your comics to fit onto standard 8 1/2-x-11-inch sheets of paper.

Include your name, address, and phone number on each page. Remember, don't send your original drawings! Send clean copies instead. If you want your work back be sure and send a SASE so they can return it to you.

Dealing with the Ups and Downs

After you mail your submission to each of the syndicates, you can expect to hear back from them in about 12 weeks or so. Rest assured that these will be the longest 12 weeks of your entire life. Don't just sit around waiting to

hear, or assume that you can stop working now that you've got your stuff out there. Keep working; you may be amazed (or dismayed) to see how much your work improves over the 12-week waiting period.

Getting picked up by a syndicate isn't easy, and you're probably going to face a lot of rejection. Part of making a career out of cartooning is that you're going to experience many upswings and downswings in your career. This section helps you handle the pendulum.

Coping with rejection

There's a strong chance that you'll receive a form letter saying "thanks but no thanks." Remember that the odds are against you; you're in good company if you've collected enough rejection letters to wallpaper your walls. Prepare yourself for rejection and accept it as part of doing business. The important thing is not to get discouraged and depressed about it; use it as a motivator to produce something bigger and better the next time around.

Rejection and failure can be a good character builder in more ways than one. For example, when the legendary cartoonist Bill Watterson submitted his first comic strip about cute little bugs, it was rejected across the board by all the major syndicates. Watterson took the opportunity to reevaluate his idea and come up with something totally new . . . and that was *Calvin and Hobbes*.

So if they do reject what you sent them, what do you do next? This may depend on why they rejected you. Often times the syndicates send a little note along with the form letter indicating why they're not accepting your comic strip. Some rejection letters may give you pointers on correcting small things or improving your art or lettering. It would be wise to take whatever advice you can get and follow it; consider any advice to be an encouraging sign — many people just get the form letter without even a real signature on it!

The syndicates may indicate that they rejected your idea because they have too many current features that are just like the one you submitted. They may indicate that they like some aspects of your idea but not others. Or they may not say anything at all. At this point you have two choices:

✔ **Revise what you submitted and come up with a new story line using the same characters.** Many cartoonists need to revise and polish story lines several times over before hitting on an idea that resonates with editors. If you love your characters, keep trying out new ideas until you find something that strikes a positive chord with editors. Even Bill Watterson (the creator of *Calvin and Hobbes*) had to revise his story lines several times before having his strip accepted by Universal.

✔ **Scrap the whole concept and come up with something totally new with completely new characters.** If you're in love with your characters, this can be really hard to do; you become emotionally invested in your creations and hate to kill them off, so to speak. But if an editor indicates that you have great ideas but unappealing characters, let them go, and work on developing characters that mesh better with your story lines.

Which route you take depends on how attached to the original idea you are. Some people can't bear to give up the characters they've developed and have grown emotionally attached to — they're like family! However, you're in business to get published and make a living, and sometimes you have to drop what doesn't work and come up with a fresh approach.

Welcome to success (but don't expect much)

On the other hand, if the syndicate likes what you sent, it may offer you a contract to create the strips on a regular basis. If you receive this special goodness in the mail, then accept my congratulations! Remember that you're one of the few to reach this point. However, you're not going to be making tons of money. The contract usually offers a 50/50 split between the cartoonist and the syndicate. Fifty percent of your income may seem excessive, but syndicates do a lot to earn their half.

To earn its 50 percent, the syndicate edits, packages, promotes, prints, sells, and distributes your comic strip to newspapers and Web sites around the world. Basically, a syndicate is responsible for bringing the cartoons from the hand of the cartoonist to the eyes of the public.

The more papers that pick up the strip, the bigger the client list and the more revenue the strip generates. After it becomes established at around 100 papers, the syndicate may decide to publish a book or look at other forms of marketing.

If the strip gets really popular, the syndicate may consider other forms of merchandising, like toys. After a strip hits the 1000 mark, it has the potential to start earning big money both from syndicate revenues and potential marketing and merchandising possibilities like TV shows or movies.

If you're fortunate enough to get a contract, you can expect to make between $25,000 and $1,500,000 a year. It all depends on how many newspapers subscribe to your comic strip and how many products and licensing deals are made from your characters. It's a real safe bet that you'll probably be much, much closer to the lower end of the scale than the higher. However, if your strip or comic characters are successful, then you can make serious money. Charles Schulz, creator of the *Peanuts* cartoons, made $35 million last year and he's been dead for over eight years!

Comprehending copyrights

Contracts are legal and binding documents, so don't sign one without reading it — all of it, even the incomprehensible, boring parts. Get a lawyer to review it if you're not sure just what you're signing. Make sure that you understand who owns the copyright to your work. In the old days (before 1988), it was routine for the syndicates to own the feature they were syndicating. This was much like TV. The guy that created classic shows like *Gilligan's Island* and *The Brady Bunch* was a producer named Sherwood Schwartz. Over the years he has made a fortune off of these shows as they have remained on TV through syndication since they were first created in the early 1960s. By contrast, the actors who gave life to these shows with their distinctive performances weren't paid anything after the shows were cancelled and received no royalties from syndication.

This trend began to change in the late 1970s with shows like *M*A*S*H*. After several high profile actors threatened to strike, the show's producers gave part ownership to the main actors in the show, which meant that they receive royalties every time an old episode is shown, which has made them all quite wealthy.

It wasn't until the late 1980s that this trend carried over into the comic strip business. In the mid-1980s a new syndicate called Creators was started by several syndicate executives who left other companies. Creators gave the cartoon creators ownership in their characters. It was a big success and the ownership trend has now carried over to the other syndicates as well.

Today it's common practice for new comic feature contracts to stipulate that the cartoonist owns his feature and the characters he or she creates. It's interesting to note that Charles Schulz didn't own the copyright to *Peanuts*, which first became syndicated in the 1950s. By the time the trend changed, Snoopy and the gang had become the most popular comic strip of all time, earning an estimated one billion dollars a year with all the numerous licensing and marketing deals.

Despite not owning the rights to *Peanuts*, Schulz still managed to make the highest paid celebrities list each year, squeaking by on $35 million a year (his contract did state that no one else could draw the comic feature). However, by not owning the rights outright he had to sit by and watch $970 million go to someone else!

Turning Your Hobby into a Business

Deciding to turn your hobby into a money making (hopefully) business is more complicated than sending out a few submissions. Although immediate financial success is unlikely, you have to be prepared for the possibility by having a business plan and an understanding of the legal steps you must follow in order to keep Uncle Sam, and more importantly, the IRS happy. Are you wondering why? The IRS defines being self-employed or starting your own business as an attempt to make a profit. Turning a profit is the primary distinction between a hobby and a business.

This section shows you how to take care of basic small business fundamentals, from forming your own company to the very important step of managing your taxes.

Meeting the criteria to call yourself a business

Becoming a legal and legitimate business has many advantages for a professional cartoonist. Starting your own business requires a little work on your part but it's well worth it, and the IRS actually requires that you do if you want to get paid. You can take the following steps to ensure you meet all the criteria:

1. **Form a Limited Liability Company (LLC).**

 Perhaps the most important thing you can do is form an LLC, or *Limited Liability Company.* An LLC is a business structure that combines the pass-through taxation of a partnership or sole proprietorship with the limited liability of a corporation. LLC owners report business profits or losses on their personal income tax returns; the LLC itself is not a separate taxable entity. This setup is a lot easier than a corporation, which is required to pay another separate set of taxes, and who wants that?

 One very important facet of LLCs is that the owners are protected from personal liability for business debts and claims — a feature known as *limited liability.* This means that if the business owes money or faces a lawsuit, only the assets of the business itself are at risk. Creditors usually can't reach the personal assets of the LLC owners, such as a house or car.

 Setting up your LLC can generally be done without a lawyer if you can read and follow instructions. In most states you start by contacting your state's corporation commission. A quicker way may be to go to your state government's Web site and download the necessary forms you need. The forms are called the *Articles of Organization.* The forms are usually fill-in-the-blank and easy to comprehend. You can also check out *Limited Liability Companies For Dummies* by Jennifer Reuting (published by Wiley).

2. **Choose your company name.**

 One of the most important things you'll be asked for on the forms is what name you'll be doing business under, so put some thought into this beforehand. You want to make sure that the name sounds professional and is related to the type of work you'll be doing. If you're at the corporation commission's Web site, you may be able to search its database to see if there's another business using the name you've selected. Generally, if there's another LLC doing business under that name, you have to come up with a different one before you can become incorporated.

3. **Publish your intention to form an LLC.**

 A few states impose an additional requirement: Prior to filing your Articles of Organization, you must publish your intention to form an LLC in a local newspaper. Check with your state to see if this is required.

4. **Submit your final paperwork.**

 After you've published your Articles of Organization in your local paper (usually for three business days), you're ready to submit your paperwork for formal approval. This approval process is mostly a formality; you should become incorporated in less than 120 days.

5. **After you're legally incorporated you can apply to the IRS for a Federal Tax ID number, also called an Employer Identification Number, or EIN.**

 To actually get an EIN number you need to go to the IRS Web site and download Form SS-4. A federal tax identification number is a number assigned solely to your business by the IRS. Your tax ID number is used to identify your business, and your clients will require it for their records so they can show the IRS that they paid you.

Keeping the IRS happy

After you form your LLC and you have your new tax ID number, you need to open up a business checking account. Having a business account can help you manage any monies that pass through your business, as well as keep track of any expenses you may want to deduct at tax time.

Banks usually require you to show them your Articles of Organization as proof of the business's existence before opening the account. After the account is in place, you'll have a place to cash and deposit all those checks you'll be getting from the syndicate! Keeping your business income and expenses separate from your personal accounts is required by the IRS. You need to be able to prove which deductions are actual business expenses with receipts and documentation. Setting up a separate account for business income and expenses is the easiest way to do this — and hang on to your receipts!

Another thing you may want to consider is some sort of accounting software that helps you keep track of your income and expenses. You can get software that does everything you need for a small business, like *QuickBooks, Quicken*, or even Microsoft's *Money*.

Maximizing deductions

Being in business means having to pay taxes. However, you're legally allowed certain deductions for business expenses, and these can be a great benefit to you. Although the tax code changes from year to year, what you're allowed to deduct in your business generally stays the same. Check with an accountant if you have any questions.

I suggest you use an accountant to prepare both your personal and business returns, just to be safe. The good thing about using an accountant is the cost of having your tax returns prepared is also tax-deductible. Here are a few other deductions to keep in mind when doing business:

- ✔ **Start-up costs:** Any money you spent starting your business is deductible.

- ✔ **Vehicle use:** The government allows you to deduct certain expenses for business vehicles, including mileage.

- ✔ **Equipment deductions:** In addition to the paper and pens you buy to draw with, that new computer you bought to scan and color your cartoons is deductible!

- ✔ **Entertainment deductions:** If you wined and dined the executives at the syndicate, then that may be deductible, usually at 50 percent.

- ✔ **Travel expenses:** If you traveled to a cartoonist convention, then those expenses may be deductible.

- ✔ **Membership fees in a professional organization:** If you pay dues they're generally deductible.

- ✔ **Advertising costs:** Costs for advertising your business are tax-deductible. These may include print, Internet/Web site costs, or other ad forms like business cards.

- ✔ **Legal fees:** Businesses often consult lawyers about business matters or to review contracts. The fees charged are deductible.

- ✔ **Software deductions:** Small businesses can deduct the cost of software purchased for exclusive use by the business.

- ✔ **Home office deduction:** If you draw from your home, and most cartoonists do, you're allowed a deduction based on how much of the home and utilities are used for business. This can be a big and important deduction for you.

Depending on the specifics of your situation, you may be able to take more deductions; a good accountant who specializes in small business can probably save you the costs of his fees and more.

Putting in a fax and separate phone line

When you want to contact a business you pick up the phone and dial its number. When people want to call you up to do business, they should be able to do the same thing. This means it's probably a good idea to have your own business line.

The other thing that you may want to consider is getting a designated fax number as well. If budget is a concern (and when is it not?), then you can use one phone line and purchase a fax that automatically answers when another fax signal is calling. The only drawback to this setup is that when you're receiving faxes you can't use that phone line until the fax is complete. Another nice option is to get a fax system set up with e-mail, so faxes are automatically delivered to your e-mail.

Keeping accurate records

Keeping good records not only helps you at tax time but also helps you do better business. You need to be able to put your hands on client's records, to keep track of when you sent submissions and to whom, and to have a place for contracts so you can refer to them easily if questions arise. Not to mention keeping track of your income and outgo so you can see if you're making any money!

With your cartooning business, you want to keep the following accurate:

- **Banking records:** Keeping accurate records helps you not only during tax time, but also if the IRS ever requests to review them (see the "Keeping the IRS happy" section for more on this subject). Your banking records include all your income and expenses. Make sure you keep receipts of supplies and any equipment you purchase that helps you do business.

- **Client lists:** You also want to keep a current list of past and present clients so that you can follow up with them about additional work they may need, including what you've submitted to them and when, so you don't send them the same thing more than once!

Keeping track of submissions also helps when you need some moneymaking ideas. That magazine cover you drew two years ago paid well; you may want to do it again. It's a good idea to send old editors a fun or colorful postcard with a current sample of your work on one side and your contact information on the other. You simply drop it in the mail, telling them that you're still around and to give you a call if they need anything in the future.

Promoting Your Work Online

In today's digital age, one of the most valuable tools you can use to market your work is the Internet. Having your own Web site is the digital equivalent of the business card, or more appropriately, a giant billboard. This section breaks down why having a presence online is important and what you need to do to get there.

Why being on the Web is important

By having your own designated Web space, you can market your work and potentially reach people who may not see your materials if you market only in the traditional ways of local newspapers and syndicates. You can show-case your work that people can't find anywhere else in newsprint, like your full-color and animated cartoons. You can also direct people to your site if they want to see the type of work you do.

You may also choose to do cartoons specifically for your site. Many cartoon-ists are opting to publish Internet-only comics on their own sites, forgoing newsprint altogether. The advantage to this is that you're your own editor and you don't have to tone down content for a family-friendly newspaper. As time goes on, webcomics will continue to grow in popularity.

How to make a splash on the Web

Webcomics have some definite advantages over print comics. Webcomics allow the cartoonist great freedom and leeway regarding creativity and subject matter, and anyone who can afford a Web site can publish his own cartoons.

The creator of a webcomic has more control over his feature than a tradi-tional cartoonist does, but he also must bear more responsibility. Webcomic creators are like small businessmen. They're responsible for not only writing and drawing the comic feature — just as if they partnered with a syndicate — but also the Web site design, advertising, marketing, and sales of related merchandise. The upside is the webcomic creator keeps 100 percent of the revenues instead of giving half to the syndicate.

The Internet has a vast sea of popular webcomics. They're done by amateurs and professionals alike, who take advantage of the ability to publish anything on the Internet. The more advanced webcomic creators display their features in full color and even use some animation. Two big aspects of creating a web-comic that can generate revenue are as follows:

- ✔ **Merchandise and books sold on the Web site:** Many online print-on-demand (POD) companies cater to Web sites that can offer books for sale as well as other merchandise such as T-shirts.

- ✔ **Advertising:** The more people come to read the comic, the more traf-fic the Web site gets and the more likely it is to pick up a small amount of revenue from advertising. You can also list your webcomic in search engines, like Google and Yahoo!, so that when people are searching for cartoons or other artwork, your site pops up. In order to list your site in a search engine, you may consider a search engine optimization service. These services can help you list your site with multiple search engines

so you don't have to list on each one individually. These services can also provide you with assistance on how to best list your site to maximize its place on a search list.

If you don't already have a Web site, I suggest you get one started. Beginners can purchase great simple programs at any software store and use them to set up a Web site. You also have the option of hiring someone to do it for you. Check out *Building a Web Site For Dummies* by David Crowder and Rhonda Crowder (published by Wiley) for a book full of info on starting, maintaining, and promoting your Web site.

Dilbert's creator: Changing with the times

Typically, syndicated cartoonists have looked to the Internet with a mix of confusion and mistrust. After all, these are people whose professional income is based largely on syndication to newspapers, and the Web is steadily eroding the newspaper's ability to land daily readers. But Scott Adams has embraced the new medium with gusto.

His Web site, www.dilbert.com, features the daily comic, of course, along with a blog updated by Adams himself, animations, and other regular features. More important, Adams is embracing the Web's ability to help him connect with his readers on a deeper level. Readers can respond to Adams' blog posts and even rewrite previous *Dilbert* comics using their own punch lines.

And of course, as they're interacting with the site, they're allowed plenty of opportunities to become aware of the many other ways to participate in all that is *Dilbert* — with their credit cards. Ever the shrewd businessperson, Adams is poised to make a seamless transition from a newspaper-based business to a Web-based one. One can only imagine Dogbert's tail wagging in approval.

Part V
The Part of Tens

In this part . . .

The Part of Tens section presents interesting and fun information in short sound bites. In this part, I look at ten steps to creating and producing a finished comic strip and give you ten tips on how to break into the cartooning world. Part of Tens chapters are meant to be fun but also informative, without taking too much time to read.

Chapter 17

Ten Steps to a Finished Comic Strip

*T*he finished cartoon strips you see in the newspaper and on the Internet make cartooning look easy, but creating a viable cartoon strip takes a lot of time and effort. In this chapter, I give you a quick overview of the steps you need to take to create an interesting, salable, well-drawn comic strip.

Researching the Market

Creating a comic strip, webcomic, comic book, or other cartoon character-based story line offers you the chance to create your very own world — a world where you have total control, creative license, and the opportunity to have fun for years to come. However, one point to always keep in mind is that cartoons and cartoon characters are commercial products. And as with any other product, one of the first things you should do is research the market.

You may have an idea for a great comic strip that's been rattling around for a while inside that hollow space between your ears. But how do you know it hasn't been done before? Basically, researching the market means perusing daily newspapers and studying the cartoons they currently publish, as well as surfing the Web to look at webcomics and other cartoons. The best way

to know these things is to research the idea and find out! The Internet, your local library, and your favorite bookstore are good places to start. (For more information on marketing your work, see Chapter 16.) Doing so can give you a good idea of what's out there and what's not and hopefully inspire you to come up with an idea that no one else has thought of yet.

Developing an Idea

Think you have a great idea for a comic strip? Everybody has ideas pop into their head, but how do you know the difference between a good idea and a bad idea? Knowing the difference may prevent you from going through a lot of trouble and frustration later. Here are a few things to consider when mulling over an idea for a comic strip:

- **Choose a subject that you find appealing.** Otherwise, you may find the idea tedious and dread working on it down the road.
- **Choose a unique idea.** Try and find something that no one else has done before to set yourself apart from the crowd.
- **Choose an idea based on a theme that you know something about.** This gives you special insight into the world you're creating and makes it easier for you to come up with future story lines.
- **Most important, be creative!** Think outside the box. Develop your characters in ways that play against stereotype, or choose a setting that's out of the ordinary.

Every creative engineer needs a solid plan, and the plan for developing your comic strip world starts with a great idea.

Composing a Theme and Main Idea

Before you jump into drawing characters and writing story lines, you need to determine your strip's main idea and theme. The *main idea* for your strip comes from the characters and the plot of the story. In contrast, the *theme* reflects the actions or events that are repeated and ongoing.

For example, the theme may be family life, work life, life in the forest, life on another planet, or any combination of the most common themes. Your main idea may center on a single father and his kids.

However, you can expand the idea to have the father and kids live on a space-ship, so your comic strip may have a high-tech, outer space, futuristic theme, as well as a family theme. These themes would emerge in the strip, which would chronicle the ongoing and amusing challenges faced by a family living in outer space.

Creating Your Characters

The ability to create and develop interesting characters is one of the best parts of being a cartoonist. Although the possibilities for character development are endless, common characters tend to fall into certain stereotypical categories. Consider creating a character that you can relate to or may have some insight into.

For example, if you're a parent, you may want to create a character who's a parent. If you're terrible at all sports except bowling, you may want to incorporate that trait into the character. Many great characters have strong and identifiable personalities, like the lovable but dimwitted dad (see Homer Simpson), the miserable boss (Mr. Slate from *The Flintstones*), or the smarter-than-all-the-adults little kid (Calvin from *Calvin and Hobbes*). These kinds of characters can provide you with endless script possibilities.

Much of who Charlie Brown was is said to reflect his creator, Charles Schulz. Charlie Brown's longtime infatuation with the little redheaded girl is no coincidence; Schulz had his own red-haired girl when he was in his twenties. Schulz proposed marriage and she turned him down and unexpectedly married someone else. Schulz never got that little redheaded girl and was forever disappointed . . . just as Charlie Brown was forever disappointed in never being able to kick the football! See Chapters 6 through 11 for more detailed information about creating your comic characters.

Designing the Setting

Your characters, like everyone else, need a place to live and hang out. Before you actually start sketching, select the setting for your strip. The *setting* includes major elements like the background and surrounding environment in which your characters coexist. Designing the right setting goes a long way toward creating your strip's overall look. The setting should complement the characters, reinforce the theme, and reflect your style.

The backgrounds and setting should enhance what your characters are doing without taking away from the main action. They add a sense of reality and are fun to draw, besides. See Chapters 12 and 14 for more on backgrounds and settings.

Writing Your Scripts

Before you can actually draw your cartoon, you need to write scripts. Similar to a movie's screenplay, the comic script is the basic foundation for the rest of the production. The movie director and camera crew would have no idea what to do without a script to follow, and you won't know what to draw without a script, either. Chapter 5 gives you the nuts and bolts for writing your scripts.

Keep a notebook to keep track of all your story lines. You may also want to set aside a certain part of the week just to write the scripts and then budget the remainder of the week to ink them up.

Another thing to consider when writing scripts is how to pace the dialogue in relation to the art. Typically, comic strips are drawn in a horizontal, multi-panel strip form made up of several individual boxes. The key in writing the script is to pace the dialogue so that it fits the respective boxes in a manner that flows. The longer you write in comic strip format, the better your timing will get.

Penciling It Out

After you develop some story lines and write your scripts, you're finally ready to start putting your ideas on paper. Begin by lightly sketching out a rough idea with your character's shapes and background elements. You don't want to go to dark with the pencil lines if you plan on erasing the sketch after you ink your line art.

If you're drawing your comic strip in the basic, horizontal, multipanel format, you need to block this area out. You do this on a large piece of paper with a pencil and a ruler.

You can also purchase paper that has already been blocked out in nonphoto blue guidelines. A comic book or Internet art supply store may carry this kind of paper.

 Regardless of your sketching method, don't sketch too heavily. You'll be erasing your lines later, so sketch light! For more information on sketching, see Chapter 4.

Slinging the Ink

After you finish the pencil sketch to your satisfaction, you're ready to move on to the final inking stage. *Inking* is basically using a brush or a pen combined with black ink to go over your light pencil sketch.

You ink the final art for a couple of reasons:

- ✔ **You need to have the art in a format that can be easily reproduced.** Pencil lines are very hard to reproduce and can fade and drop out, making your art hard to read. By contrast, nice, dark, black line work is easily reproduced and therefore easy for people to read.

- ✔ **It's so much fun!** Using a brush and black India ink is a longtime tradition in cartooning. Inking your cartoons can produce art that's crisp and clean, like that of Bill Watterson and Walt Kelly, or energetic and fluid, like the work of Richard Thompson and Ralph Steadman.

 When inking your work, don't just trace your pencil lines, because doing so produces work that looks stiff and deliberate. The key is to lightly sketch out your work in pencil and then do all the drawing with pen and ink or a brush. This method allows the final art to have a softer, more spontaneous line quality and to be more appealing to the eye. (Chapter 4 tells you everything you need to know about inking your cartoons.)

Lettering

After you ink in your art, add dialogue to your word balloons. Lettering should be neat and clean and reflect your style by being complementary to the line art.

You may choose to write in the lettering first before you ink the art so that you have enough clear space for lettering. You can adjust the art around it later. It's really up to your own personal preference, so experiment and see what works best for you.

Using a computer type font is okay if you use one that doesn't look like a computer type font; otherwise, your lettering will appear too rigid and stick out like a sore thumb. Hand lettering your work takes longer than using a type font, but the results pay off because it will most likely look better and complement the rest of your line art (see Chapter 13 for all the details on lettering your cartoons).

Scanning In Your Work

The last step in the process is to scan your artwork into your computer. You must scan your line art in the computer in order to color it, resize it, format the image file, and, of course, e-mail it or post the image on the Web.

To scan in your black-and-white line art, follow these steps:

1. **Place your artwork face down on the scanner glass.**

2. **Select Bitmap mode to scan in black-and-white line art.**

3. **Scan in your line art at 300 dpi or better.**

4. **Save your work as a TIFF file.**

Turn to Chapter 15 for more on scanning your artwork into your computer.

Chapter 18

Ten Secrets to Breaking in to a Cartooning Career

In This Chapter

▶ Sending your work to a syndicate

▶ Getting your cartoons in comic books, greeting cards, and magazines

▶ Joining professional organizations

▶ Finding inspiration and resources online and in books

*E*very young aspiring cartoonist wants to know how to break in to the cartooning business. However, finding information on how to actually become a published cartoonist isn't easy; colleges don't offer a specific degree that will land you a job, and you'll find few seminars on the subject.

You need to consider many important factors when getting into the business. After you're satisfied that you have what it takes to be a professional cartoonist, you have to start thinking about marketing your work. When you're starting your cartooning career, it's important to think of your work as a product, just like any other business would. Your characters may be near and dear to your heart, but to the people who market cartoons, they're just another commodity.

The market you're aiming for helps you decide what type of product to pitch, and vice versa. Certain types of cartoons appear only in certain media. Comic strips are marketed to newspapers and Web sites, editorial cartoons are marketed to newspapers for their editorial pages, and gag panel cartoons can be marketed to magazines.

In this chapter, I tell you some of the tricks of the trade that can help open the doors to a career as a cartoonist. These include how to find markets that may welcome your work, great conventions or events to attend, and what professional organizations you may consider joining.

Making the Decision to Pursue Your Dreams

One of the first steps to breaking in to the cartooning business is simply to make the decision to try. You envision yourself drawing a successful cartoon. To do so, you first have to sit down and try. You can't reach your dreams if you don't take the first step. Stop making excuses and jump in. After you start drawing, polish your work before sending it out, and remember that your competition is enormous — but don't let that discourage you completely. Every famous cartoonist started out as an unknown.

Belonging to a Syndicate

To succeed as a professional cartoonist, you have to grasp the importance of syndication. You can't make it in newsprint cartoons without belonging to a syndicate. *Syndication* simply means selling the presentation of cartoons to multiple users. Syndicates represent cartoonists and sell their work to news-papers and magazines. Syndication is every cartoonist's goal, but few really understand what a syndicate is and how it works. For more on syndication, check out Chapter 1.

If you think you have what it takes, you can contact several major syndicates directly for more information:

- ✔ **Artizans:** Submissions Editor, Artizans, 11136 – 75A St. NW, Edmonton, Alberta, T5B 2C5, Canada; https://zone.artizans.com.

- ✔ **Cagle Cartoon Syndicate:** www.cagle.com.

- ✔ **Creators Syndicate:** Creators Syndicate, 5777 W. Century Blvd., Suite 700, Los Angeles, CA 90045; www.creators.com.

- ✔ **King Features Syndicate:** Submissions Editor – Comics, King Features Syndicate, 300 W. 57th St., 15th floor, New York, NY 10019; www.king features.com.

- ✔ **Tribune Media Services:** TMS Submissions, 435 N. Michigan Ave., Suite 1500, Chicago, IL 60611; www.tmsfeatures.com.

- ✔ **United Media:** Comics Editor, United Feature Syndicate/Newspaper Enterprise Association, 200 Madison Ave., New York, NY 10016; www.unitedfeatures.com.

✔ **Universal Press Syndicate:** John Glynn, Acquisition Editor, Universal Press Syndicate, 1130 Walnut St., Kansas City, MO 64106; `www.amuniversal.com/ups`.

✔ **Washington Post Writers Group:** James Hill, Managing Editor, The Washington Post Writers Group, 1150 15th St. NW, 4th floor, Washington, DC 20071-9200; `www.postwritersgroup.com`.

Jumping into the World of Comic Books

If you dream of being a successful cartoonist, one of the best arenas you have an opportunity to succeed in is the world of comic books. The comic book industry has grown faster in the last decade than any other cartooning-related industry.

Comic books were once thought of as something read by nerds or geeks, but those nerds and geeks are laughing all the way to the bank. All you have to do is look at how many movies have been made in recent years that were based on popular comic books: *Superman, Batman, Hellboy, Spawn, Iron Man, X-Men, Spider-Man, Sin City,* and the *Hulk,* just to name a few. DC Comics, Marvel Comics, Image Comics, and Todd McFarlane Entertainment are some of the biggest comic book publishers, and they're always looking for new talent. But you've got to be really good to get a job there!

Taking a trip to the largest comic book convention

If comic books are your passion, why not start at the big kahuna of comic book conventions? To demonstrate how much the comic book industry has grown, all you have to do is look at Comic-Con International San Diego, commonly known as Comic-Con or the San Diego Comic-Con. This annual convention is traditionally a four-day event that runs Thursday through Sunday and is usually held in late July at the San Diego Convention Center.

Originally showcasing comic books, the convention has expanded over the years to include a variety of pop culture areas such as anime, manga, animation, video games, newsprint comics, webcomics, toys and collectibles, and, of course, the movie industry.

The convention is the largest of its kind in the world, with more than 145,000 attendees in 2008. The event is basically a *Star Trek/Star Wars* convention on steroids and is an absolute must-see for any cartooning fan. Attendees can browse the hundreds of booths set up by professional cartoonists and industry-related practitioners showcasing their latest art, toys, or comic book publication; sit in on any number of lectures and seminars scheduled throughout the convention; and meet many of the star illustrators, like *Spider-Man* creator Stan Lee, or the latest star of a comic book-based movie.

Marketing to Greeting Card Companies

Another great way to get your foot into the cartooning business is through greeting cards. Greeting cards are a popular item and offer promising opportunities to an aspiring cartoonist. Someone has to draw all those amusing sketches, sight gags, and one-liners on all those humorous cards. Why not you?

Greeting cards come in a wide range of designs and cover all sorts of holidays, events, and special subjects. Many of these cards showcase cartoon gags or funny characters to deliver a message to that special someone. Hundreds of companies make greeting cards in the United States alone. If you think you may want to try your hand at creating some greeting cards and you think you're really good, two of the major greeting card companies are:

- ✔ **American Greetings,** 1 American Rd., Cleveland, OH 44144-2301.
- ✔ **Hallmark,** P.O. Box 419034, Mail Drop 216, Kansas City, MO 64141.

There are numerous smaller greeting card companies as well. This is just a brief list:

- ✔ **Avanti Press,** Submissions, 6 W. 18th St., 6th floor, New York, NY 10011.
- ✔ **Comstock Cards,** Production Dept. – Gaglines, 600 S. Rock Blvd., #15, Reno, NV 89502.
- ✔ **Freedom Greetings,** Art Submissions, 38A Park St., Medfield, MA 02052.
- ✔ **Gallant Greetings,** 4300 United Parkway, Schiller Park, IL 60176.

Selling Your Work to Magazines

Another way to break in to the cartooning industry is by taking a stab with magazines. Take a quick glance through many magazines today and you'll be surprised to discover that all sorts of them run a cartoon or two in their monthly issues. Cartoons are published in a wide variety of magazines, ranging from *Road & Track* to *Better Homes and Gardens*.

Magazines typically run what are known as *gag* cartoons, also called *panel* cartoons, which are cartoons that use only a single panel and are usually more sophisticated than comic strips. Magazine cartoons also rely more on the caption and punch line to tell the story and less on the art. Consequently,

many of the more successful magazine cartoonists draw in a simple, minimalist style that highlights a sense of sophistication and is less "cartoony" than other genres.

Perhaps one of the most popular magazines that has a history of running sophisticated panel cartoons is *The New Yorker,* which runs cartoons from a staple of regular freelancers. If you think you can inject an intellectual, highbrow sense of humor into your work, contact *The New Yorker* at 4 Times Square, New York, NY 10036 to find out what type of material the magazine is looking for and what you need to do to submit.

Joining the Association of American Editorial Cartoonists

The Association of American Editorial Cartoonists (http://editorial cartoonists.com/) is a professional organization concerned with promoting the interests of staff, freelance, and student editorial cartoonists in the United States. It's the only formal organization that includes and represents editorial cartoonists exclusively. Joining an organization like the AAEC can have many benefits for an up-and-coming editorial cartoonist. These include making valuable contacts, learning the business from seasoned professionals, and getting constructive feedback on your work.

The AAEC was officially formed in 1957 by a small group of newspaper cartoonists led by John Stampone of the *Army Times.* It was created to promote and stimulate public interest in the editorial cartoon and to create interaction between political cartoonists. The annual AAEC convention is held around June of each year in various cities around the country. These conventions are popular and allow cartoonists to meet with others from the journalism community, including publishers, writers, historians, and collectors. Members of the AAEC include nearly every major editorial cartoonist working today.

One of the great things about the AAEC is its recognition of the brightest young cartoonists in the country. One way the AAEC does this is by giving the annual Locher Award, which honors the best college editorial cartoonist in the nation. The award was named after the late son of Dick and Mary Locher. Dick is a Pulitzer Prize-winning editorial cartoonist for the Chicago Tribune, best known as the artist for the *Dick Tracy* comic strip. Since 1987, the AAEC has given the Locher Award to some of the best young cartoonists in the country, who've all gone on to have a successful career in cartooning, including the author of this book, who won the award back in 1996.

Being Part of the National Cartoonists Society

The National Cartoonists Society (NCS) (www.reuben.org/) is the world's largest and most prestigious organization of professional cartoonists. The NCS was born in 1946 when groups of cartoonists got together to entertain the troops during World War II. They found that they enjoyed one another's company and decided to get together on a regular basis.

Joining the NCS has many benefits for professional cartoonists as they begin their career. These include:

- Learning the business from some of the biggest names in cartooning (networking is always beneficial; it really is true that it's who you know, not what you know, in many business situations).
- Being continually encouraged to grow in your work.
- Making some great lifelong friends who know what your life is like. Misery does love company, and commiserating about deadlines, or worse yet, difficult editors or clients, can help you feel less alone in what can be an isolated job.

Today, the NCS membership roster includes more than 500 of the world's major cartoonists working in many branches of the profession, including newspaper comic strips and panels, comic books, editorial cartoons, animation, gag cartoons, greeting cards, advertising, magazine and book illustration, and more.

Membership is limited to established professional cartoonists, with the exception of a few outstanding persons in affiliated fields. The NCS is not a guild or union, although members join forces from time to time to fight for their rights, and the organization regularly uses the talents of the membership to help worthwhile causes.

Looking at the Most Popular Cartoon Site on the Web

If you want to get a better feel for what a successful cartoonist needs to do, you should check out perhaps the most popular cartooning Web site: Cagle's Professional Cartoon Index at www.cagle.com. News junkies and cartoon fans won't want to miss this great site, which is updated daily with the latest

cartoons. Part of the MSN/MSNBC Web site, it showcases the best editorial cartoons from all the top political cartoonists in the world. You can find thousands of cartoons covering the latest issues in politics and pop culture there.

Checking Out Cartoon Blogs

In the digital age, keeping up with the cartooning world with news and inside information from cartoonists' personal Web sites and blogs is important. You can find thousands of cartooning Web sites and blogs out there; just use your favorite search engine to search for "cartooning blogs" to see what I mean.

Here are just a few Internet sources to get you started:

- ✓ **The Daily Cartoonist (`dailycartoonist.com`):** A great resource for news and the inside scoop about cartoons and comics.

- ✓ **The Comics Reporter (`comicsreporter.com`):** As the name suggests, this site is invaluable for keeping up on what's going on with comics.

- ✓ **Richards Poor Almanac (`richardspooralmanac.blogspot.com`):** From Richard Thompson, the creator of the new comic strip *Cul De Sac*. A revealing look inside his cartooning process.

- ✓ **Journalista (`www.tcj.com/journalista`):** "The Comics Journal Weblog," a great blog to keep you up-to-date on the latest inside news regarding cartooning.

Reading about Cartooning

One of the best ways to become attuned to the vast number of cartooning markets is to invest in a few books that give you the ins and outs of the industry. And one of the best ways to become a better cartoonist is to study the work of some of the foremost practitioners in the field.

Many great books are out there, but here's a list to get you started:

- ✓ *Artist's & Graphic Designer's Market* (edited by Erika O'Connell; Writers Digest Books) contains a wealth of information, including names and addresses of magazines, newspapers, and other potential markets for your work.

- ✓ *The Best Political Cartoons of the Year,* editions 2005 through current.

- ✓ Any book collection about *Mad* magazine.

✔ Books by any of the following cartoonists:

- Paul Conrad
- Robert Crumb
- Jack Davis
- Mort Drucker
- Walt Kelly
- Pat Oliphant
- Ted Rall
- Charles Schulz
- Bill Watterson

Index